DESIGNING THE WORLD'S BEST

EXHIBITS

MARTIN M. PEGLER

DESIGNING THE WORLD'S BEST

EXHIBITS

MARTIN M. PEGLER

VISUAL REFERENCE PUBLICATIONS, INC.—NEW YORK

Copyright © 2003 by Visual Reference Publications, Inc.

Visual Reference Publications
302 Fifth Avenue
New York, NY 10001

Distributors to the trade in the United States and Canada
Watson-Guptill Publishers
770 Broadway
New York, NY 10003

Distributors outside the United Sates and Canada
HarperCollins International
10 E. 53rd Street
New York, NY 10022

Library of Congress Cataloging in Publication Data:
Designing the World's Best Exhibits
Printed in China
ISBN 1-58471-038-1
Designed by Dutton & Sherman

CONTENTS

INTRODUCTION

If variety is the spice of life—then this volume of exhibits is all spice, light, color and excitement, and as varied and international in scope as one could hope for. The trade-show stands and exhibits presented in this lively collection include shows that literally span the world: from Singapore, Shanghai and Beijing, to Sydney, Australia, to Brno in the Czech Republic, Munich, Dusseldorf, Frankfurt and Cologne in Germany, Basel in Switzerland, Bologna in Italy, London and Glasgow in the United Kingdom, on to Toronto in Canada and across the U.S. from New York to Chicago to Las Vegas and Los Angeles with stops in Boston, Atlanta, Orlando, New Orleans, Pickerton, Cleveland, Detroit, Denver and San Francisco. The exhibits selected are the work of 30 designers/design firms that are also situated worldwide.

As varied as the locations are, the products that were presented: autos, trucks, motorbikes and aircraft, computers, electronics, communications, telecommunications, networks and networking, furniture and furnishings, tiles and ceramics, fibers and fabrics, retail fixtures and fittings, decorative props and retail enhancements, clothing, drink, entertainment and games, dolls, toiletries, medicines and medical supplies, music and musical instruments, photography, printing, real estate manage-ment and mall and shopping center developers—and even exhibits for the exhibit designers themselves to serve as "calling cards" at the Exhibitor's Show.

Wherever and whenever possible I have tried to incorporate the designers' and the clients' words into the accompanying copy so that the reader can better understand the "challenge" the designer faced and how the "solution" evolved. We can better understand what was accomplished when the designer expresses that achievement. For a design to be successful, brand identification and image enhancement seem to be the major requirements followed by the need to expose clients and potential clients to the exhibitor's wares. The reader will find that in a majority of the booths interactive kiosks and stands are featured along with plasma screens—getting larger and larger—rear projections, back-lit graphics, colored lights. A sense of discovery and fun is built in as well. Designers, when possible, make full use of the cubic space by building up. They take advantage of the high ceilings in the exhibit halls to build towers or beacons or two or more levels and eyecatching features that can be seen from across the exhibit hall floor.

The trade show exhibits are arranged in this book by the square footage occupied rather than the product

offering. It is important to see how designers face the challenge of creating a total brand image in a 200 sq. ft. space as well as in a 2000 or 20,000. or 40,000 sq. ft. space. However, exhibits are not just seen at trade shows or at conferences. Exhibits are today appearing in corporate headquarters and visitor's centers, in museums and libraries as educational and entertainment features, in showrooms converted into exhibit areas, in historic locations, malls and shopping centers and they have even gone "on the road" and the trucks or busses become the venue when they are parked at a selected location. At the end of this collection we have added some of these exhibits and also arranged them in a spatial progression.

To obtain the material for a book of this scope there are many people and organizations that I must thank. First and foremost I do appreciate the time and effort of the many design firms whose works are represented here.

In their busy schedules they made the time to get the material to me and answer the questions I needed answered to be able to show their work to you—the readers. Without the talents of the photographers who took the images reproduced here this would have been a mostly blank collection of pages with blobs of copy referring to nothing. I do sincerely appreciate their efforts and their generosity in sharing their work with us. I also want to thank some of the other design firms who were only too eager to share their completed exhibits but were unable to because of copyright problems. Here's hoping there will be smoother sailing for the next collection.

Enjoy, absorb, appreciate—and may you find pathways to your own "solutions" from the "solutions" shown here.

—Martin M. Pegler

DESIGNING THE WORLD'S BEST

EXHIBITS

MARTIN M. PEGLER

CIOT

IIDEX—*Toronto, ON 2003*
EXHIBIT DESIGN—*ll X lV Design Associates, Toronto, ON*
PHOTOGRAPHY—*David Whittaker*

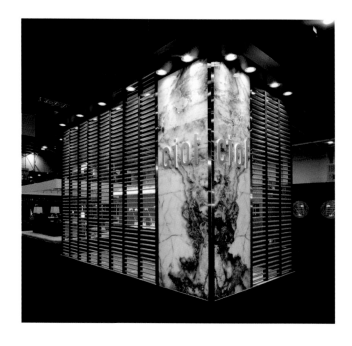

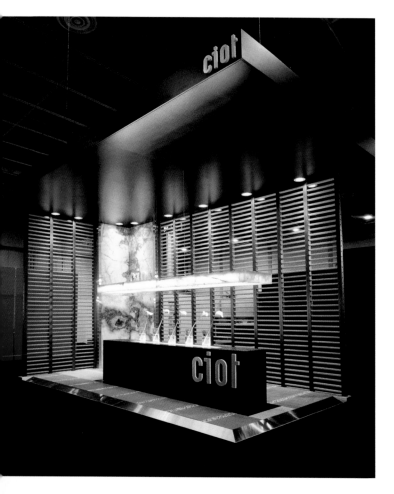

To showcase some of Ciot's newest European imports of stone and tile and to demonstrate applications for these products, Ciot commissioned this exhibit designed by ll X lV Design Associates of Toronto. The concept behind the design was to "put to rest any illusions that stone and tile finishes are cold and unfriendly."

The semi-enclosed 200 sq. ft. space permitted the staff to interact with clients and potential buyers in "a far more intimate and luxurious setting than is typical at such trade shows." Serving as beacons were the white onyx vertical corner details and the matching suspended panel fixture. Horizontally-slatted screens in Italian terra cotta showed off the new product's exciting potential for interior screens and/or exterior architectural detailing. In addition, it added "a wood-like warmth" to the design.

The flooring combined prefabricated terrazzo stone tiles with limestone slab tiles and those—along with the other Ciot products displayed—created "a simple, warm and richly-textured and patterned setting designed to inspire innovative thinking among architects and interior designers."

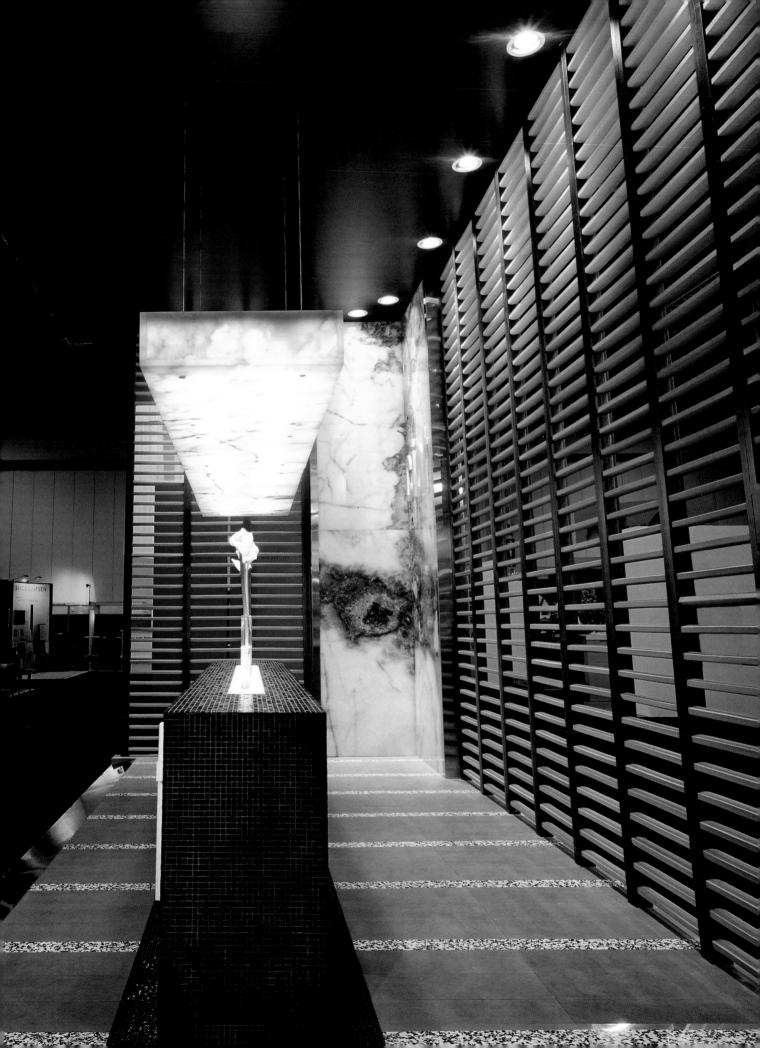

LATHER

EX-TRACTS SHOW—*New York, NY*

EXHIBIT DESIGNER—*Canzoneri Designs,*
Jean-Pierre Brodeur

EXHIBIT FABRICATION—*Deva Productions, Los Angeles, CA*
Danny Esteras / Damon Vix / Paul Boak / Brian Lance

LIGHTING & SPECIAL EFFECTS—*Jean-Pierre Brodeur*

PHOTOGRAPHY—*Margaret Keasbury, Deva Productions*

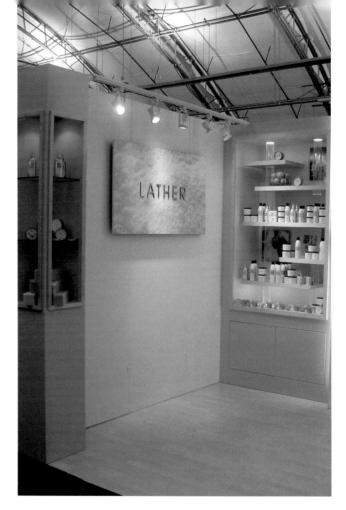

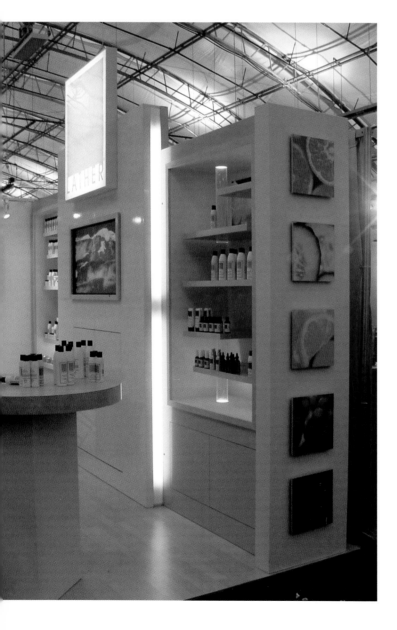

Lather is a "modern apothecary"—"a fusion of ancient practices and modern techniques." For its appearance at the Ex-Tracts Show in the Javits Center in New York City, the client Emilie Hoyt retained Jean-Pierre Brodeur of Canzonieri Designs to create a 200 sq. ft. exhibit which would "capture the essence of the product and properly communicate it to Lather customers."

To establish the look of the booth, the designer combined elements of Feng Shui with elements of Zen. "Modern architectural lines were used in conjunction with organic shapes and finishes to create a modern yet natural feeling in the space" which was fabricated by Deva Productions of Los Angeles. High gloss Hascolac paint was used to affect "a seamless—almost flowering effect" on the back walls that showcased the product. The color scheme was white, light green and blue with blonde wood flooring and accent trim to reflect the architectural look of the existing Lather boutiques. The wood touches "enhanced the organic shapes and elements used in the space—giving it a more natural feeling."

The Zen spirit was captured on the large plasma screen which was the focal element in the stand. Here "moving images (lavender covered hills, babbling brooks,

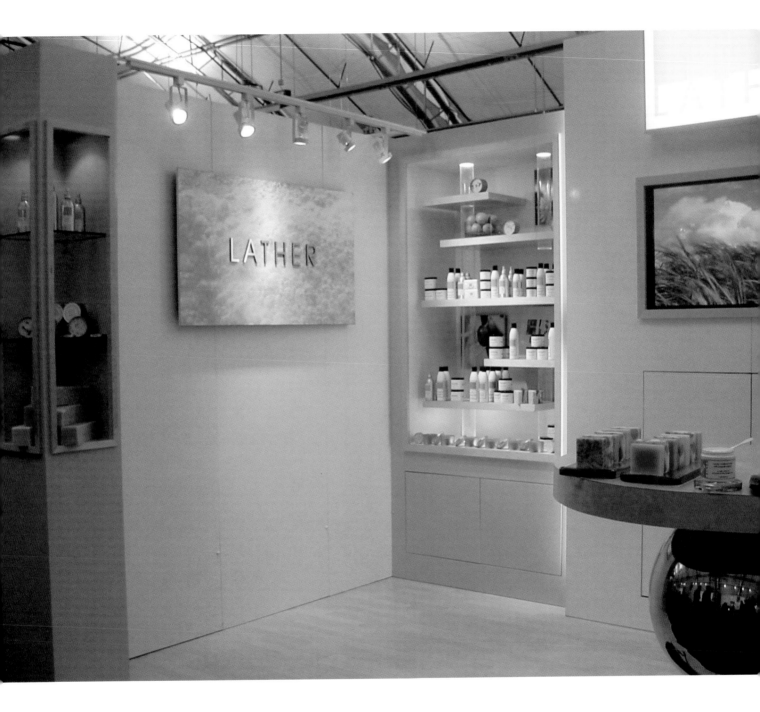

etc.) were essential to creating the feeling of life and motion in the space." To further communicate the natural essence of the product, there were still images of fruit, flowers, plants and vegetables.

"The booth was successful because it properly captured and communicated the essence of the company and its product."

RUFUS
LEONARD

DESIGN EXHIBITION—*Business Design Centre, London, UK*
EXHIBIT DESIGNER—*Brinkworth, London, UK*
PHOTOGRAPHY—*Courtesy of Brinkworth*

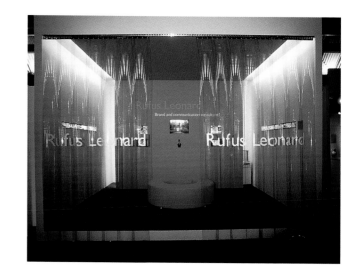

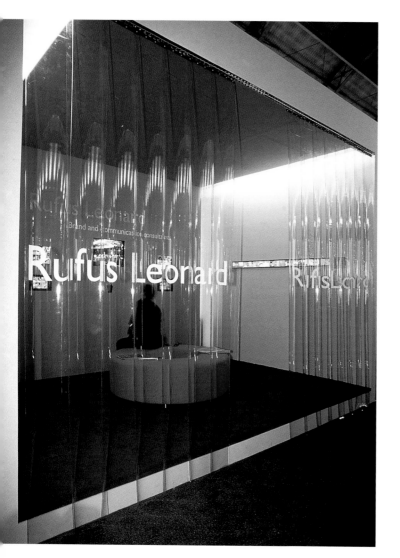

The concept behind the 200 sq. ft. stand "was to offer a refuge from the typical overheated exhibition hall environments." To accomplish this for Rufus Leonard—a firm of branding and communication consultants—Brinkworth designed this freestanding, fully air-conditioned oasis.

The three walls were constructed of wood and the interior faces were finished with the Rufus Leonard corporate colors. A single orange donut-shaped seat was provided and the company's work was viewed through a live link-up with the Leonard office. There were also small images of previous projects which were viewed in two "discreet" horizontal light boxes set onto the side walls of the booth.

"The stand proved to be a successful environment in which to meet clients—differentiated, confident and humorous—and, crucially for a successful and established company, far removed from the hard sell of the neighboring stands." The colored and layered "slush puppy" alcoholic drinks that were served also helped to cool things off.

ATELIER TORINO

BMW OPEN—*Munich, Germany*

EXHIBIT DESIGNER—*Gruschwitz, Grobenzell/Munich, Germany*

EXHIBIT FABRICATOR—*Criterion, Grobenzell/Munich, Germany*

LIGHTING & SPECIAL EFFECTS—*Criterion*

PHOTOGRAPHY—*Studio Gruschwitz*

For a small, intimate introduction to the art of fine tailoring techniques and the fashionable styling of menswear by Atelier Torino, the design team of Studio Gruschwitz created this white-on-white, 265 sq. ft. stand which appeared in the BMW-Open in Munich, Germany.

Samples of the finished menswear were presented on dress forms attached to contemporary wood and metal stands. They appeared against the translucent white corrugated plastic panels that surrounded the stand on three sides. Making a dramatic and startling statement was the cantilevered conference table that filled the center of the space. An angled mirror panel backed up by the corrugated material broke the symmetry of the design and also replayed the color accent of the tulips set into a steel sided container filled with white pebbles. The tulips set the Spring theme.

What made this design so effective? "A very special image—a mixture of elegant men's fashions and the unique daring design of the furnishings." The designers also felt that the stand attracted attention because of "a certain purity in an exquisite ambiance with a warm, living, blooming area in the middle."

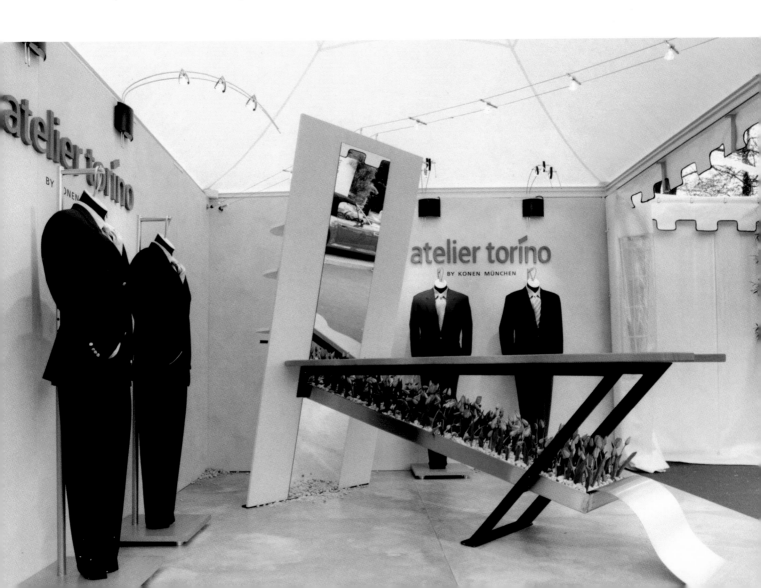

PRESENTATIONS PLUS

GLOBALSHOP—*McCormick Place, Chicago, IL 2003*

EXHIBIT DESIGN & FABRICATION—*Presentation Plus, Long Lake, MN*

DESIGNER—*Craig Gustasfson*

DESIGN TEAM—*Craig Gustafson / John Dougan / Kevin Silus*

PHOTOGRAPHY—*Craig Gustasfson & Kevin Silus*

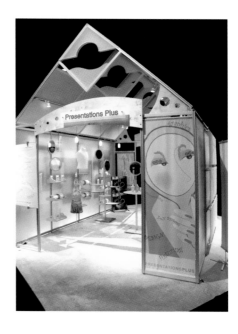

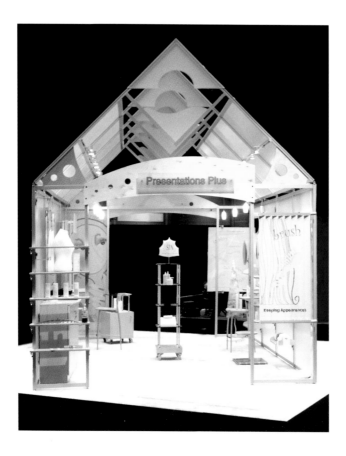

The store-within-a-store concept was created by, constructed for, and featured the fixture designs of, Presentation Plus. It was created to show off the capability and versatility of Presentation Plus's new ZoN merchandising system and their Salon-inspired fixtures at the 2003 Globalshop exhibition. In addition, the concept showcased the design firm's ability to create custom graphics which were coordinated to match the color palette of the exhibit.

The open-for-viewing house sat diagonally across the 20 ft. x 20 ft. space and the semi-translucent, pale green plexiglass side panels provided a degree of privacy within while also serving as the background for the pastel-colored, lighthearted graphics. The lightweight, satin aluminum ZoN structural extrusion system formed the decorative skeletal framework which supported the frosted panels and the artwork. Accents of burnished brass complemented the matte finish of the structural metal and the natural wood used for the assorted salon fixtures and accessories.

Simple, frosted white drop lights hanging from the peaked "roof," added warm accent light and caused the interior to glow when viewed from the traffic aisles of the show. Inside the limited space the designers were able to create a vignette of a beauty spa with the firm's products. All it took to build the eyecatching and inviting "house" was one hand-held tool.

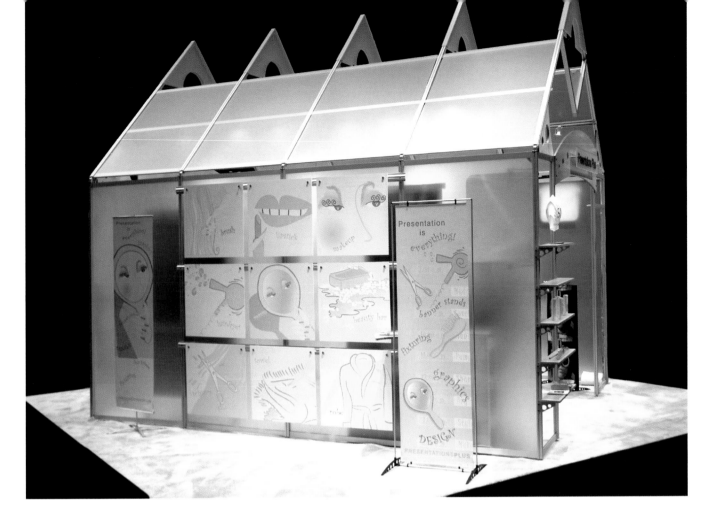

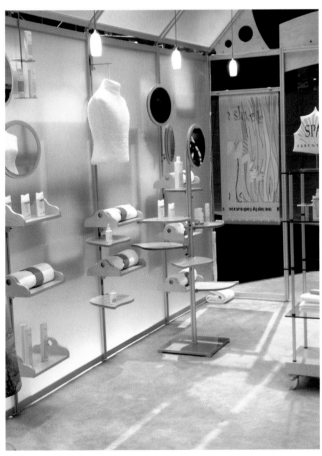

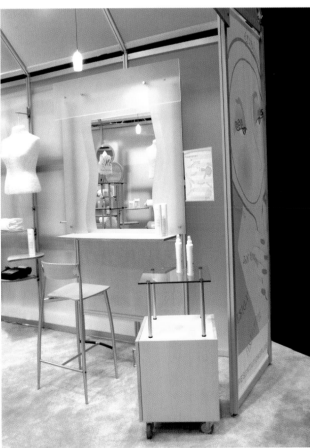

ARCONAS

IIDEX SHOW—*Toronto, ON*

EXHIBIT DESIGNER—*II X IV Design Associates, Toronto, ON*

Don Menchions / Keith Rushbrook / Yvonne Ho / Jenny Lee

EXHIBIT FABRICATOR—*Arconas*

PHOTOGRAPHY—*David Whittaker*

"I/O" is a new line of light, contemporary furniture whose name refers to the "inside/out" design. It was created by Arconas, a well known Canadian furniture manufacturer and it was introduced at the IIDEX Show in Toronto. Within a space of 400 sq. ft. the client wanted to present as many product variations as possible in a simple, clean setting that would not distract from "the pure product lines of the products" themselves.

II X IV Design Associates divided the space into four accessible "rooms" by means of 16 ft. high, internally lit, back-to-back expanses of translucent drapery suspended from a diagonally-set I-beam construction. Huge signage letters were suspended in front of each panel and each "room" had its own colorway to further delineate the different spaces. The white-washed wood floor of the stand complemented the flowing drapery, the architectur-

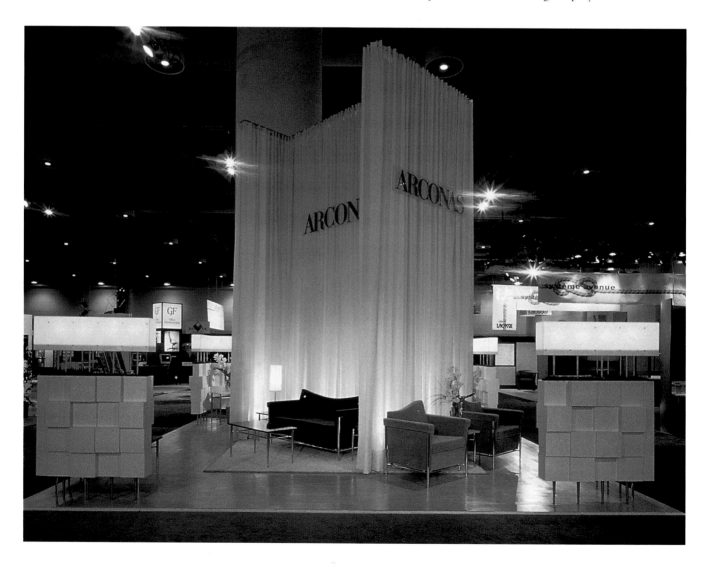

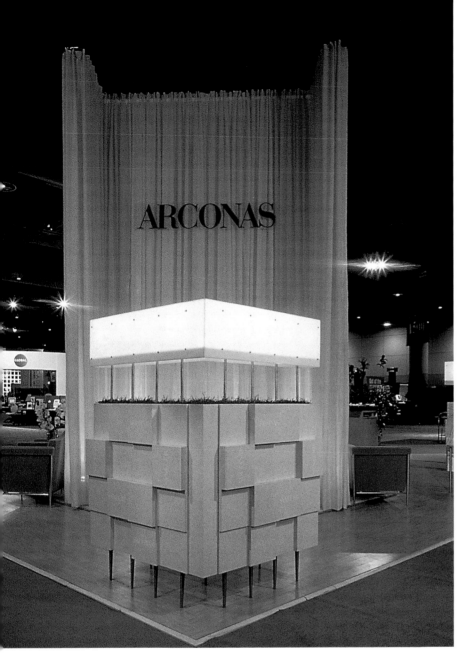

al corner elements and the creamy, off-white area rugs that helped to center each "room."

To further define these four areas, feature walls at the booth corners incorporated more signage. These corner fixtures also "illuminate a sly reference to the 'inside/out' origin of the product name." These elements incorporated insets of galvanized metal troughs planted with tightly manicured, crisp, green, live grass and they were topped with soft glowing acrylic shaded light boxes. The play of

shadows created by the in and out placement of the white cubes created an architectural quality that contrasted with the grass above. While the furniture wears its frame on the outside, the booth design brought some of the outside in.

According to the exhibit's designers, "The exhibit depended upon 'walls of light' for its dramatic effect, supplemented by perimeter 'hedges' topped with light."

MOSS

EXHIBITOR SHOW—*Las Vegas, NV*

EXHIBIT DESIGNER—*Mauk Designs, San Francisco, CA*

EXHIBIT FABRICATOR—*Moss*

PHOTOGRAPHY—*Mitchell Mauk of Mauk Designs*

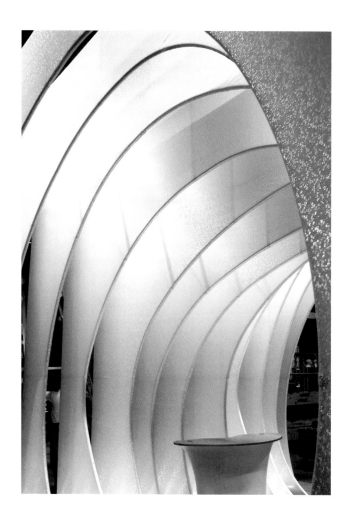

Moss is a manufacturer of fabric components for trade shows and the 400 sq. ft. space was designed by Mitchell Mauk of Mauk Designs for an Exhibitor Show in Las Vegas, NV where designers, fabricators and suppliers of trade shows and exhibits come together with the clients looking for that talent.

The objective, for Mauk, was "to break out of the stretched fabric suppliers cliché exhibits—swoopy, curved, stretched fabric with colored lights." To accomplish this, the design team created the "cave" which enclosed an intimate area where the Moss representatives and the potential clients could meet. Using stretched fabric over aluminum tubing "a clean—almost sterile—environment was created. The simplicity and clarity of Moss's exhibit stand stood in stark contrast to the screaming, candy colored anarchy of the competitors exhibits."

The exhibit was quickly set up and required only half a truck for shipping. The white plastic floor—made of recycled plastic—and the aluminum tubing, were all recyclable.

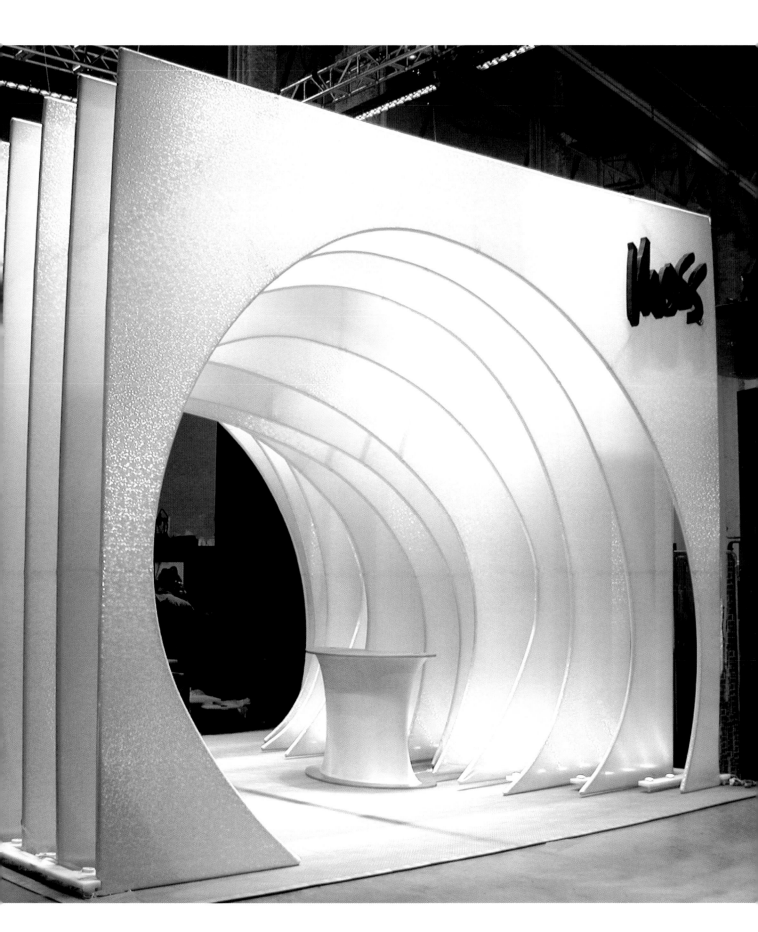

PHILLIPS
EDISON

ICSC SHOW—*Las Vegas, NV 2000*
EXHIBIT DESIGN—*Lorenc + Yoo Design, Roswell, GA*
Jan Lorenc / Sakchai Rangisyakorn / Steve McCall /
Susie Caldwell
EXHIBIT FABRICATION—*Geograph Industries, Harrison OH*
PHOTOGRAPHY—*Rion Rizzo, Creative Sources, Atlanta, GA*

Working in a limited space and with a limited budget, Lorenc + Yoo Design created this bright, sunny and eye-opening 400 sq. ft. stand for Phillip Edison's appearance at the International Council of Shopping Centers' show in Las Vegas.

Since that show (like most trade shows but maybe a bit more) is all about "deals," the designers were able to fit three conferencing areas into the allotted space along with a front reception area. The company desired "to portray an image that would reflect a sophisticated coming-of-age without compromising its youthful energy and creative spirit." The fresh, free feeling and color selection carried through that concept.

The entrance to the stand was highlighted by a bold, sweeping 14 ft. high cantilevered arch made by an aircraft fabricator. The white metal structural armature with acrylic rice panel inserts added to the youthful, energetic feeling of the design. On the white wall facing the traffic aisle were nine illuminated shadow boxes filled with "everyday consumer goods." The reception desk curved from the aisle into the reception area and it repeated the square cut-out motif that appeared on the outer wall. A translucent wall system defined each of the three offices and "provided a sense of spaciousness." The small but efficient conference rooms featured light, custom furniture and panels with photographs of the Phillips Edison properties.

The materials used to construct the booth—aluminum, acrylic, fiberglass, MDF and plastic laminates—combined with the soft illumination throughout—lamps, uplights and hidden internal illumination—turned the enclosed exhibit into as soft glowing "jewel box" on the exhibit hall floor.

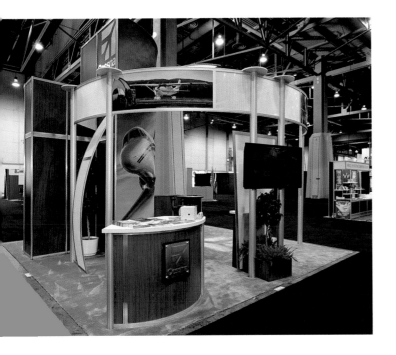

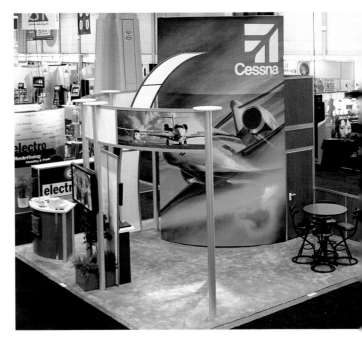

CESSNA
AIRCRAFT CO.

CESSNA AIRCRAFT CO.—*COMDEX Show, Las Vegas, NV*

DESIGNER & FABRICATOR OF EXHIBIT—*Chicago Exhibit Productions, Bolingbrook, IL*

DESIGNER—*Joe Koziarski*

FABRICATION TEAM—*OCTANORM USA, Exhibit System components*

FABRIC IMAGES—*large mural*

PHOTOGRAPHY—*Courtesy of Chicago Exhibit Productions*

Cessna Aircraft Company chose to have Chicago Exhibit Productions create this 400 sq. ft. exhibit as a rental—"to test the effectiveness of the COMDEX show as a viable venue" for the company. The success for Cessna was evident during the show by the attendance at the stand. The exhibit was recognized with a Silver Tower Award from the Business Marketing Association.

The sleek, curved lines of the exhibit's design, which was created out of system component parts usually reserved for custom exhibits, complemented the design lines of the Cessna aircraft which were represented by the large 12 ft. x 16 ft. fabric mural. The graphic depicted a Citation X corporate jet in flight against a background of a setting sun. Curved headers, at the front of the stand, with photos mounted on two sides showed lifestyle illustrations of the thrill of owning Cessna single engine aircraft. Moving Cessna light logos traveled from the aisle through the booth and up the face of the giant graphic while large plasma screens, mounted to the header support columns, played Cessna videos and promoted the "Learn to Fly" program.

A small conference area was set off in a corner of the booth, and storage was located behind the graphic panel. A small curved reception desk at the opposite corner provided information and literature. The open traffic flow within the booth allowed several visitors to move through the space at the same time without the feeling of being crowded or rushed.

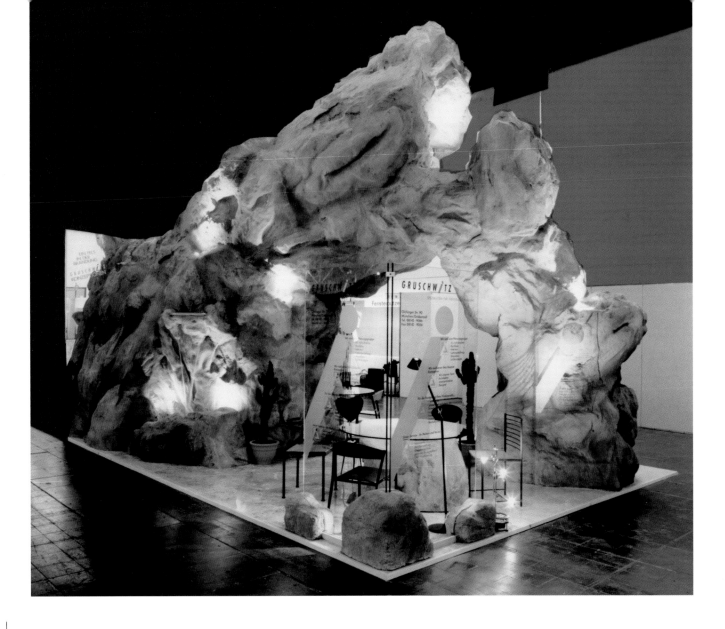

GRUSCHWITZ

EUROSHOP—*Dusseldorf, Germany*

EXHIBIT DESIGN—*Studio Gruschwitz, Grobenzell/Munich,
Germany*

FABRICATION OF THE EXHIBIT—*Baumgarten, Switzerland*

PROPS & DECOR—*Grauer Werbetechnik, Feldgeding*

PHOTOGRAPHER—*Suhan, Dusseldorf, Germany*

To present its many design services to the visitors from all
over the world at Euroshop in Dusseldorf, Studio
Gruschwitz designed this unique, attention-getting amor-
phous glowing "rock cave" or "grotto" in a 20 ft. x 26 ft.
space. According to the designers, "The powerful expres-
sion of the old rock—as a symbol of stability and resisting
the surges of time—and the marketplace as viewed
through panels of clear plastic, makes the visitor curious
and invites him in."

The glowing and "growing" rugged mass of fiberglass
was surrounded, at the perimeter of the space by simple,
clear plastic screens which carried statements about the
design firm. There were several arrangements of tables
and chairs where the staff could discuss their work with
interested, potential clients, and they could explain how
Gruschwitz could "profile them through design and
architecture." "The warm atmosphere was appropriate
for professional and human communication."

OUTER BANKS

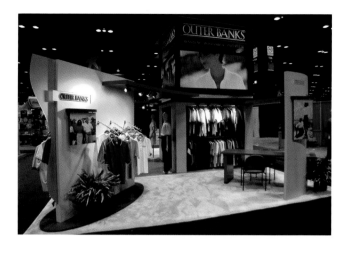

MOTIVATION SHOW—*McCormick Place, Chicago, IL 2002*
EXHIBIT DESIGNER/FABRICATOR—*Chicago Exhibit Productions, Bolingbrook, IL*
DESIGNER—*Joe Koziarski and Eric Lax*
PHOTOGRAPHY—*Will Bannister*

For Outer Banks' appearance at the 2002 Motivation Show in Chicago, the Chicago Exhibit Production group designed and constructed a highly visible and graphic statement in the allotted 600 sq. ft. space. The mere presence of the booth on the floor—for Outer Banks—was a big departure from previous exhibits that focused primarily on extensive product display. "The new exhibit focused much more on projecting an image and lifestyle that would connect with younger buyers, while still providing the ability to display a wide variety of product."

Using large, lifestyle graphics on pull-down "window shades" combined with woodgrain "boutique finishes," the designers affected the desired upscale image for Outer Banks. The pull-down graphics also serve to "hide" clothing racks built into the central tower which featured four different graphics on top. These graphics

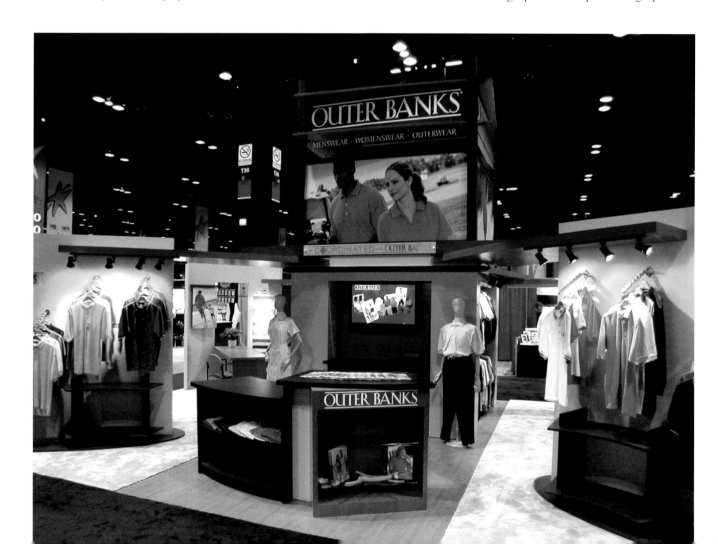

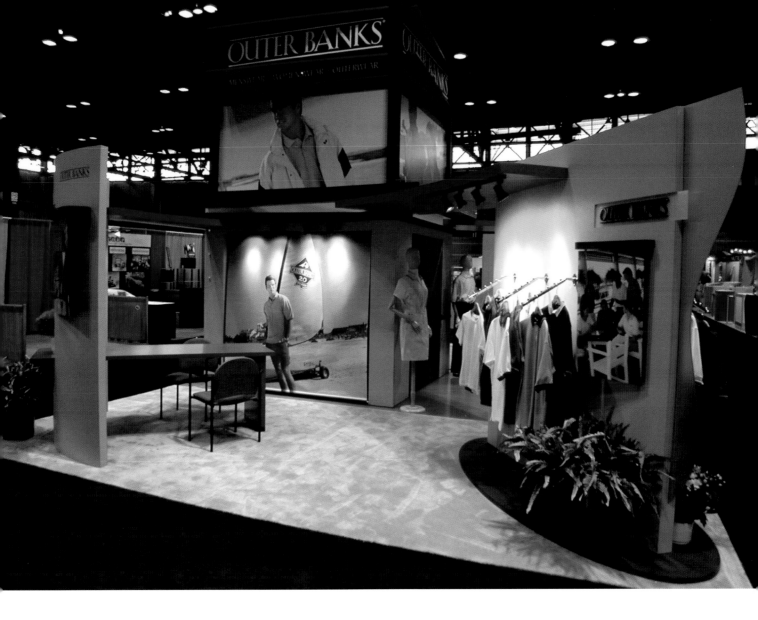

served to draw attention to the exhibit space below while projecting the desired lifestyle image to the targeted demographics. Additional shades, attached to cross headers, provided a degree of privacy for the meeting areas in this otherwise open booth.

A series of curved wall partitions peeled off the square central tower and created several specialized "boutiques" which were visible from the show's traffic aisles. Off these partitions the selected garments were displayed from waterfall brackets and illuminated by a strip of spots cantilevered off the partition. "To create a drama and interest" through the lighting contrast, the designers were able "to further the boutique feel to the overall design."

The effective traffic flow through the space seemed not only to maximize the selling area but allowed visitors to peruse a variety of product in small, easy to grasp and appreciate clusters. Throughout, it was the lifestyle graphics that furthered the brand image.

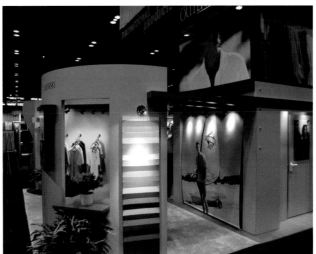

TRANSFORMIT

THE SPECIAL EVENT SHOW—*2002*

EXHIBIT DESIGN & FABRICATION—*Trasformit, New York*

PHOTOGRAPHY—*Kathy Chapman*

In response to an ever-growing need for cost effective, lightweight and adaptable fabric units that can be used either as walls, partitions or suspended over exhibit display areas—units that can be lit without rigging—the designers at Transformit evolved "Fascinating Rhythms." The design firm introduced this concept of stretch Lycra fabric over aluminum frames combined with light and music at the Special Event Show in 2002. From there, the stand was quickly taken apart and shipped off to Dusseldorf where it appeared at Euroshop and from there back to the U.S. and to Chicago for the 2002 GlobalShop where it caused quite a stir.

Fascinating Rhythm is a new collection of tension fabric shapes inspired by musical notes and symbols. The collection contains pieces that can be "mixed and matched to create an environment conveying the user's desired 'tone.'" The different elements have names such as Trill, Riff, Crescendo and Staccato and, as shown here, the "Symphony" of different component "sounds" played out in a 20 ft. x 30 ft. island space and it soared up to 16 ft. in height.

The fabric perimeter walls were effective in creating "a soft, tranquil environment within the exhibit—a drastic contrast to the bustle of the show floor outside the exhibit." The units are lightweight, easy to install and a perfect background for the of changing colored lights.

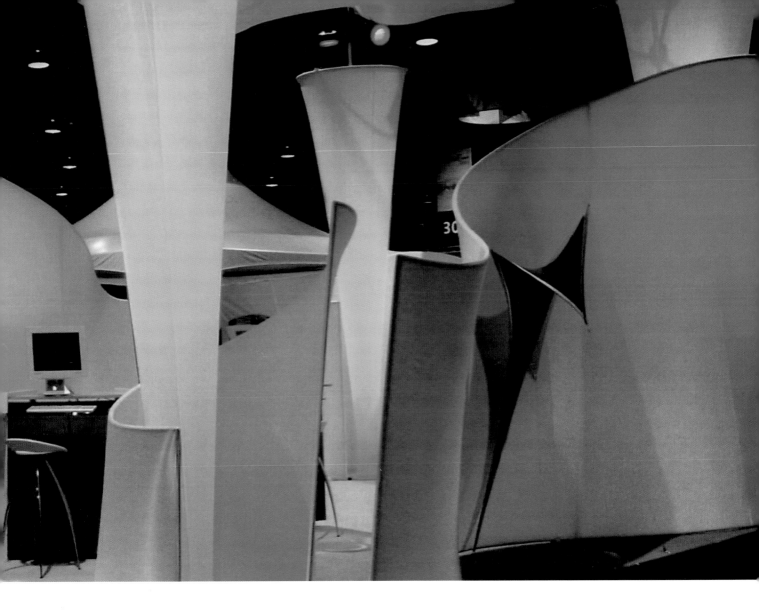

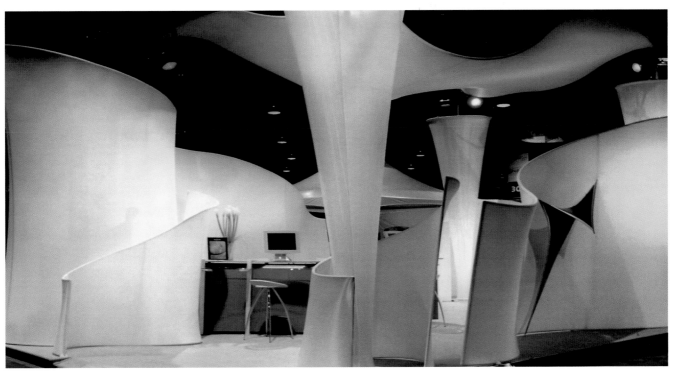

DAVIS STREET

ICSC SHOW—*Las Vegas, NV 2001*

EXHIBIT DESIGNER/FABRICATOR—*T L Horton Design,*
 Dallas, TX

DESIGNER—*Garry Cohn*

DESIGN TEAM—*Krystyna Bojanowski*

PHOTOGRAPHY—*Joe Aker*

In a rather small space—600 sq. ft.—the sharp, clean and contemporary white and red design created by T L Horton Design for Davis Street made a really big statement on the floor of the ICSC Show in Las Vegas.

The curved red tower that backs up the arced white reception desk set up front at the corner of the rectangular space carried the Davis Street logo well up above the heads of the show attendees that filled the aisles. Stainless steel grids filled with translucent plastic panels extended out from either side of the tower to create a viewing area behind it. The floor is white and white laminates covered the curved dividing wall which was accented with a series of angled vertical panels. The subtle angle of the leaning panels was complemented by the tilted framed graphics which highlighted the various Davis Street properties. An opening in this dividing wall led to the rear and more private area where conferencing took place.

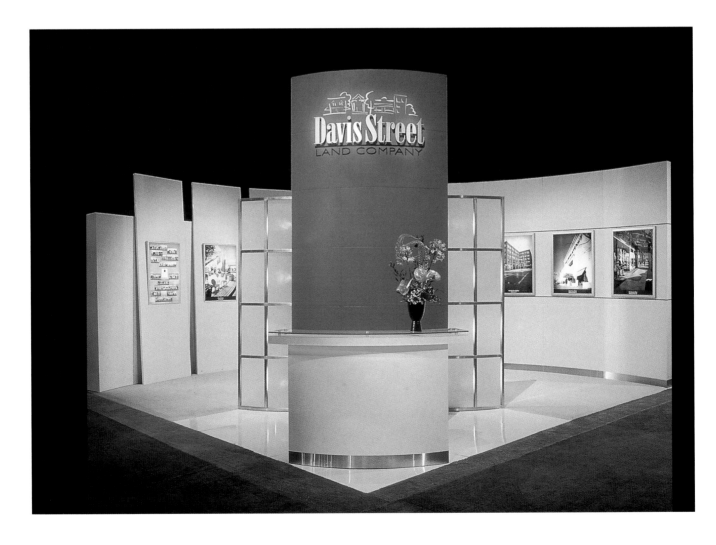

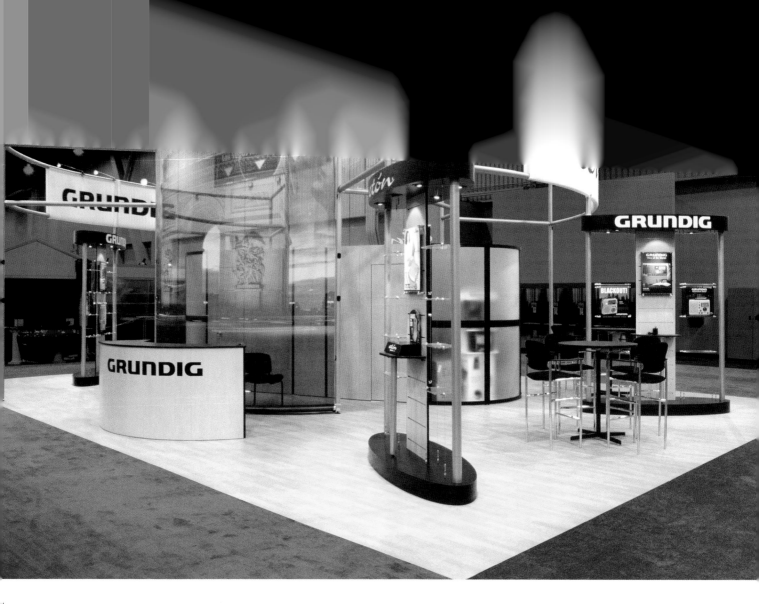

G R U N D I G

CES INTERNATIONAL—*Las Vegas, NV 2003*

EXHIBIT DESIGN & FABRICATION—*Skyline Exhibits,*
 Eagan, MN / Allison Schrein

PHOTOGRAPHER—*Einzig Photography Inc., New York, NY*

Working in a relatively small island space of 20 ft. x 30 ft., the exhibit designed by Skyline Exhibits was kept light and open to encourage attendees to enter, move around and interact with some of the elements displayed on the tall, elliptical kiosks.

The central, skeletal, circular drum tower was constructed of round pipes and partially sheathed with sheer, translucent graphic panels. Conference rooms were sectioned off inside the semi-transparent drum and the curved reception desk—in front—followed the sweeping line of the tower. Two pie-shaped constructions swept out from this focal unit and they, in turn, served to incorporate the four light looking kiosks which, at other times, serve as product exhibit cases in the lobby of Grundig's corporate headquarters.

Blonde wood laminates accented with black lacquer and brushed metal on the light colored floor—plus the graphics which were mostly images rather than type—helped to create this "Less is More" look which the client had called for.

SPACE CONCEPTS

INTERIOR DESIGN SHOW—*Toronto, ON*
EXHIBIT DESIGN—*ll X lV Design Associastes, Toronto, ON*
 Don Menchion & Keith Rushbrook
PHOTOGRAPHY—*David Whittaker*

The design firm, ll X lV Design Associates was given 600 sq. ft. of space at the Interior Design Show in Toronto and asked to create—as a focal element of the show—their concept of how to affect "a living space" in a minimum area without extensive division, subdivisions or costly partitions. The designers, Don Menchion and Keith Rushbrook were impressed by research on space station and lunar bases done by the Japanese about 20 years ago and by the 1999 Aerospace Conference where a presentor showed how by using existing "space lab" structural modules with the addition of simpler, lightweight interior partitions and suitable furnishings, it would be possible to convert warehouses, lofts and unused office buildings into "hotels." The exhibit as designed served "to influence and inspire both the public and other design professionals" with the possibilities.

The central feature was a geodesic dome—20 ft. in diameter and 14 ft. at the highest point. The lightweight,

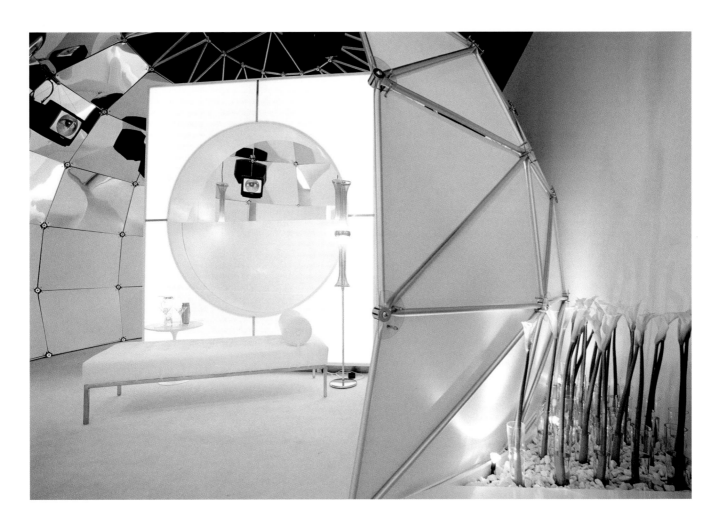

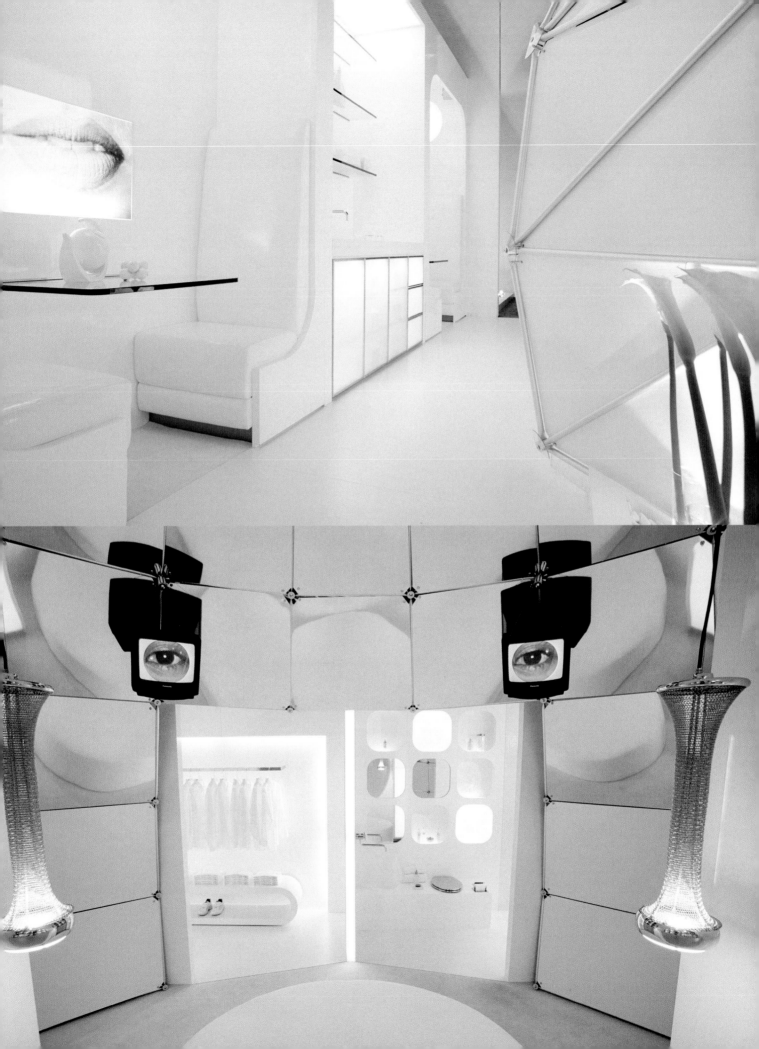

modular frame was unfolded from a large suitcase and completely assembled in three hours. Surrounding the dome is a "garden" of tall cylinders and each vase contained a single calla lily. The theatrically-illuminated dome—a triumph of a white-on-white design—was furnished and finished in plastics, glass and metal, yet created an "unexpectedly snug and inviting" feeling. The designers used a simple, flexible and quick-to-install surfacing system of Sintra panels with ingenious Lexan and chrome connectors. A thin, flexible highly-polished laminated mirror covered the upper panels of the structure while the lower ones were coated with a warm white, matte finish. A high density, white wool carpet was laid on the floor and a white Saarinen table was used along with a white leather and chrome chaise and a chrome lamp with a chain metal shade.

Behind this vignette was a MDF and plywood square, shallow box with a sandblasted circular glass insert through which the sleeping area was seen. An illuminated

arch served as the headboard for the 6 ft. diameter, ultra suede bed which was flanked by pendant chain light fixtures. Prefabricated, polyester resin coated MDF materials were used to make the various "living requirements" such as the base of the sandblasted glass topped dining table. The primary flooring in all three modules was laminate and the main wall finish was white combined with clear and mirrored glass accents. These were accented by the gleaming

European metal accessories and the entire set-up was washed by several different incandescent light sources. All in all, the design presented extraordinary variety and was a spectacular, inviting and involving exhibit that one visitor described as " Buckminster Fuller meets Tom Ford of Gucci."

CERAMIC
TILES OF
ITALY

AIA NATIONAL CONVENTION—*Denver, CO*
EXHIBIT DESIGN—*Mauk Designs, San Francisco, CA*
 Mitchell Mauk & Ingrid Ballmann
PHOTOGRAPHY—*Andy Caulfield, Needham Heights, MA*

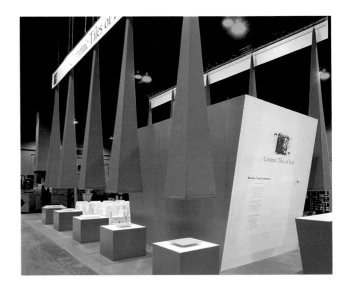

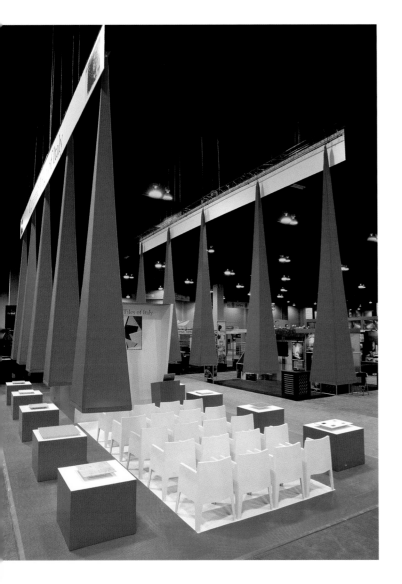

Designed by the Mauk Design firm to sit on an island space of 20 ft. x 40 ft. at the AIA show in Denver, the brilliant minimalist red and white design functioned as a showcase for Italian tiles. Commissioned by the Italian Trade Commission, the designers created a setting in which the imported tiles were treated as art objects. Even though the purpose was to show off the tiles, they were used sparingly to keep down the shipping weight of the exhibit.

The visitor to the show was immediately grabbed by the ten elegant, tall, pyramid-shaped lamp shades of Ferrari red (the Italian auto color) fabric stretched over aluminum frames. Lined up on either side of the long sides of the space—five to a side—they cast their light onto the equally red squares with white tops upon which rested some of the select tiles. According to the designers, "The design of the exhibit uses a serious classical layout reminiscent of a Roman temple. Contrasting materials, geometric shapes and colors create a visually exciting environment in which minimalist elements allow the ceramic tiles to be displayed much like art objects."

The flooring—red bordering a white central expanse—was made up of snap-together, anti-fatigue matter tiles. Five rows of four white molded chairs faced a white partition which carried information about the product. Presentations were made here. The rectan-

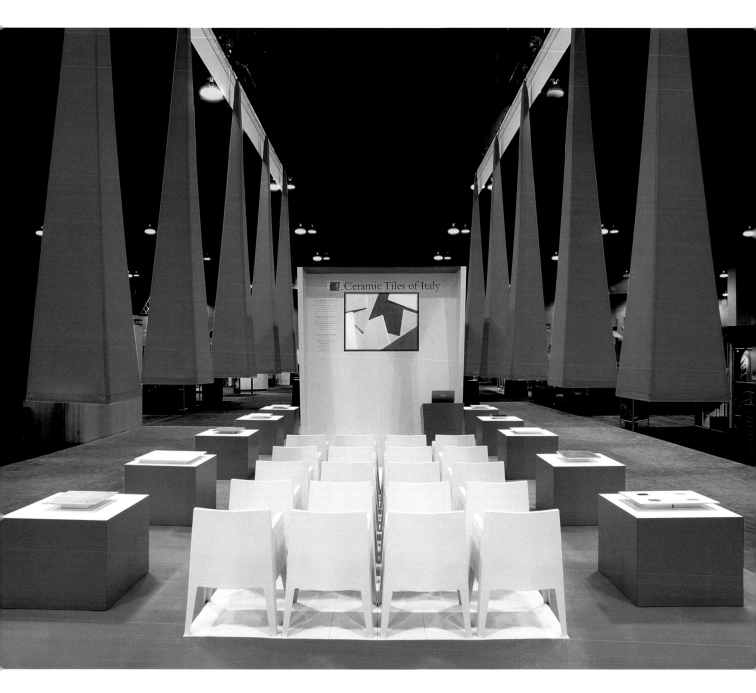

gular structure with its inward sloping sides provided an area for storage as well as conferencing needs. A larger plinth—its shape echoing that of the structure behind it—served as a reception desk at the far end of the display.

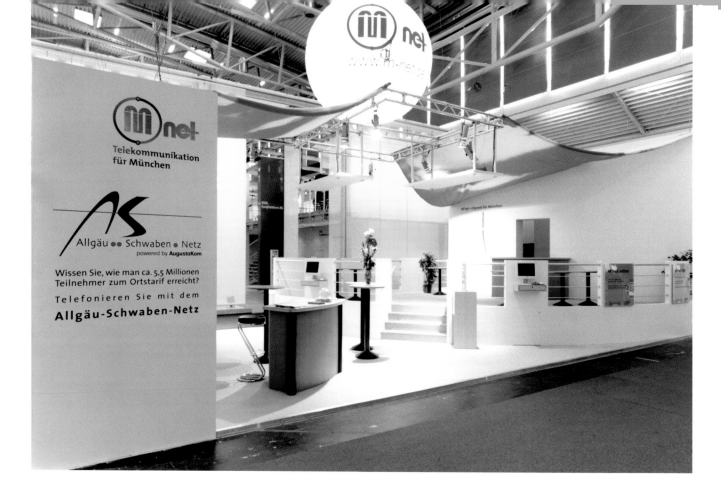

M-NET

SYSTEMS SHOW—*Munich, Germany*

EXHIBIT DESIGNER—*Studio Gruschwitz,*
 Grobenzell/Munich, Germany

EXHIBIT FABRICATOR—*Riedl, Rottan Inn*

PHOTOGRAPHER—*Foto Konig, Munich, Germany*

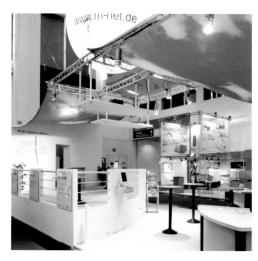

The light, airy exhibit created by Studio Gruschwitz for M-Net—a communications company showing at the Systems Show in Munich—consisted of two levels in a long, narrow 800 sq. ft. space. In keeping with communication and airwaves and such, the designers symbolically tented the space with sky-like graphic fabric panels suspended over the stand below. The large panels were anchored by the aluminum space frame construction that also served to hold the spotlights that flooded the mostly-white space with clear, warm light.

The reception/information desk was located on the hall floor and at either end of the space semi-circular mezzanines were raised up and it was here that conferencing and entertaining took place. The two raised areas, combined with the white metal rod railings and the sky waving above was somewhat reminiscent of a cruise ship at sea.

According to the designers, "The whole set-up created an expression of lightness and an invitation to stay and to savor communication with others."

GRUSCHWITZ

EUROSHOP—*Dusseldorf, Germany*

EXHIBIT DESIGN—*Studio Gruschwitz, Grobenzxell/Munich, Germany*

EXHIBIT FABRICATION—*Criterion*

PROPS & DECORATIVES—*Grauer Werbetechnik, Fledgeding*

PHOTOGRAPHY—*Studio Gruschwitz*

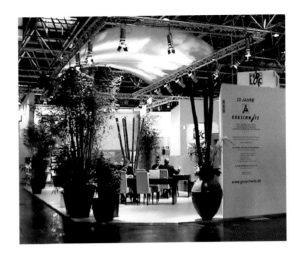

In the middle of the tumult and excitement of a major trade show that happens once every three years, Studio Gruschwitz created this idyllic, open "agora"—"a classic place where people enjoy coming together to enjoy a particular experience"—in an 855 sq. ft. area.

To ensure that harmonious and relaxed ambiance, the designers followed many of the tenets of Feng Shui. In the center of the space—under a cloud-filled sky graphic—is a long basin filled with white gravel and slow running water trickles over the stones and the orchid plants recessed into the basin/planter. This symbolizes the energy flow of the positive chi. "The same energizing and harmonizing elements were repeated by having fountains at the entrances."

In contrast to the slick, contemporary black planters and the long sleek black tables that extend back to the white basin/planter are the numerous bamboo plants which complement the white orchids and add a feeling of "grace and charm." The three tables serve for conferencing and design meetings.

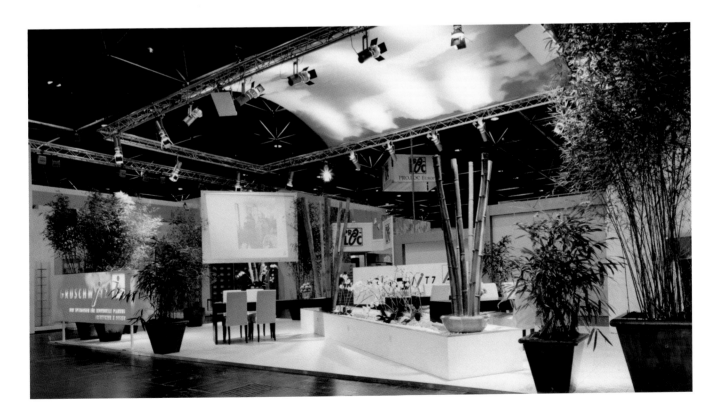

3 M

NEOCON/IIDEX SHOW—*Toronto, ON*

EXHIBIT DESIGN—*ll X lV Design Associates, Toronto, ON*

PHOTOGRAPHY—*David Whittaker*

"Create drama within a limited budget." That was the challenge presented to ll X lV Design Associates by the 3M Company when they decided to enter the NeoCon/IIDEX trade show in Toronto in a 900 sq. ft. space. Here they would show off their wide and versatile range of films and inks. Since 3M products can be used for so many purposes (visual merchandising, display, illuminated signs, wall murals, architectural glass and window finishing—even floors) the designers developed a slogan— "Make it real or make it 3M"—and the concept was born.

A garden theme was conceived since what is more real than nature? 3M had created a tough, slip resistant "Floor Minder" film which showed beach pebbles and a

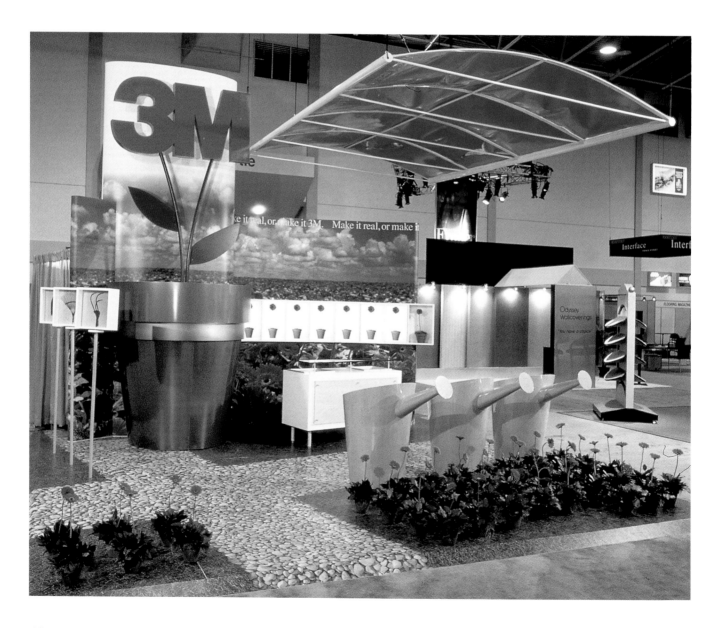

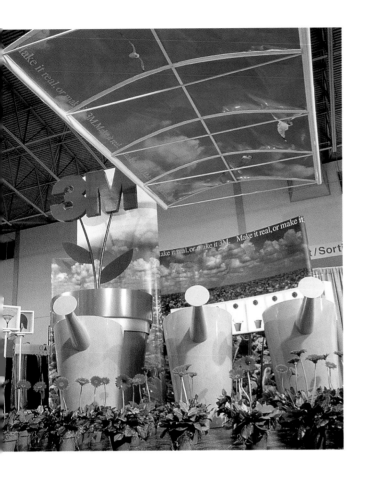

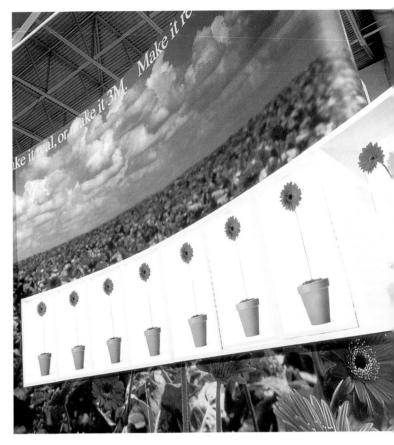

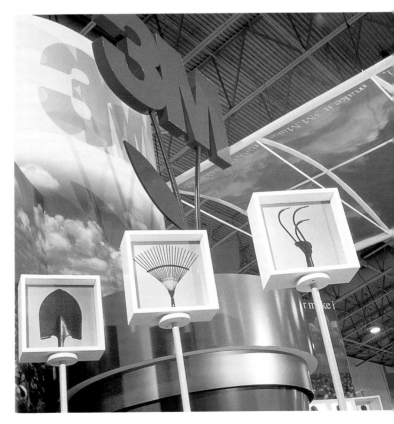

grassy green lawn and those became the flooring for the stand. A "sky"—printed on translucent film—was set into a simple arched framework that hung over the grassy expanse which was divided by the pebble-surfaced pathways. Live gerbera daisies in small clay pots at the front of the display were referenced in a black and white photo of a vast field of the same—printed on opaque film—and applied to a flex ply background. A colored version of the same scene appeared on a superimposed backdrop. Three giant plywood watering cans with continuous play screens set into them were surfaced with 3M's high intensity, reflective sheeting to simulate galvanized metal.

The company's logo blossomed in brilliant red out of a giant flower pot also surfaced with 3M's Scotchcal film. Guests were invited to make images of garden tools, printed on 3M's "one way view" perforated window marking film, appear or disappear by turning the provided handles. This unique exhibit most effectively showed so many of the client's product line that it received the Arido Award for 2001.

PALLADIUM

ICSC SHOW. *Las Vegas, NV*

EXHIBIT DESIGN—*Lorenc+Yoo Design, Roswell, GA*
Jan Lorenc / Sakchai Rangisyakorn / Steve McCall

EXHIBIT FABRICATION—*Geograph Industries,*
Harrison, OH

PHOTOGRAPER—*Rion Rizzo, Creative Sources, Atlanta, GA*

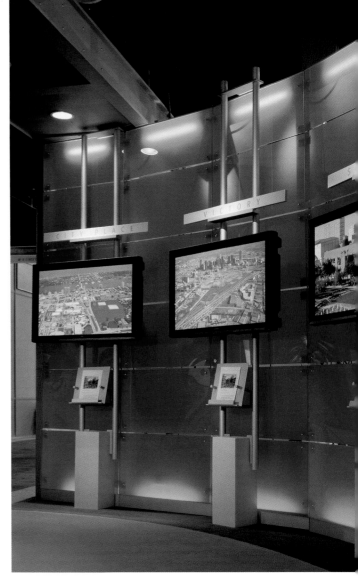

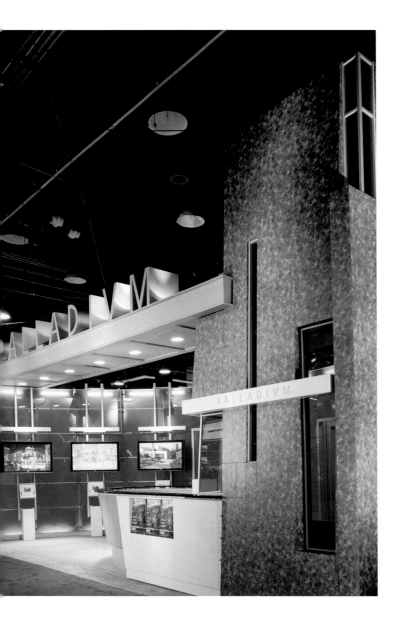

Palladium is a New York-based innovative and progressive real estate development company and for their appearance at the International Council of Shopping Centers (ICSC) Show in Las Vegas in 2001, they envisioned a new exhibition environment that communicated their corporate spirit. The design firm of Lorenc+Yoo was called upon to visualize that "vision" in an exhibit space of 900 sq. ft.

That spirit was expressed in a design that featured a 10 ft. high curvilinear wall that showcased the company's current projects on large format, flat panel displays that could be easily viewed and scrolled. In this exhibit all the graphic images were gathered onto four flat plasma screen displays "thereby uncluttering the walls, creating visual impact, and providing for flexible delivery of images." Creating an almost "surreal museum-like reception space" were the displays suspended on aluminum tubes which connected the internally illuminated wall to

the stone-like plinths below. The company's name—in dimensional letters—appeared atop an overhead aluminum channel and perforated metal soffit which created an "introductory threshold" to the reception area. A 14 ft. high tower enveloped the reception seating and the curvilinear reception desk that anchored the tower. "The asymmetrically-composed tower facade of translucent windows and open slits symbolized the company's aggressive construction initiative."

The curved wall, previously mentioned, served as a screen wall to the conference areas and the food service space behind the reception zone. Unusual elliptical or circular mesh fabric "dome" lighting fixtures hung over the office and conference spaces and the walls here were punctuated by an irregular pattern of linear slot windows.

The colors and materials symbolized the client's construction abilities—blue-green plexiglass for glass; creamy-grays for limestone; green-browns for copper; and purple and apple green for gypsum surfaces. Brushed aluminum served as the accent note throughout.

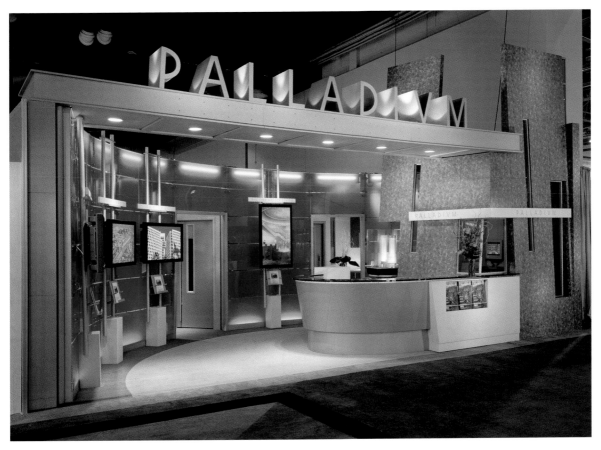

TEC

COVERINGS 2000—*Orlando, FL*

EXHIBIT DESIGNERS—*Perkins & Will / Eva Maddox
 Branded Environments, Chicago, IL and Exhibit Partners*

PRINCIPAL IN CHARGE
 (DESIGN/STRATEGY/CONCEPT)—*Eva Maddox*

DESIGN DIRECTOR—*Eileen Jones*

SENIOR DESIGNER—*Greg Keffer*

DESIGNER—*Carly Cannel*

GRAPHIC DESIGNER—*Melissa Kleve*

EXHIBIT FABRICATOR—*Exhibit Partners, Jim Kursar*

PHOTOGRAPHY—*Courtesy of Perkins & Will*

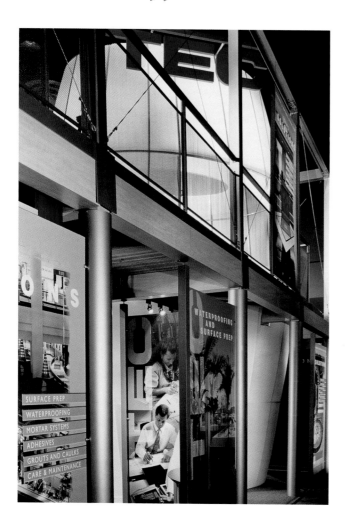

TEC Specialty Products manufactures bonding agents for use with finished flooring materials such as granite or ceramic tile. To introduce their products and brand name to architects and designers they commissioned Eva Maddox of Perkins & Will / Eva Maddox Branded Environments to conceptualize a trade show exhibit of 1200 sq. ft. and Jim Kursar of Exhibit Partners was brought in to construct it. "As co-designers they brought a sensitivity and awareness of the architectural and design community during the conceptual process," said Jim Kursar.

The resulting exhibit, shown here, was a two story structure with a modular framework that served as the basic "building block" and that allowed for a variety of future booth shapes and access points when adapted to other show venues. Since the attendees to this trade show would naturally be interested in "how things go together?"—"this influenced our decision to express the exhibit structure including exposed beams and columns and cross bracings as much as possible." The structural framework was visible throughout and it was combined with assorted high tech materials and also featured connecting the levels' stairs of maple and mahogany woods, nickel plated, steel mesh railings, sisal floor coverings and cross beams finished in maple with bar grating atop the cross beams.

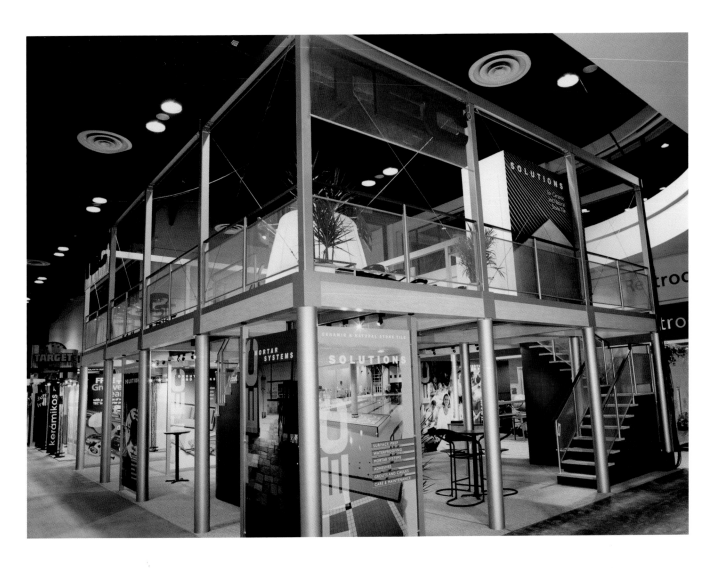

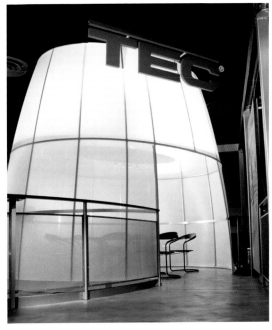

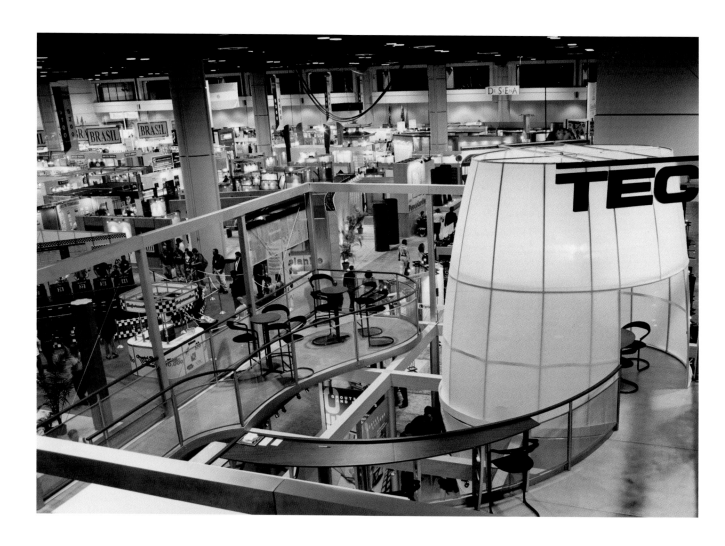

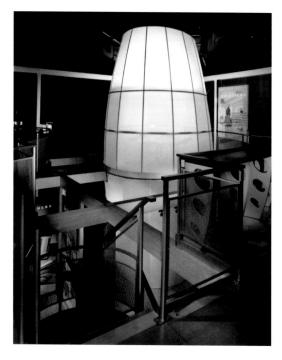

Extending up from the exhibit hall ground level and beyond the undulating pattern of the mezzanine level was a stretched fabric and aluminum framed, illuminated "tower" that, according to Eva Maddox, "provided an engaging visual 'beacon' across the trade show floor while also serving as a conference room at ground level." A curvilinear stairway and balcony "infused the exhibit with an engaging form, focusing the space to a centralized atrium where product demonstrations were performed." The mezzanine balcony accommodated the hospitality service as well as more space for one-on-one talks.

Throughout there was this interplay between natural and man-made finishes—"metaphorically alluding to TEC's capabilities with a variety of products." The exhibit received a Silver Award from Exhibit Design for a double deck space created at less than $150 per sq. ft.

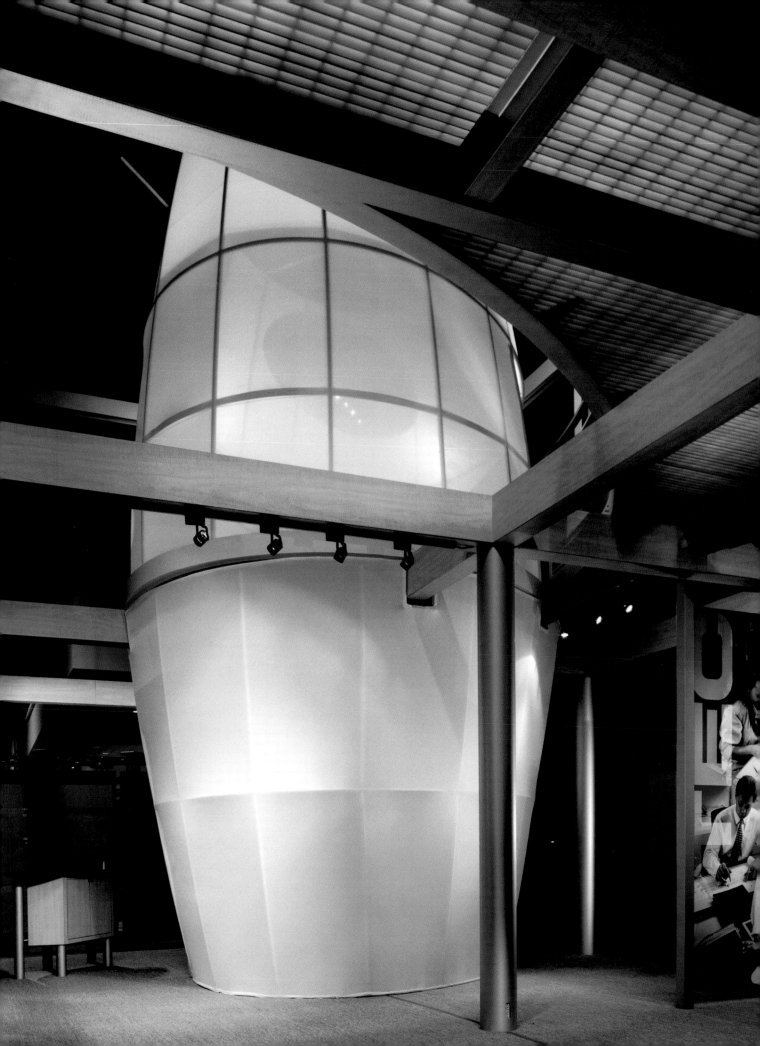

DISCOVERY
CHANNEL

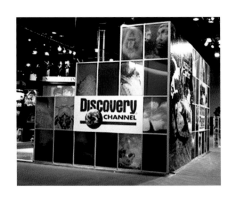

LICENSING EXHIBIT—*Javits Center, New York, NY*
EXHIBIT DESIGN & FABRICATION—*L2 Productions, New York, NY*
PHOTOGRAPHY—*Courtesy of L2 Productions*

Working in a space of 1200 sq. ft., the designers of L2 Productions created a modular display for the appearance of the Discovery Channel at the Licensing Show in New York City. Using an aluminum modular structural system of rectangular frames that can be extended vertically or horizontally, the designers "created a crossword puzzle design in which the visuals filled in the blanks."

The graphics played a vital role in the design and they were drawn from the properties or programs that are syn-

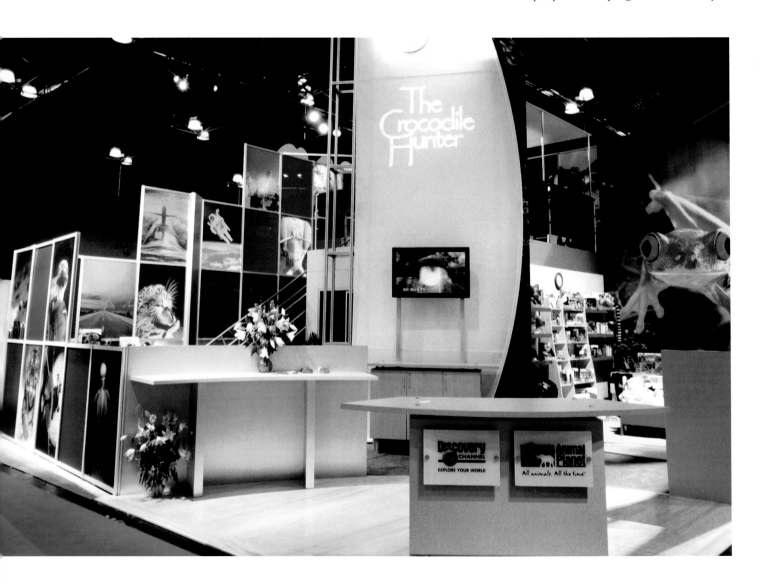

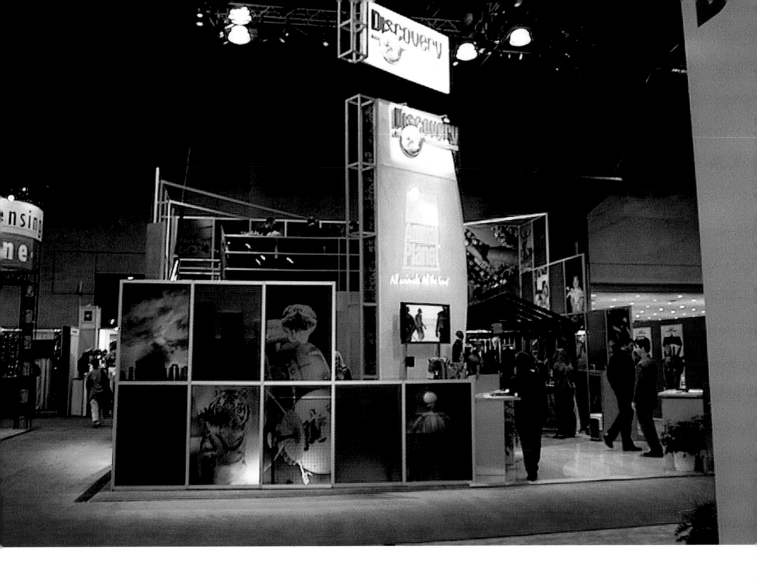

dicated for showing on the Discovery cable channel. Spaced between the graphics were occasional blue and blue/violet translucent plastic panels and in some areas—for the sake of lightness—the open grid of the framework appeared just as that—an open grid. The construction rose up to a second or mezzanine level which was fitted out as a hospitality suite and yet had areas for conferencing.

The booth was entered from one corner of the 30 ft. x 40 ft. island space and behind the reception desk there arose a single three story high fin also constructed out of the same module system. It not only carried the Discovery name and logo well up over the floor of the hall but it also held a giant plasma screen upon which film clips of the various properties or programs played on and on. Inside the booth visitors could move about between the individual stands and stations where attendees could sample some of the programs on the monitors provided and the bookcases lined up under the mezza-

nine. These natural wood units showed off the books, CDs , DVDs, games and other tie-in materials created for the assorted programs that appear on the Discovery Channel. A super, super graphic of a red eyed frog swimming in a 16 ft. x 12 ft. ambiance of green, dominated one of the interior walls and it was visible from quite a distance in the crowded hall.

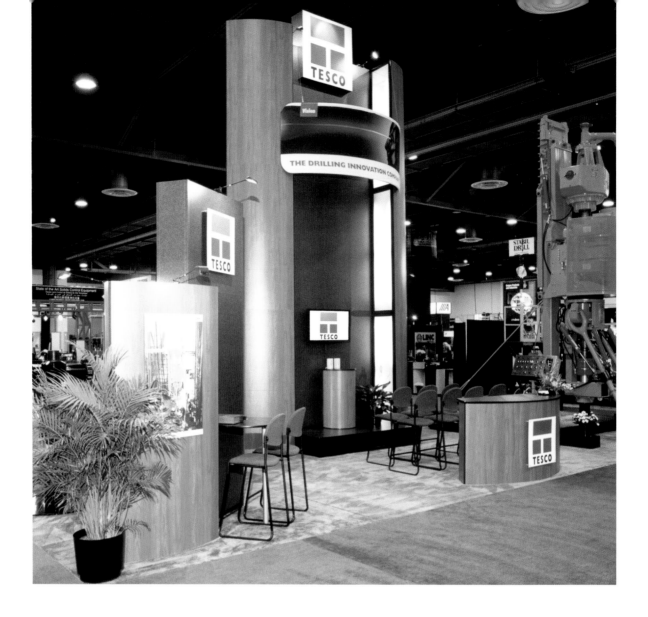

TESCO

OFFSHORE TECHNOLOGY CONFERENCE—*Houston, TX 2002*

EXHIBIT DESIGN & FABRICATION—*Skyline Exhibits, Eagan, MN, Dan Berg with Steve Martin & Tony Savor*

PHOTOGRAPHY—*Barchfield Convention Photographers, Houston, TX*

For their client, Tesco, the designers at Skyline Exhibits produced a modular exhibit which would not only appear in the 30 ft. x 40 ft. space at the Offshore Technology Conference in Houston but it was designed to be adaptable to 20 ft. x 30 ft. spaces in other venues. Even the tower covered in oiled cherry and graphite talc laminates was designed so that its 24 ft. prominence at this show could be reconfigured to adapt to an 18 ft. maximum height requirement.

Aside from showing several of their massive pieces of machinery, the focal point of the exhibit was the tower and the built-in stage where live demonstrations and presentations were made. The strong vertical lines of the exhibit was complemented by the soft curves evident on the tower itself, the reception desk up front and the graphic-bearing partitions on the floor that also provided a degree of privacy for on-the-floor conferencing.

MILLER ELECTRIC

FABTECH INT'L—*Cleveland, OH*

EXHIBIT DESIGN & FABRICATION—*Skyline Exhibits,*
Eagan, MN

Joe Shimek with Sue Fuerstenburg & Fred Howe

PHOTOGRAPHY—*Oscar & Associates, Inc., Chicago, IL*

The most visible and encompassing element in the Miller Electric exhibit that appeared at the Fabtech Int'l Show in Cleveland was the truly eye-catching and enveloping glowing signboard that soared over the 1400 sq. ft. space. Supported by a metal truss construction the 30 ft. x 30 ft. x 10 ft. high cube of stretched fabric not only carried the company brand logo and name but a checkerboard pattern of product graphics combined with squares of Miller's signature blue color

The white carpeted floor which was tinted by the blue gels set over the ambient lamps was filled with Miller products and there was still ample space allowed around each unit to encourage close-up inspection and/or actual product demonstration. Backing up the display area was a replay of one of the sides of the overhead graphic panels. The graphics were reproductions of lifestyle photos in the company's collection and they added the "graphic intensive" look for this booth at this show.

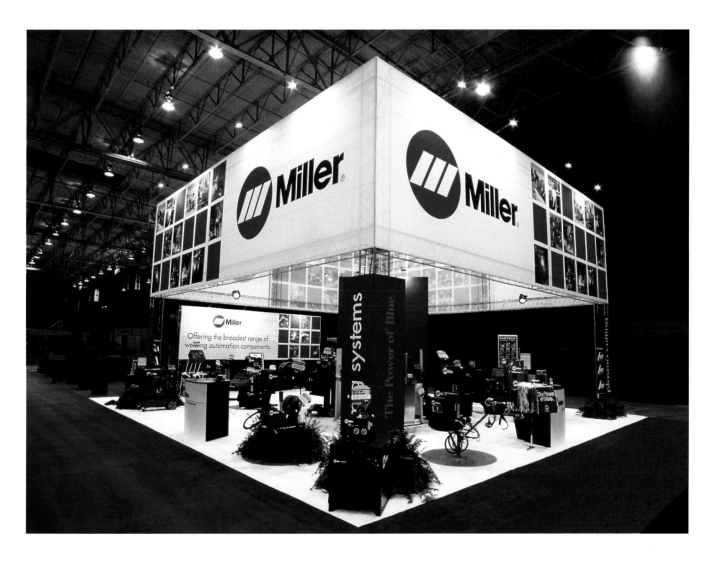

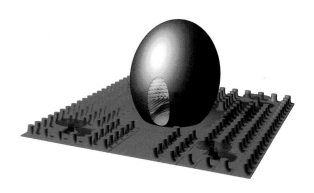

MUZAK

GLOBALSHOP—*Chicago, IL*

DESIGNER OF EXHIBIT—*Karim Rashid Studio*
 Karim Rashid

EXHIBIT FABRICATION—*Fiberglass World; Barrango*

LIGHTING—*Focus Lighting*

PHOTOGRAPHY—*Esto Photography*

How do you stand out in a crowd when everyone around you is begging for the spotlight? Ask Muzak. The audio imaging company found the perfect solution when they hired Karim Rashid Studio to collaborate on an unforgettable experience for GlobalShop 2003. Karim Rashid delivered a design that demonstrates the emotional power of Muzak's core products, Music and Voice, while point-

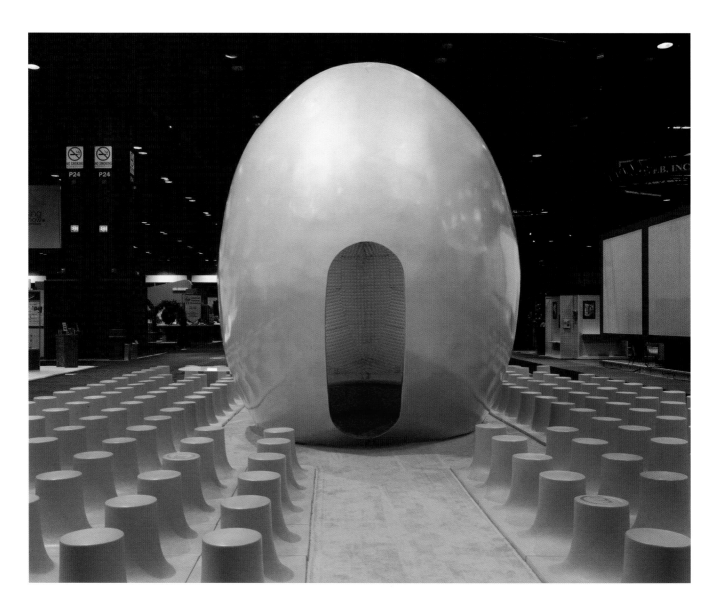

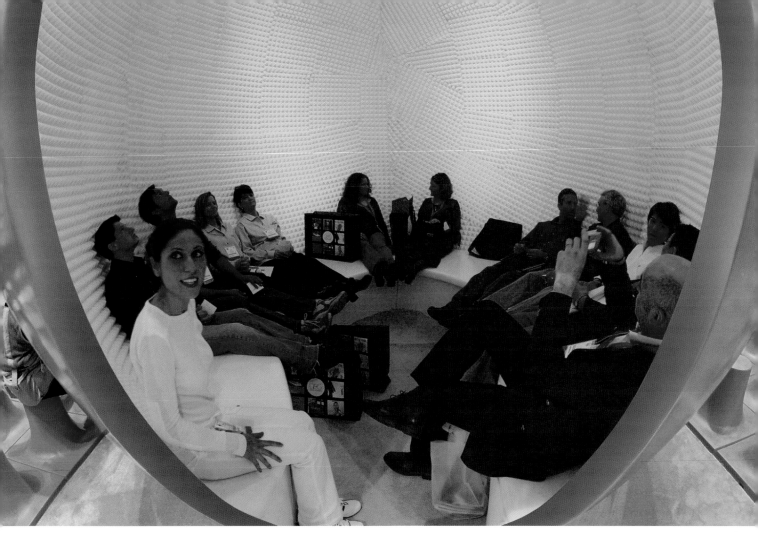

ing to the future of inter-sensory branding. Together, their creative visions brought the Muzak brand to life through the Sensorium.

The Sensorium is an amorphous, pod-like container of sound surrounded by a 30 ft. x 40 ft. monumental grid of hot pink plobular modules. Upon entering the pod, visitors found themselves on a journey into brand; literally seeing with their ears. Inside the cocoon of music and changing colored lights visitors were invited to sit on a sculptured bench that encircled the listening station. The Sensorium provided an escape from the tumult that raged outside and transported visitors into a Muzak experience created through powerful, emotional music.

It "was more art exhibit than trade show booth" and Muzak "created an experience with audio architecture and the Sensorium that was a pure expression of the soul of the Muzak brand." According to Alvin Collis, Muzak's Senior VP of Brand, "Audio architecture needs to transcend the simple act of hearing; it must be felt in an emotional and powerful way. The Sensorium reduces the sensory inputs of touch, smell, sight and taste in order to

focus on the sense of hearing. Music and Voice are combined within the Sensorium to transport the participant to a place of pure emotion—a journey into brand."

Not only was the booth a total sensation at the 2003 GlobalShop, it was awarded the Best Booth of Show and attracted much attention from the world of design.

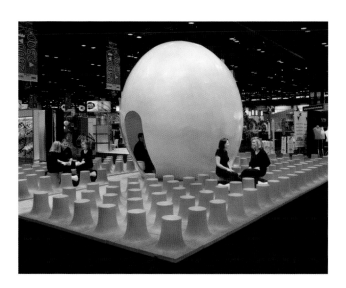

KENNAMETAL

CHINA INTL. MACHINE TOOL SHOW—*Beijing, China*

EXHIBIT DESIGNER—*Folio Group, Pittsburgh, PA*

Gary Zak of Zak Designs / Charles Biggs / Linda Bilotto

EXHIBIT FABRICATION—*Uniplan, Beijing, China*

PHOTOGRAPHY—*Charles Biggs of Kennametal*

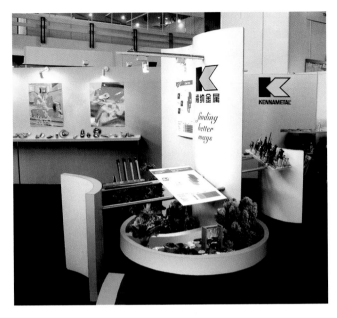

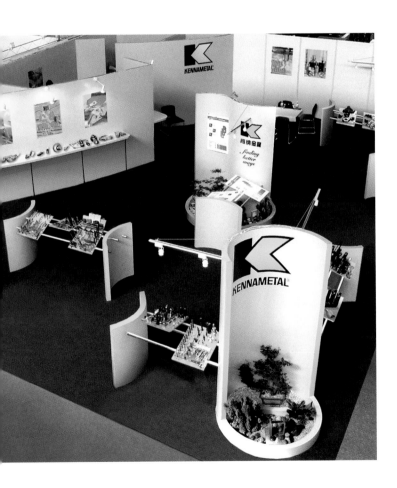

Since this exhibit was designed for Kennametal's appearance at the China International Tool show in Beijing, the lead designer of the project, Gary Zak of Zak Design, working with the Folio Group team, felt that the marketing strategy behind the exhibit had to be one that was suited to and targeted at the Chinese attendees. Zak felt that "a Zen quality and harmony" had to be integrated into the design to affect a more open feeling towards the western sales campaign for Kennametal's products and capabilities. The design also had to "somehow merge both the Far East and Western cultures plus have the artistry of Feng Shui."

Stark white laminates were used to create a sense of "visual serenity." There was a general absence of clutter and the design was simple and fresh. There was a clear contrast to the product panels which were on low profile displayers—36 in. high and below eye level. The curved symmetry inherent in various segments of the exhibit structures "reflected the virtues of the snake and served as a bow to the Eastern cultures." Yin/Yang or East/West was represented symbolically in the convex/concave curved cavities as well as in the flip/flop juxta-positioning of the product panel arrangements in the assorted areas of the stand. Also adding to the cultural deference were the Bonzai trees, miniature waterfallls (Feng Shui for positive chi) and calligraphy "added to the ceremony of tranquility." There were also the areas

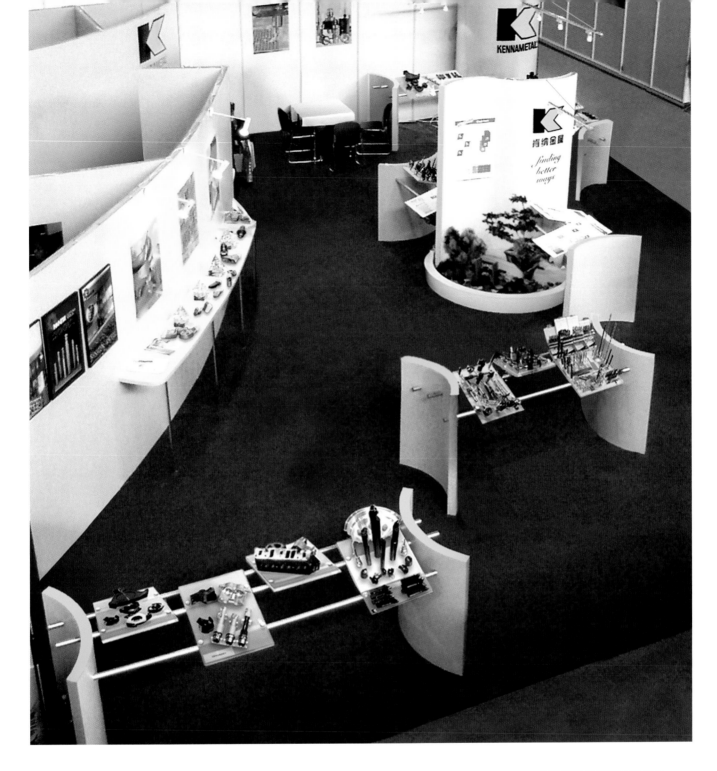

of raked sand or gravel—Kare Sansui—and the distinctive stone ornaments displayed in the rounded alcoves or "shrines." Symbolizing bamboo stems were the three steel horizontal beams used "for the display balance of product panels and for lightness and openness."

The stand also featured two conference areas and a kitchen service zone at the back side of the exhibit space where the food for hospitality was prepared

SPIRENT COMMUNICATIONS

NETWORLD INTEROP SHOW—*Las Vegas, NV*
EXHIBIT DESIGN—*Mauk Design, San Francisco, CA*
EXHIBIT FABRICATION—*Exhibit Group/Giltspur, Las Vegas, NV*
PHOTOGRAPHY—*Andy Caulfield, Needham Heights, MA*

Spirent Communications gathered five smaller companies under its banner. and was planning to use its appearance at the NetWorld+Interop Show to show off its new, stronger position in the field. The concept for the exhibit that was created by Mauk Design for this Hawaiian-based company that specializes in performance analysis systems for telecommunication networks, centered around the elliptical-shaped, translucent tower that rose over 25 ft. off the exhibit hall floor and the half tower that complemented it and also served as the backup for the half-round information/reception desk. These two heroic satin metal and translucent plastic forms were joined by three multi-task stations equipped with monitors, keyboards and other interactive features. The silver/white towers were accented with Spirent Communications' signature blue color which appeared on the logo/signage and on the finishes of the reception desk and the kiosks on the floor.

To enter the high-tech tower there was a glistening metal staircase that spiraled part way up the side so that visitors could enter at a full level up from the ground. There were other entrances at ground level to the various conference rooms situated at the base of the tower as well. To "represent the swift movement of data throughout a communications network," the exhibit designers added chasing lights spiraling around the central, two story high structure and that stimulated a sense of excitement as well to the glowing inverted, truncated elliptical cone.

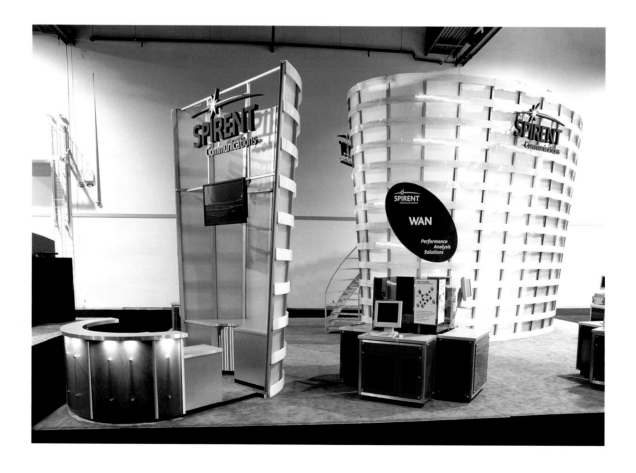

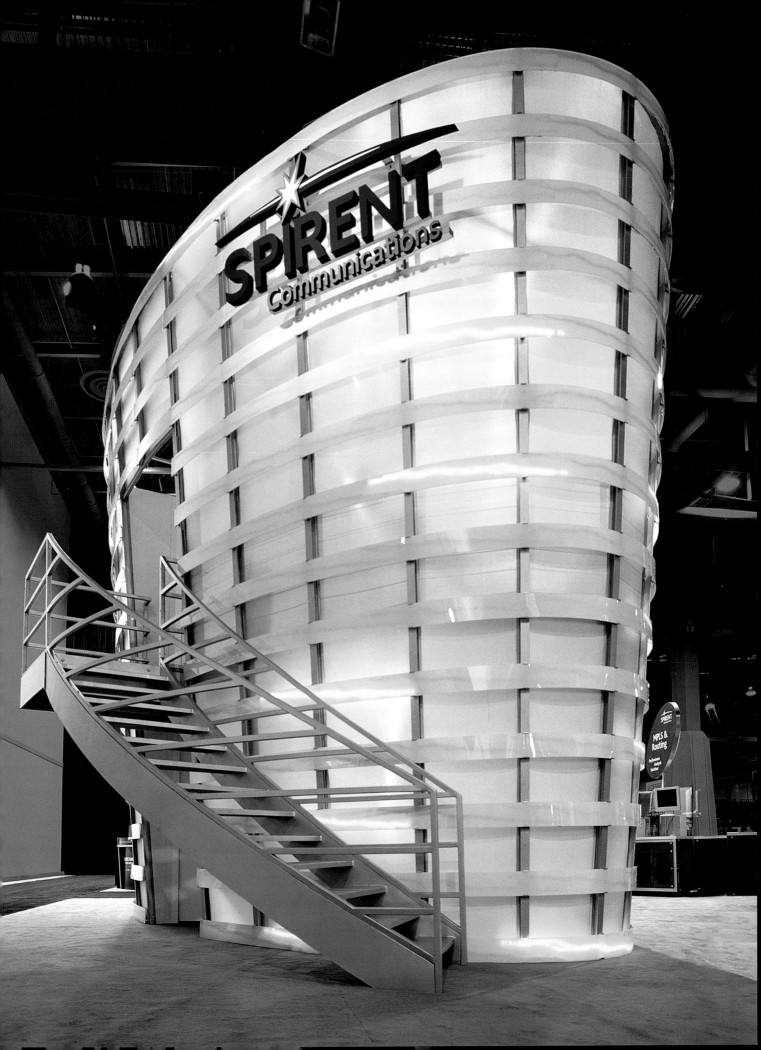

WEINERDOG/ SUNRISE GREETINGS

NATIONAL STATIONERY SHOW—*Javits Center, New York, NY*

EXHIBIT DESIGN—*Hamilton Exhibits, Indianapolis, IN*

DESIGNER—*Abbie Greene*

FABRICATION TEAM—*Lynne Damen / Bob Jontzen*

PROPS—*Don Smith Studios & Dimension Design*

PHOTOGRAPHY—*Courtesy of Hamilton Exhibits*

InterArt required an exhibit that would showcase three different product lines within the 1760 sq. ft. space at the National Stationery Show in New York. Hamilton Exhibits came up with the thematic "Disney-like" approach which was unique at this type of show and that also helped to position InterArt "as a leader in the industry," and further promoted the company "as an innovative, artistic trendsetter in the Marketplace."

The exhibit soared to over 16 ft. off the floor and the sweeping, undulating "magic-carpet-like" fabric ceiling—80 ft. long—ended with an heroic sized WeinerDog protruding from the canopy at the top of the display. Three dimensional WeinerDog characters were used in the display areas below along with oversized props that helped to bring the characters to "life." Dog bed shaped seats encircled a water bowl of unusual proportions

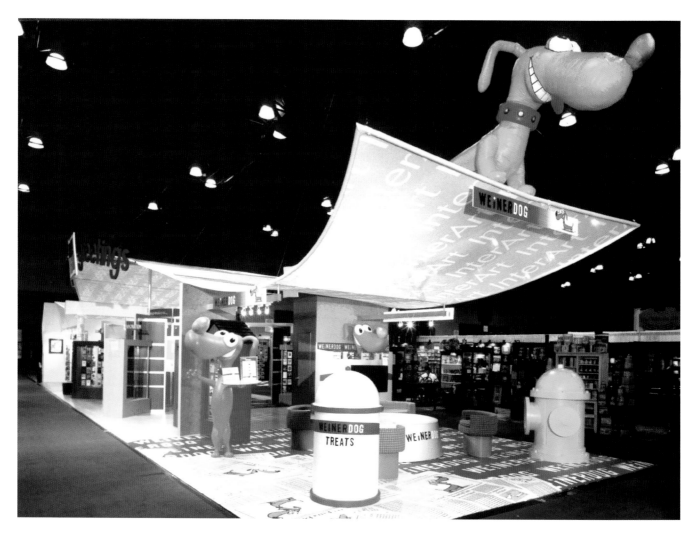

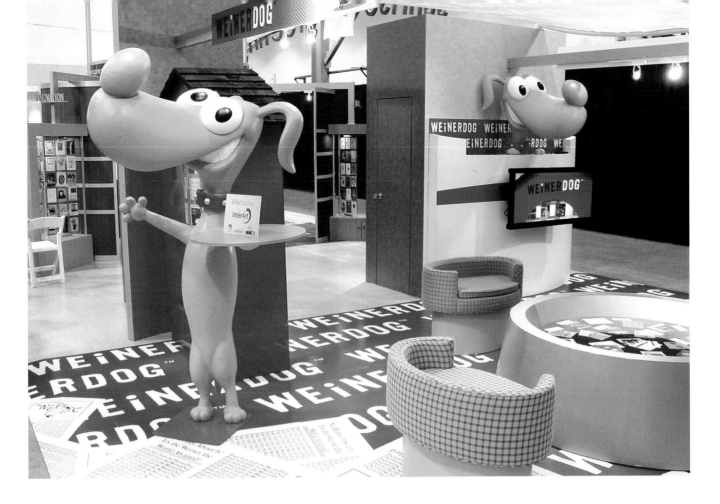

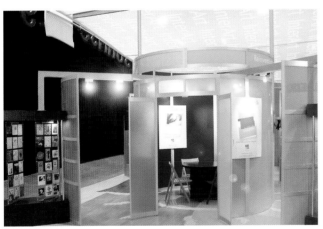

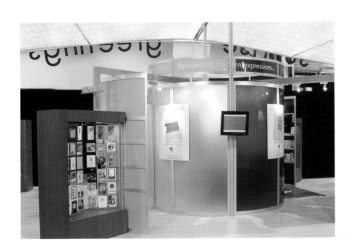

where attendees viewed card samples, and a large doggie treat jar held give-away "dog tags." A semi-shaped dog-house with revolving card holders displayed additional card samples.

A centrally-located private conference area was positioned in the middle of the exhibit space and this "centerpiece" matched the company's sunrise logo. A third brand was featured at the back end of the display and it incorporated surface textures "with the look and feel of real oil paint on canvas." The framed "artwork" was shown here as art might be presented in a museum.

The overall flexibility of the exhibit design makes it possible to use the elements to launch new brands at future shows.

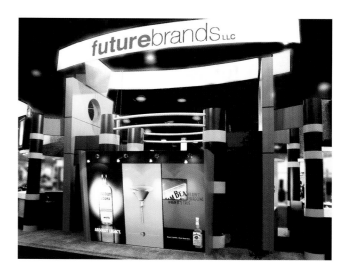

FUTURE
BRANDS

NIGHTCLUB & BAR SHOW—*Las Vegas, NV 2002*

EXHIBIT DESIGN & FABRICATION—*Chicago Exhibit*
 Productions, Bolingbrook, IL
 Eric Lax / Joe Kosiarski / Manuel Uribe

LIGHTING & SPECIAL EFFECTS—*Optikinetics*

PROPS & DECORATIVES—*Gamma Photo Lab*

PHOTOGRAPHY—*Larry Burton Photography*

The client, Future Brands, wished to promote two of their brands—Jim Beam and Absolut—on the floor of the Nightclub & Bar Show in Las Vegas. To create the exhibit that would fill the 1800 sq. ft. island space, Future Brands called upon the creative and fabrication talents of Chicago Exhibits Productions.

The exhibit promoted the "premium and ultra premium brands" of the new joint venture and helped to position Future Brands as "THE pre-eminent marketer of distilled spirits." To reinforce that upscale image, visitors

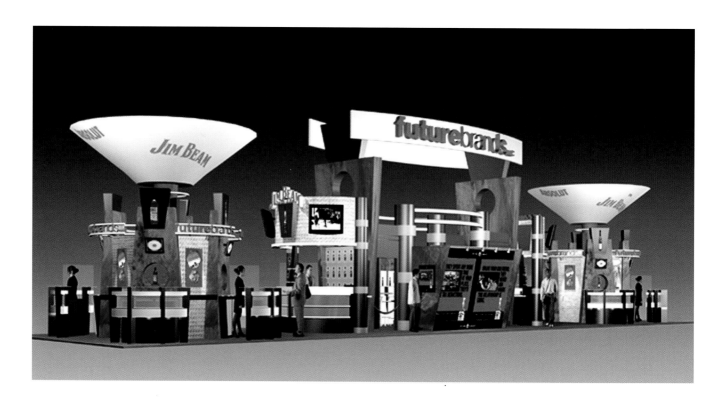

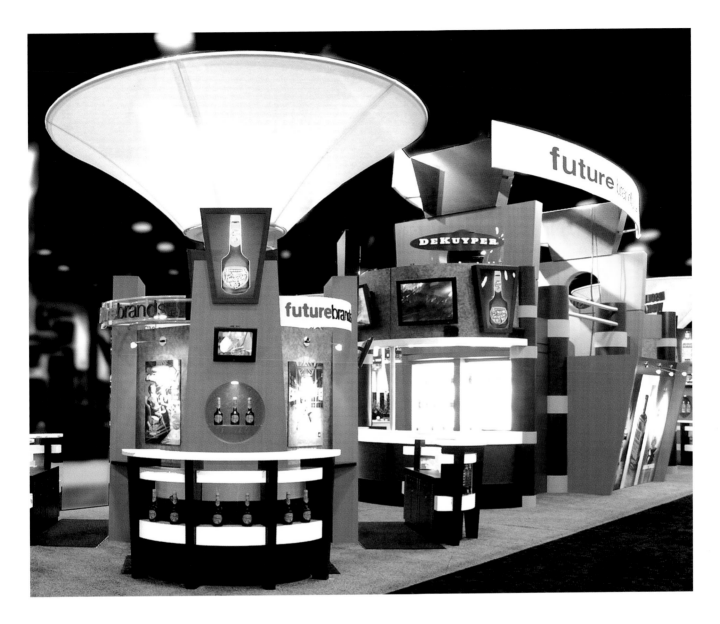

were met at either end of the stand by fabric canopies designed to simulate Martini glasses. These canopies were tall enough to be visible throughout the hall and they served as projection backdrops for interior projection of the brand logos of the featured drinks. The large, curved serving stations, at either end of the space, allowed Jim Beam the room to efficiently serve samples to the large crowds drawn to the booth. Future Brands was also able to deliver their marketing message by means of large light boxes overhead, recessed light boxes with shelving for product display at eye level, and video monitors all positioned around the serving stations. The centrally-located storage space, located behind the large

murals showing new products for Jim Beam and Absolut, made it easy to keep the two serving stations stocked. Private conference rooms, also in the center of the stand, facilitated meetings with buyers away from the activity going on at the serving stations at the two ends of the booth.

Future Brands ended up dominating the show and earned the "Best of Show" award from the sponsors of the show, *Nightclub & Bar* magazine.

INTEL

SIGGRAPH SHOW—*Los Angeles, CA 2001*
EXHIBIT DESIGNER—*Mauk Designs, San Francisco, CA*
PRINCIPAL—*Mitchell Mauk*
DESIGNER—*Laurence Raines*
PHOTOGRAPHY—*Andy Caulfield, Needham Heights, MA*

Intel's powerful presentation on the floor of the Siggraph Show was due to the dynamic and forceful design prepared by Mauk Designs for the show in Los Angeles. A pair of massive white structures softened only by their rounded corners, served as book ends to the raised central reception/meeting area which was filled with interactive demo stations. The central area was highlighted by the heroic scale of the curved canopy over it and Intel's message—in big, cut-out letters—"Powering Digital Media." The underside of the canopy that rated "ohs" and "ahs" from the computer-oriented attendees featured 48 plasma screens and 24 mirrored panels for a spectacular play of

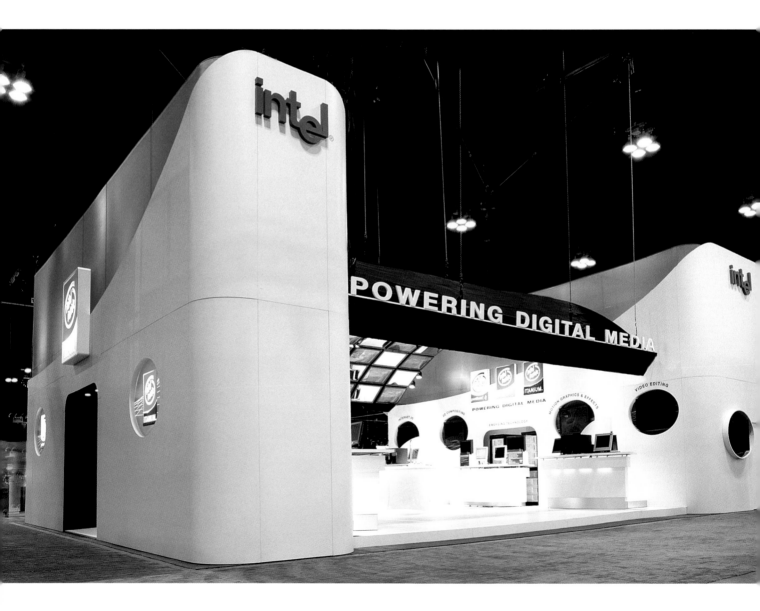

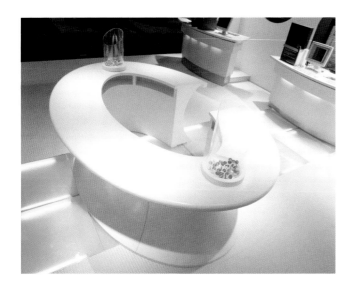

light and color over the otherwise white-on-white space. "Almost completely surrounding you as you enter the booth is a ceiling that depicts the World of Intel. Huge and encompassing, it remains light as it floats 9 ft. off the floor." Since to computer users SPEED is everything, Intel's message was reinforced and visually interpreted by the "illustrated" canopy and the exhibit's "design language and forms."

The white-on-white central exhibit space included a raised textured floor with a central inset of thick, translucent plastic which was illuminated from below. The elliptical reception desk of molded plastic was complemented by the bowed work stations on either side.

Conference rooms and storage spaces were housed in the bulky, 16 ft., white laminate finished end structures. Cut out entrances on their long sides allowed visitors to enter the central area from the side aisles. The massive feeling was somewhat relieved by the soft, sweeping curve of the "Intel" signature blue color that "cut" the unit. Porthole windows on the ends and the aisle and central facing sides were filled with either Intel messages or plasma screens that showed some of Intel's features such as Video Editing, Motion Graphics, etc. Recessed in one of the arched opening was a display of Emerging Technology.

Many of the exhibit's components such as the flooring, the illuminated glass flooring and many of the wall panels were reused in other exhibits .

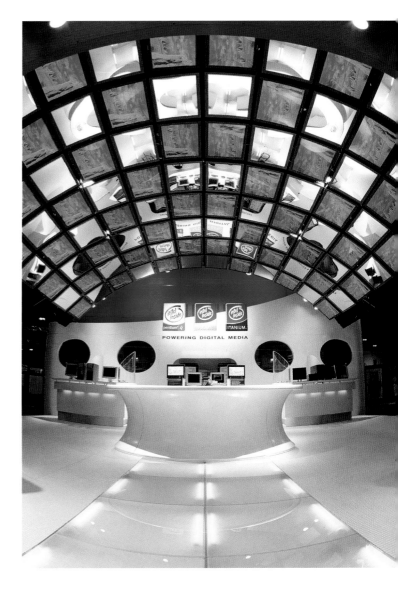

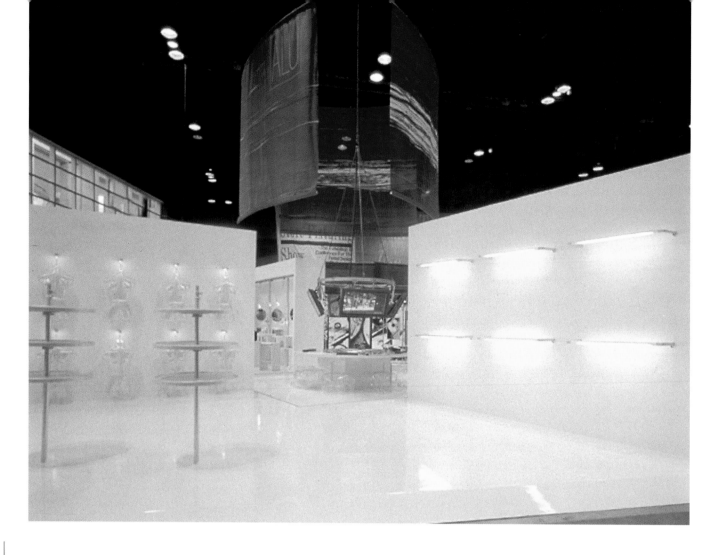

ALU

GLOBALSHOP—*McCormick Place, Chicago, IL 2002*

EXHIBIT DESIGNER/FABRICATOR—*ALU, New York, NY*

PHOTOGRAPHY—*Courtesy of ALU*

GlobalShop is an industry show and the industry and the show is all about presentation and showmanship. ALU is a designer/manufacturer of systems that are architectural, modular and flexible. For their 2000 sq. ft. space the design team went with lots of white accented with red and orange to get the attention of the crowds that filled the aisles. Red and orange fabric banners and suspended panels provided the emphasis for the white flooring and interior partitions and constructions. Visible from anywhere in the hall were the three giant, striate patterned banners that formed a "tower" or beacon and also carried the ALU logo up over the activity on the floor below.

In an abstract way, the ALU design team created a series of vignette settings in which to show off their systems and the store fixtures for fashions, accessories, salons and cosmetic areas as well as consumer electronics, telecommunications, and trade show and exhibit construction. Featured was the STYLO system which provided 360 degree merchandising capabilities and the inflatable, transparent AUTOFORM—a lightweight dress form/torso that is available in a variety of colors. The AUTOFORMS were shown hanging off illuminated wall plugs on one of the white partition walls that was used to turn the stand into a maze where attendees could wander from one vignette to another—finding new fixture concepts for different types of merchandise.

The lighting, whether internal or visible, added sparkle and enhanced the colors of the merchandise shown in the settings while the white walls and floors created the feeling of a big, open space.

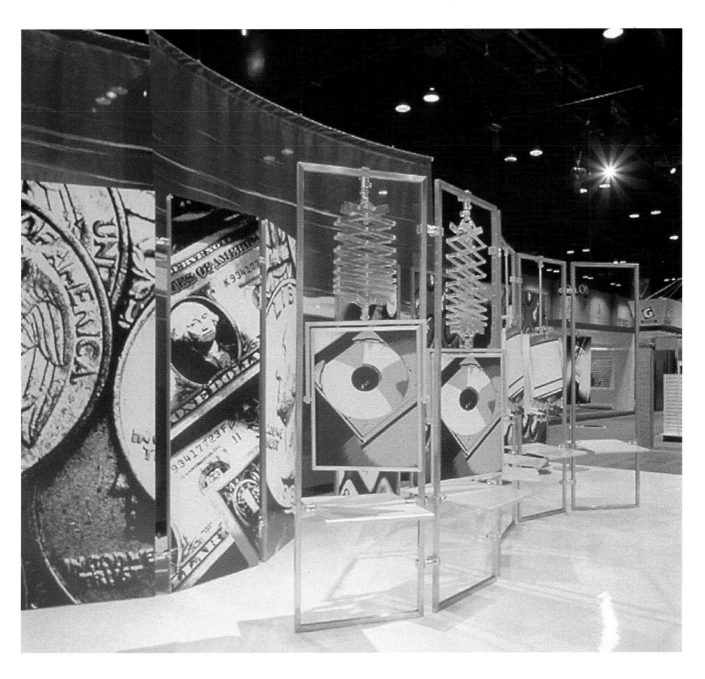

PREIT

ICSC SHOW—*Las Vegas, NV 2001*

EXHIBIT DESIGN —*Lorenc + Yoo Design, Roswell, GA*
 Jan Lorenc / David Park / Steve McCall / Gary Flesher

EXHIBIT FABRICATION—*Geographic Industries, Harrison,*
 OH

PHOTOGRAPHY—*Rion Rizzo, Creative Sources Photography,*
 Atlanta, GA

PREIT, one of the fastest growing management companies, introduced itself to the ICSC Convention attendees with this exhibit created for them by Lorenc + Yoo Design. Within the 2000 sq. ft. space the objective was to introduce "the company brand with a singular image and identity that reflects its new persona—a financially sound, diversified and spirited PA-based real estate leader."

The image, mission and message were incorporated into all aspects of the design scheme. "The company's entrepreneurial energy is celebrated against the tableau of Philadelphia's urban architectural traditions." The abstract, leaf-shaped canopy that hovers over the central reception area suggested PREIT's focus on growth opportunities and its ability to respond to rapid market changes.

Additional "energy and power" was introduced throughout the space by means of vibrant colors juxtaposed against modern architectural elements and the use of vivid graphics.

The green and wood grained reception desk appeared under the skeletal wood "leaf" canopy from which hung PREIT's full name—Pennsylvania Real Estate Investment

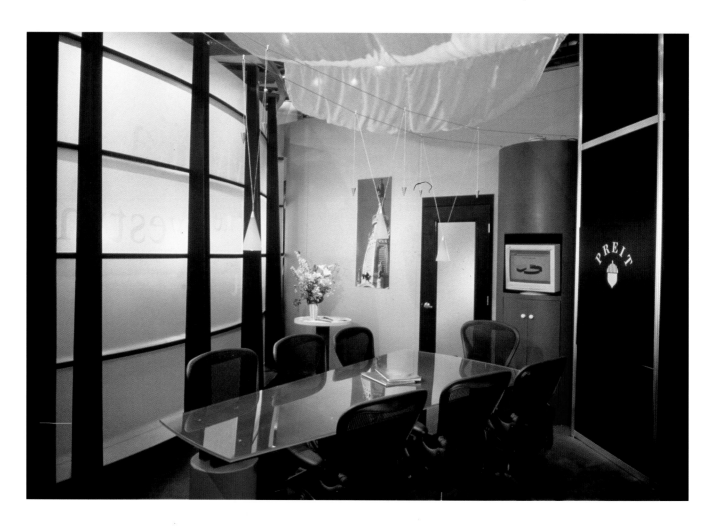

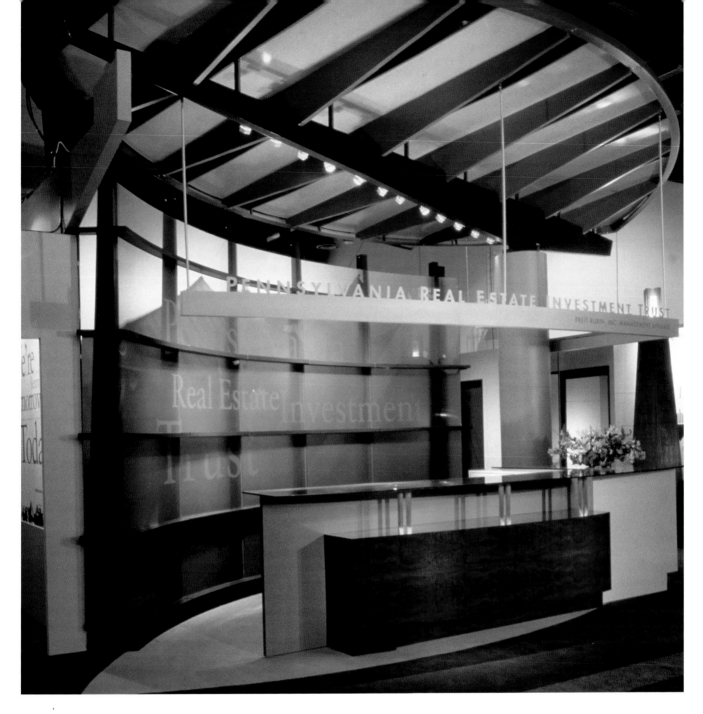

Trust." The reception desk/area was backed up by a curved black grid screen filled with a giant photomural of the Philadelphia urban skyline reproduced on translucent plastic panels. Accents of red, ochre yellow and blue/violet added jolts of energizing color to the design and these colors appeared in some of the "offices" fitted behind the aforementioned sweeping grid partition. Since personal interaction with potential clients was PREIT's aim, the designers cleverly fit 11 small conference spaces into the stand's design.

This exhibit helped to reposition the new company as "a dynamic force in the commercial real estate investment industry."

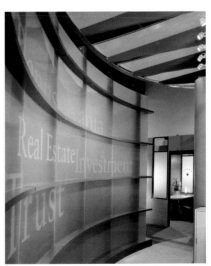

RESPIRONICS

MEDTRADE SHOW—*New Orleans, LA*

EXHIBIT DESIGN—*Zak Designs, Pittsburgh, PA*

DESIGNER—*Gary Zak*

EXHIBIT FABRICATOR—*Carpenter Connection*

AUDIO VISUALS—*Internet Services Corp.*

PHOTOGRAPHY—*Gary Zak*

The design challenge for Gary Zak of Zak Designs was to create an exhibit that would satisfy two different factions in the client organization. Some wanted a traditional exhibit with only product display while others preferred an interactive concept with no product display. The design that evolved combined interactive stations and advanced technology with product display, and also furthered the client's message—"Always Thinking."

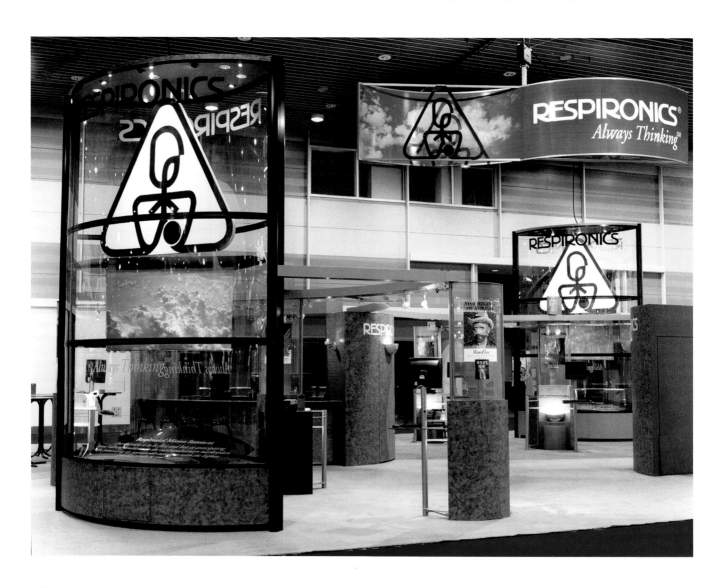

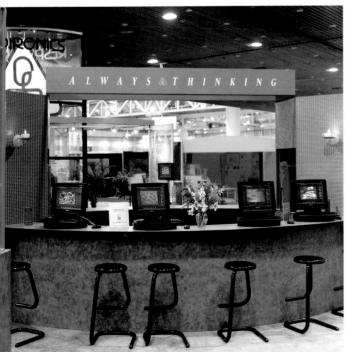

The complete exhibit of four major elements and several interactive/product display stations fit into the 40 ft. x 52 ft. space at the Medtrade Show in New Orleans. The floor was patterned with a strong Yin/Yang curve. A pair of elliptical towers at opposite corners of the space—made of curved Lexan plastic panels contained in a black lacquered framework—sandwiched the large Respironics logo while the company name appeared high up on the arced plastic panel. An "animated" sky and cloud projection below the logo reinforced the "Always Thinking" slogan. The towers were actually constructed as four stackable modules and the tower height could be adjusted to other height restrictions when the exhibit was used in other venues.

Each product line appeared on a semi-round workstation with light sconces below the translucent shelving. An illuminated cavity between the clear plexiglass and the frosted secondary shelf "created a distinct showcase for accessories and fittings for the product." The curved perforated metal backing served to hold graphics on magnetic vinyl sheets while still being a "visually barrier free" support for the overhead electrical feed/lighting troughs. Mounted on a vertical pole that also worked as a leg for the display unit was a flat monitor screen and keyboard. This same tubular structure contained the necessary cable and power connections for operating the interactive elements.

In addition to conferencing areas there was the Cyber Café where clients and prospective clients could enjoy a cup of coffee while browsing the Respironics website. The "cup and saucer" light sconce added to the friendly and relaxed spirit of this area.

EURO-PRO

INTERNATIONAL HOUSEWARES SHOW—*McCormick Place, Chicago, IL 2003*

EXHIBIT DESIGN & FABRICATION—*Chicago Exhibit Productions, Bolingbrook, IL*

DESIGNER—*Joe Koziarski*

SPECIAL FEATURES—*Fabric Images, Elgin, IL*

PHOTOGRAPHER—*Will Bannister*

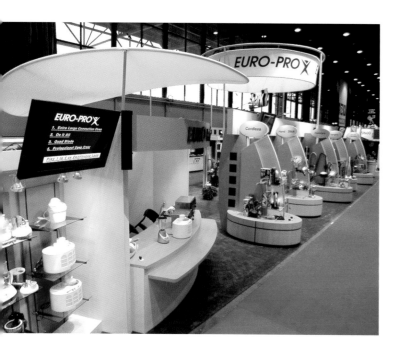

Subtly presented and reiterated throughout the 2250 sq. ft. exhibit created by Chicago Exhibit Productions for Shark Vacuum Cleaners was the "shark" motif. Effective traffic flow was devised so that the buyers attending the International Housewares Show were exposed to the entire product lines of Euro-Pro and Shark and the two names were prominently visible on either the overhead drums of stretched Lycra on aluminum frames or up high over the collected fixtures on signs applied to fascia walls.

The strongest "shark" impact was on the numerous shark fin-inspired displayers/demo modules lined up along the main aisle. The elliptical bases supported the red sweeps that sandwiched the translucent fin outlined in silvery metal. The motif was also repeated in the overhead fabric structures atop the private demonstration/conference room at the front of the exhibit space and reappeared in the product sampling station at the rear of the space. Throughout, the wood grained laminates and the curved shapes on the displayer modules

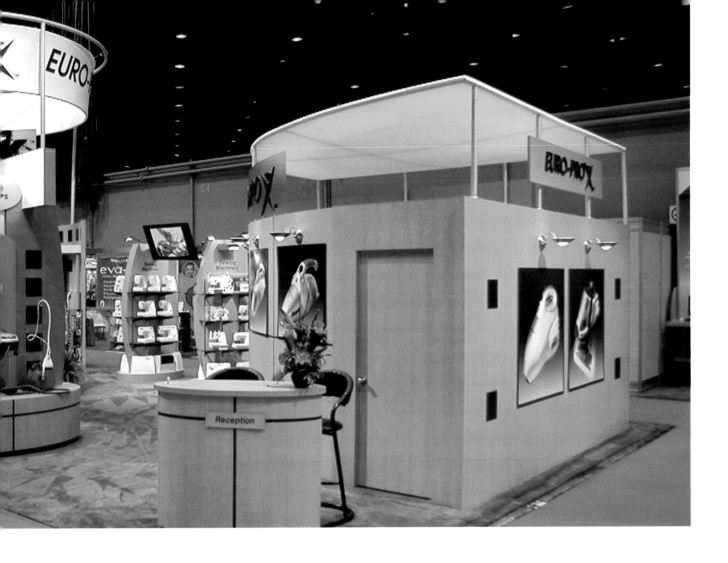

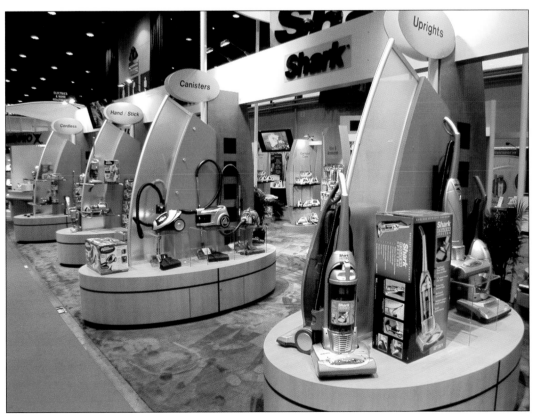

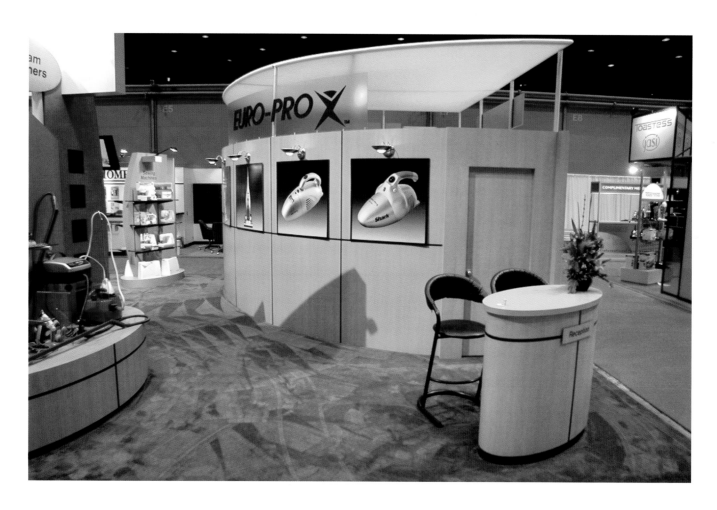

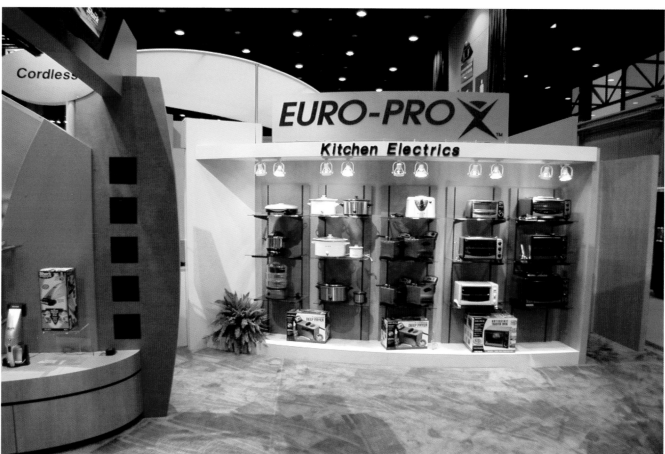

"created a connection between the entire product line."

In setting up the display and demo modules, the designers created elements that gave them leeway in how to arrange or rearrange the traffic flow and still provide ample space around each station for live demonstrations. If and when the sales staff felt the prospective buyer might be really interested, the buyer-to-be could be taken into the private demo room where business could be conducted away from the other attendees The room was a semi-circular structure covered with the same light wood finish used throughout the space and capped with a semi-circular ceiling raised about 2 ft. over the 8 ft. tall unit. The Euro-Pro logo, printed on a plastic material, sat atop the curved end of the room.

Plasma screens mounted strategically throughout the space played the company's messages while adding spots of bright color and flashing images.

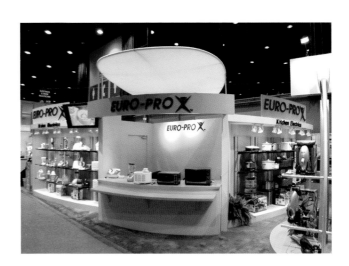

ATELIER TORINO

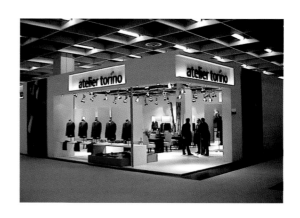

HMW SHOWS—*Dusseldorf and Cologne, Germany*

EXHIBIT DESIGNER—*Studio Gruschwitz,*
 Grobenzell/Munich, Germany

EXHIBIT FABRICATION—*Criterion*

PHOTOGRAPHY—*Studio Gruschwitz*

Illustrated on these two pages are two different exhibits for the same client—Atelier Torino—designed by the same firm, Gruschwitz, and made to fit into a space of 2365 sq. ft.

In one case, the Spring HMW Show that took place in Dusseldorf, the designers enclosed the space and suggested a private showing of a very special collection of menswear designed and manufactured by Atelier Torino. Emulating an upscale boutique, the "display window" is suggested on the aisle by five fitted suit forms presented against floating translucent corrugated plastic panels and a flat shelf that becomes a table and serves as a "floor"

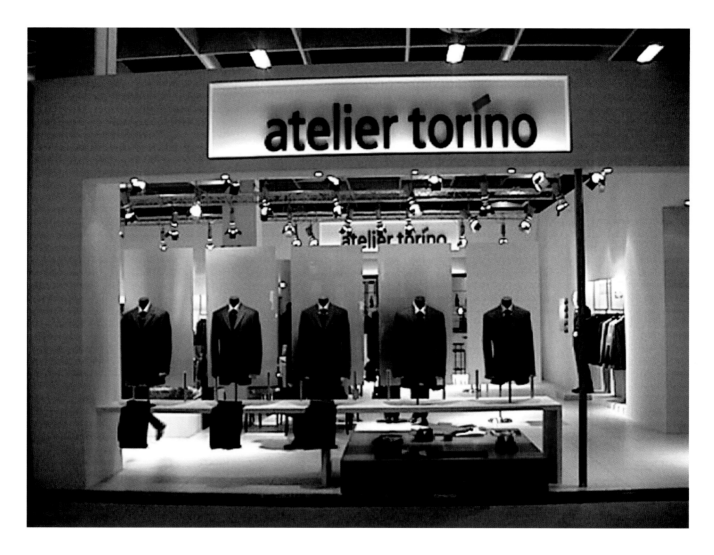

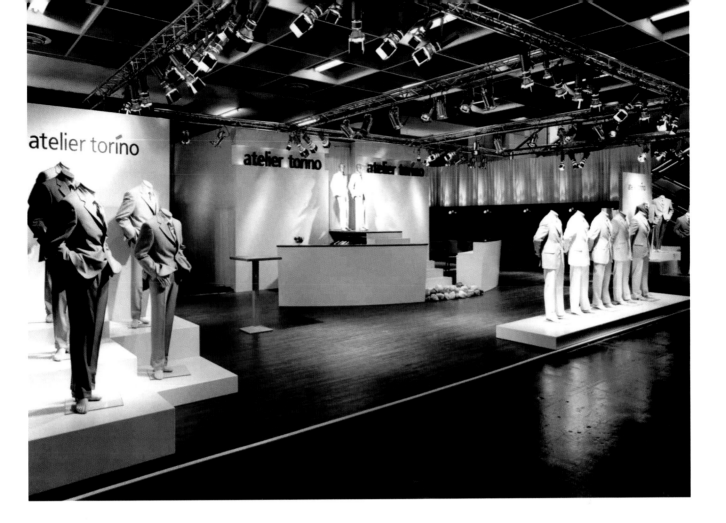

for the window. It also provides a surface on which the pants can be draped. Tucked beneath the shelf is a bright red lacquered platform on which the coordinated accessories are displayed.

Inside the white-on-white space there are more featured garments presented against the softly-illuminated plastic panels as well as several contemporary style tables and chairs for conferencing and order taking. Along the perimeter walls a wider selection of suits and jackets is shown shoulder out on hang rods. The Café was an important element in this design and it took on the look of an intimate sophisticated wine bar in which black accents spiked up the repetitive use of the same lightweight white plastic panels The same black lacquered tables and neutral covered chairs that appeared in the boutique were used here. Throughout, in recessed illuminated shadow boxes, fashion accessories were displayed as dimensional "still lifes."

For the HMW Show in Cologne, the designers opted for "a wide open space—as an expression of purity and elegance—with a certain masculine but Spartan quality." This presentation was more theatrical and more dynamic

with assorted sizes and heights of platforms building up at either end of the long exhibit space. In the center there was a dramatic staircase going up and back and ending with "stage" where two abstract figures appeared between the blue illuminated logo signs. Lined up—front and center—were five headless forms in a variety of white outfits but all in the same pose. The dimensional dressed figures in the two side clusters were also posed in the same position—much like a chorus in a musical production. The overhead lighting system added to the theatrical quality of the exhibit.

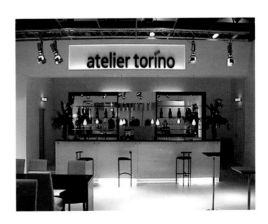

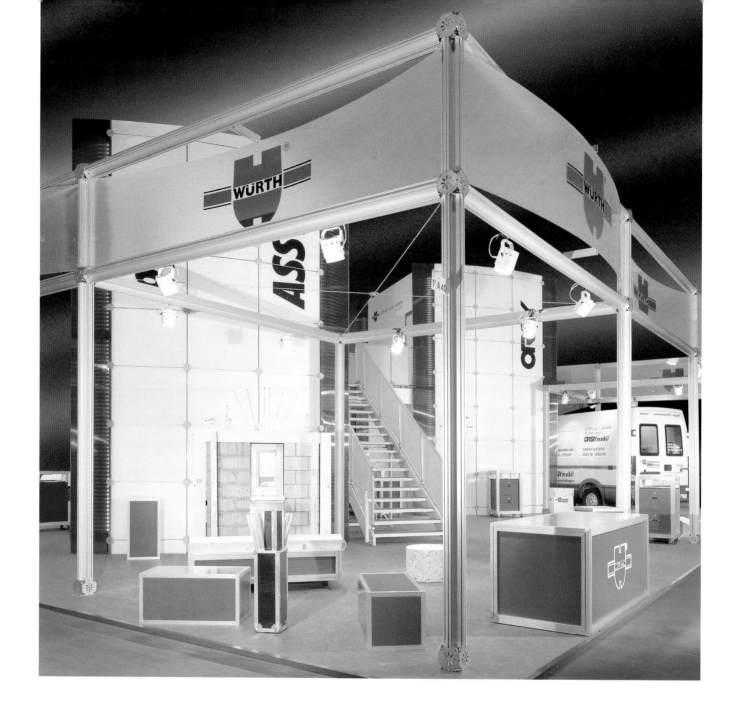

WÜRTH
COMPANY

SWISSBAU—*MCH Messe, Basel, Switzerland 2002*
EXHIBIT DESIGN & FABRICATION—*SYMA, Switzerland*
PHOTOGRAPHY—*Courtesy of Syma Systems*

Designed for the Wurth Tool Company, this dynamic, two story high exhibit was created and constructed by Syma of Switzerland as a series of modular pieces that can be combined to create this striking appearance or make smaller scaled presentations at different shows which do not call for this much spectacle.

By using Syma's own exhibit building system— MOLTO—and combined with Syma's other construction systems "a clear spatial structure with prominent structural elements allowed uniform integration of the corporate design." Support was provided by the back-lit plexiglass that served as the skin over the metal skeleton and whose "curved style evoked the dynamism of the client."

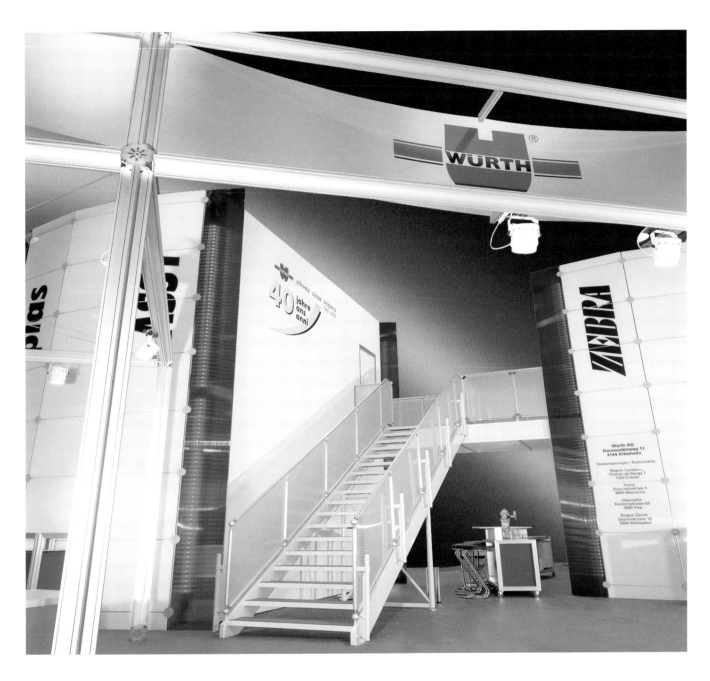

Within this tall structure with its dramatic metal and plexi-sided staircase were offices, hospitality areas, conference rooms and storage space. It was not only "eye-catching both from a distance and close-up" but "enhanced with an overhanging glass facade and connected with a footbridge." All in all, the net result was "an open and inviting stand design that helped to cultivate and establish new contacts."

BASF

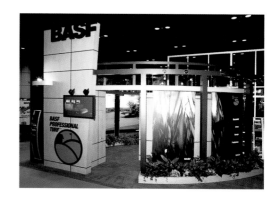

GOLF COURSE SUPERINTENDENTS ASSOCIATION OF
 AMERICA—*Orlando, FL*

EXHIBIT DESIGN & FABRICATION—*Chicago Exhibit
 Production, Bolingbrook, IL*

DESIGNER—*Joe Koziarski*

SUPPLIERS—*Octanorm USA, Exhibit System components /
 The Photo & Repro Group / Fabric Images /
 Van Bruggen Signs*

PHOTOGRAPHY—*Courtesy of Chicago Exhibit Productions*

The indoor/outdoor concept created and fabricated by Chicago Exhibit Productions for BASF Specialty Products (Turf and Pest Control business groups) was effective enough to not only draw large crowds to the 2400 sq. ft. space but to win a Tower Award from the Chicago Chapter of the Business Marketing Association.

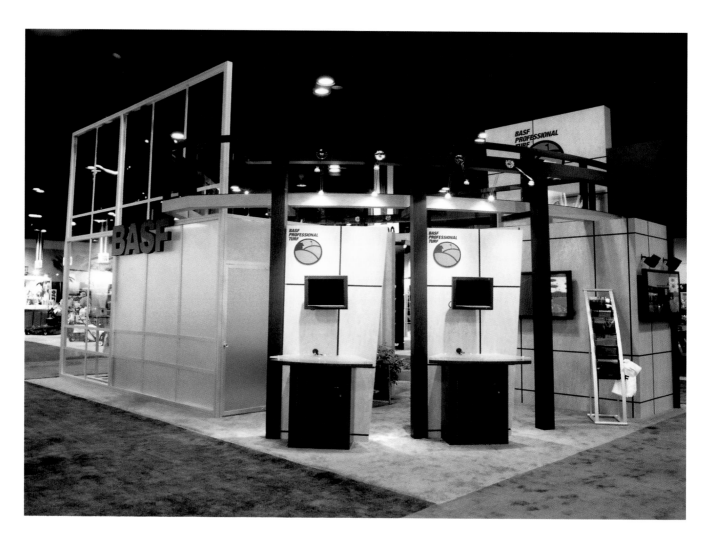

By changing the carpet colors from blue to green, the designers helped to define the in/out theme. The large circular sign made of spandex fabric stretched over an aluminum frame had BASF on one side and the company's logo on the other and it served as an overhead beacon for the space. It was visible from several aisles away in the exhibit hall. Using a combination of Octanorm's exhibition construction system and Octanorm's Maxima system plus custom elements, the designers were able to produce the assorted exhibit modules which also provided greater flexibility for the client as well. These elements can be arranged in different configurations yet "maintain visual consistency for their identity."

Among the special features in the BASF exhibit were the video stations on the perimeter of the booth space and these eventually led to a large presentation area in the center of the space. The A/V presentation that

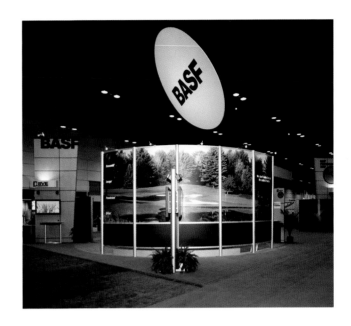

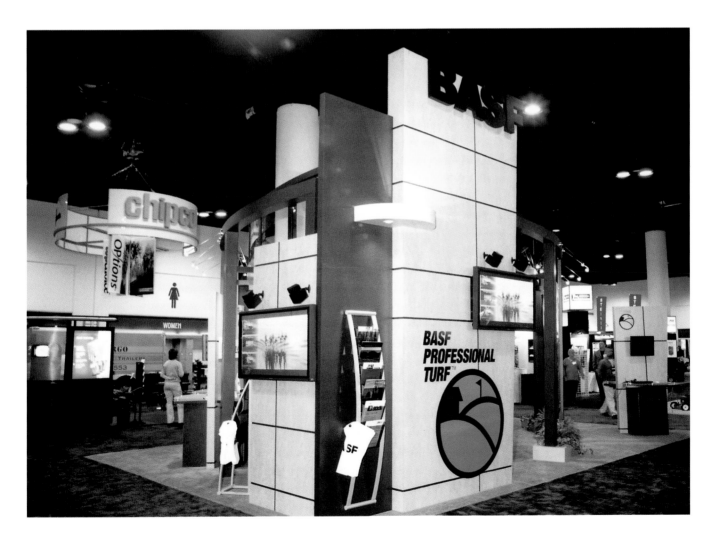

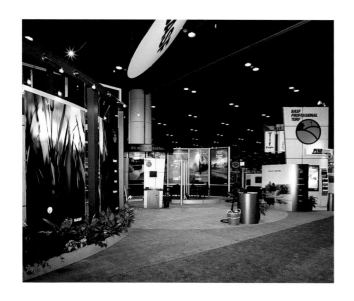

played on the small monitors also appeared on the large plasma monitor in the center and provided a continuity to the marketing message.

Since the attendees were mainly golf course superintendents, the multi-panel murals showing a golf course created a visual tie with the targeted visitors. Large graphic panels—some double sided—also served to either divide presentation areas or create partitions for the conference spaces. The use of the oversized photo murals "created huge visual impact." The open floor plan kept traffic moving throughout the stand and the BASF staff was able to interact with a great many visitors.

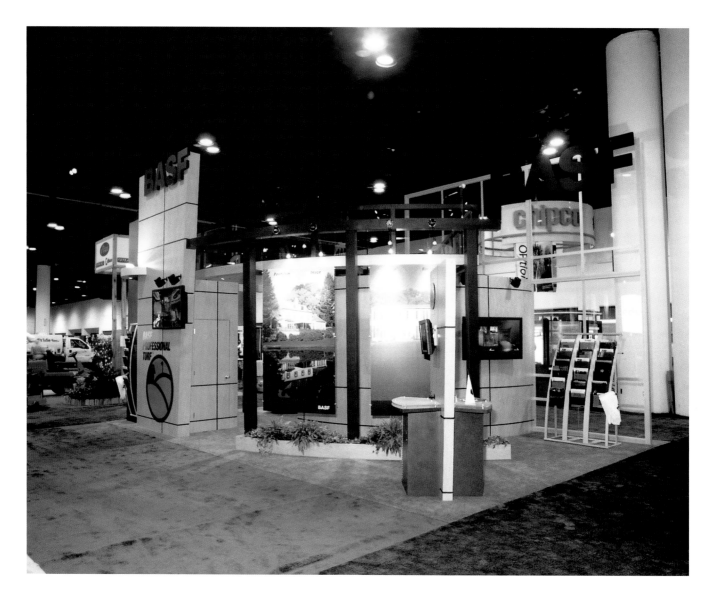

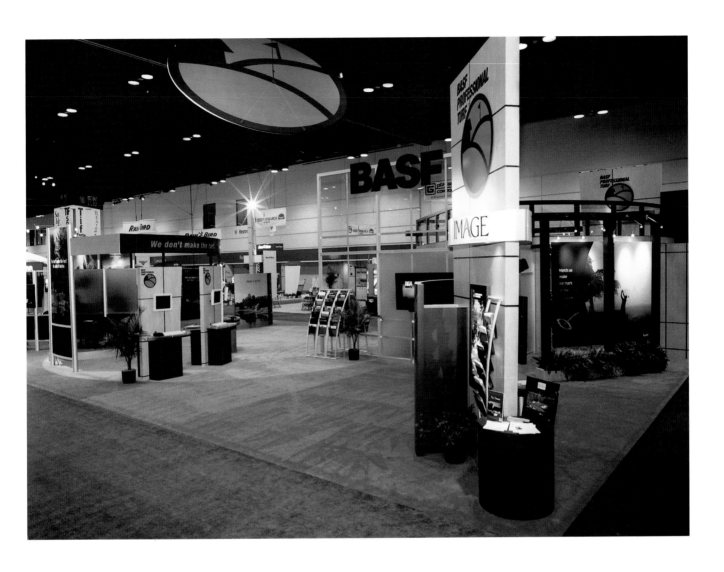

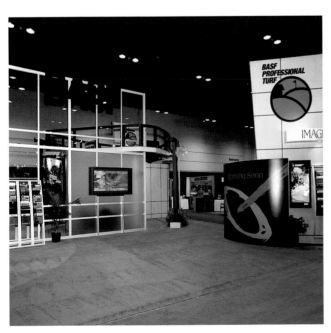

SERVICEWARE

CUSTOMER RELATIONSHIP MANAGEMENT SHOW—*San Francisco, CA*

EXHIBIT DESIGN & FABRICATION—*Carpenter Connection*

DESIGNER—*Gary Zak of Zak Designs, Pittsburgh, PA*

A/V—*Benack Sound Production, Inc.*

PHOTOGRAPHY—*Gary Zak*

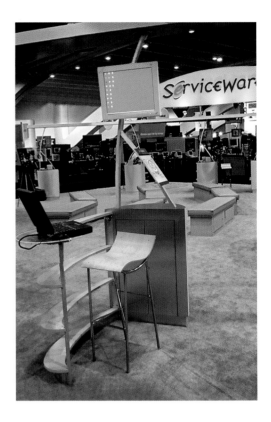

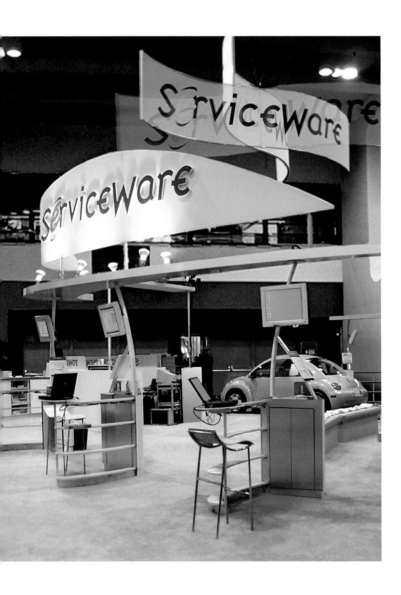

By using a recognizable TV game show format—"Who Wants To Solve A Million Errors"—the firm was able to demonstrate their capabilities with Internet life lines to their website for solutions. The lime green VW Beetle that was a focal feature in the space was the main prize though other prizes were awarded during the show "to encourage audience participation and maintain a high level of attention throughout these live demonstrations."

The placement of the stage at the back of the space maximized the booth for traffic flow from all four sides. A rotating, double sided, "S" curved header suspended from overhead identified the booth and various accents within the booth were created to echo that "S" as the workstation stools, and the elliptical "e" icon of the company logo which represents the "e-commerce" value appeared on the overhead beams and the workstation railings. The open curved railings led to the workstations that contained a laptop, a flat monitor screen, and a dual purpose cabinet stand with feature graphics on top and storage space below. A "toll booth" layout of wide open aisles funneled crowds between the workstations to the seating area in front of the stage. Overhead ID with wire management beams connected the individual workstations.

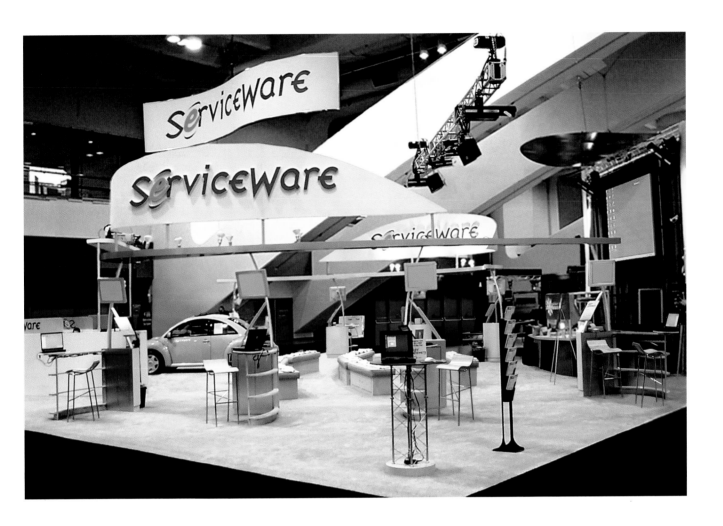

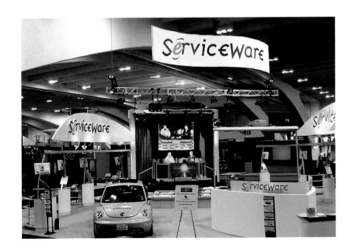

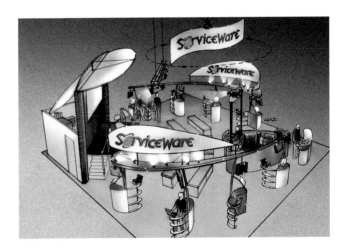

Materials were selected to "give a human touch and warmth to the high tech, e-commerce nature of the company." Maple wood and maple veneers were combined with metallic ivory Zolatone painted surfaces and brushed brass laminates. Purple laminates and green accents from the glowing plexiglass panels completed the palette.

ELI LILLY
& CO.

PRI-MED MIDWEST—*Boston, MA*

EXHIBIT DESIGN & FABRICATION—*Hamilton Exhibits,*
 Indianapolis, IN

DESIGNER —*Jeffrey M. Lake*

A/V—*Nearlife*

PHOTOGRAPHY—*Courtesy of Hamilton Exhibits*

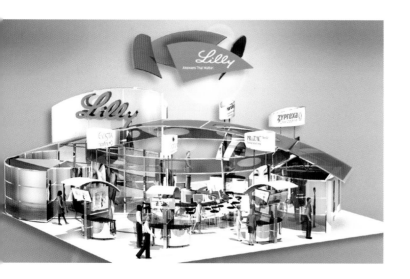

This exhibit designed for the Eli Lilly & Company appeared at the Pri-Med Midwest show in Boston. Created and fabricated by Hamilton Exhibits to suit the open 2500 sq. ft. island space, the entire exhibit worked together to "form a complete experience for the attendee from the moment they enter the stand. All five senses are stimulated."

Very high tech and high end laminates and metals were used in finishing the assorted modules that make up the total "experience." From a distance one could see the perforated metal rings that circled over and encompassed a family of brands and made them one. Large back-lit signs emanated from the tops of the detailing kiosks with light boxes or plasma screen capabilities that stood on the floor. These highlighted some of the Lilly brand names. The reception area/information desk was housed under a curved roof made of red perforated metal. Facing the aisle was one of the several larger-than-life graphics used in the exhibit. This was one of the unique features in the exhibit and a first ever "infrared touch wall" incorporated into a display. Attendees were invited to walk up to the wall and "touch a person" on the graphic. The heat of the touch activated the system and it proceeded to morph into a patient's testimonial video.

Throughout the modular design, strategically-placed lighting added a warm and inviting quality to the ambiance. Adding to the "interaction" was the hospitality bar which featured touch screen quiz games. The design also included a fairly large conference room which could be subdivided into smaller, more intimate spaces. The unified but open environment reinforced the corporate message and the individual product branding—"One Company, Many Brands."

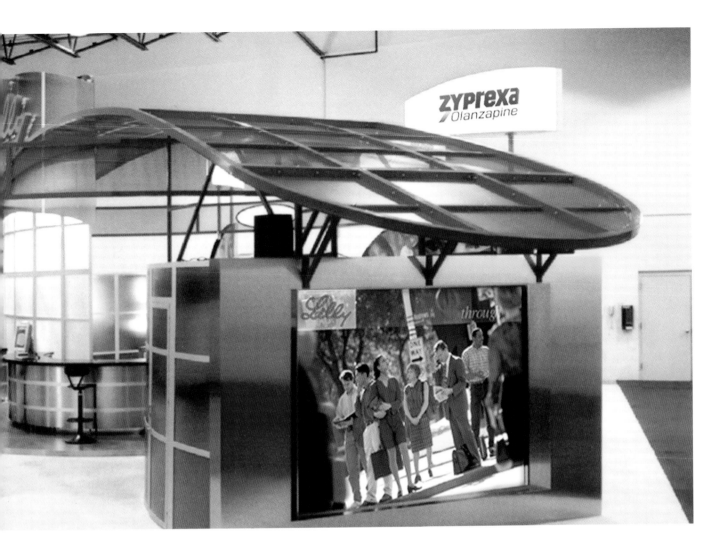

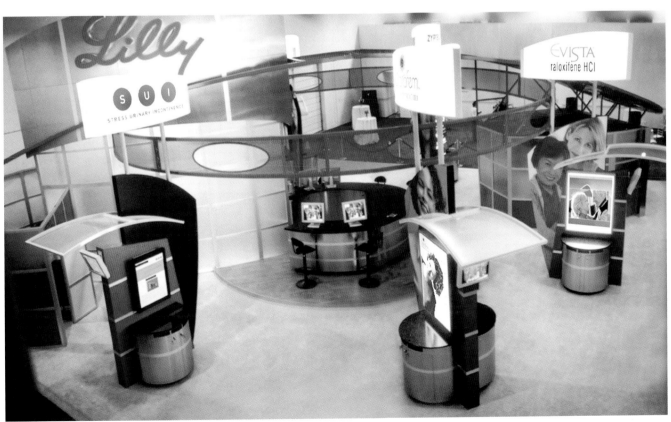

WINNTECH
DIGITAL
SYSTEMS

GLOBALSHOP—*Chicago, IL*

EXHIBIT DESIGN & FABRICATION—*Winntech Design Group, Kansas City, MO*

CO-CREATIVE DIRECTOR—*Brian Harvey*

ART DIRECTOR—*Rhana Castle*

ARCHITECTURAL DESIGNERS—*Adam Herbig/Carmen Thoma/Hope Spano*

GRAPHIC DESIGNERS—*Gretchen Townsend/Thomas Davies*

PHOTOGRAPHY—*Alistair Tutton, Winntech*

The Winntech Digital Systems' design group created this flexible showpiece exhibit that would reflect the multi-faceted services, design, manufacturing and installation capabilities of the company. Since Winntech participates in two trade shows annually and takes a 50 ft. x 50 ft. space at each show, this exhibit was designed to meet the needs of two different markets. At GlobalShop retailers and retail-related designers are seeking solutions to merchandising problems that vary from apparel to food to in-

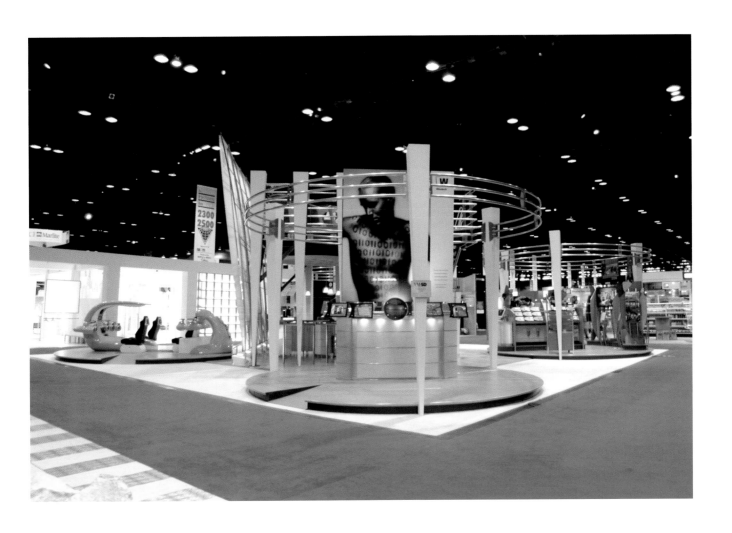

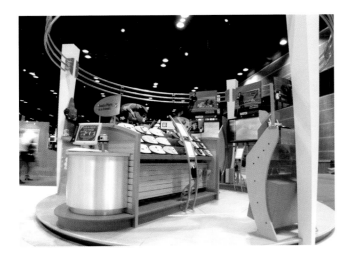

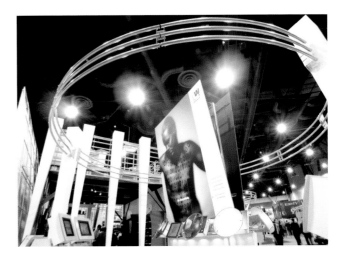

store information kiosks and more. At the Consumer Electronic Show (CES) the attendees are more focused in the field of consumer electronic merchandising. "The net result of these differences demanded an exhibit solution that could allow a diverse range of fixtures to be displayed within the booth while ensuring that Winntech would present a consistent corporate brand image at both shows."

The unveiling of this exhibit at GlobalShop coincided with the release of Winntech's new corporate identity and thus the key graphic elements were formed from massive reprints of Winntech's own brand imagery. "These images depict the individual elements of Winntech's design and manufacturing cycle as individual

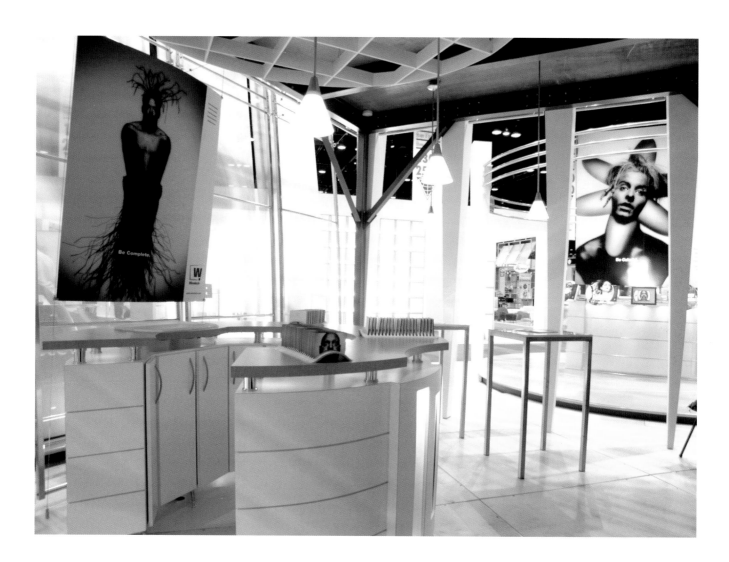

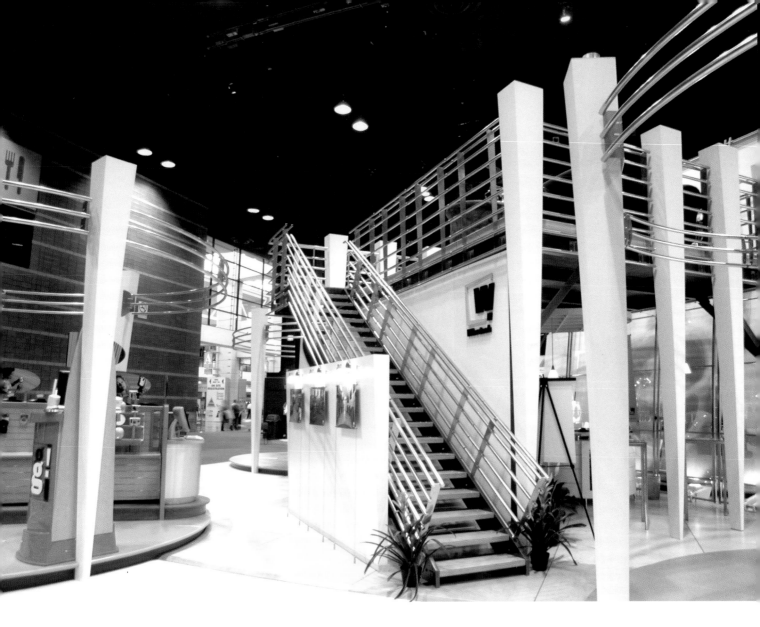

people and merchandising product." The design solution came in the form of an "art gallery"—the fixtures were featured as art installations and the services as a range of interactive and non-interactive information stations. The layout of the booth consisted of a series of elevated disks or platforms defined by swirling metal rings circling overhead and giant graphic blow-ups. Upon these were placed the larger merchandising fixtures and the non-interactive and the interactive information stations/kiosks. These disks surrounded the central, two story high structure "that created an informal meeting space above the level of the main trade show floor and a meet-and-greet station under the mezzanine."

Due to its presence—its smart and stylish look—its effective product merchandising—the exhibit was awarded Best Booth at Show at GlobalShop 2002.

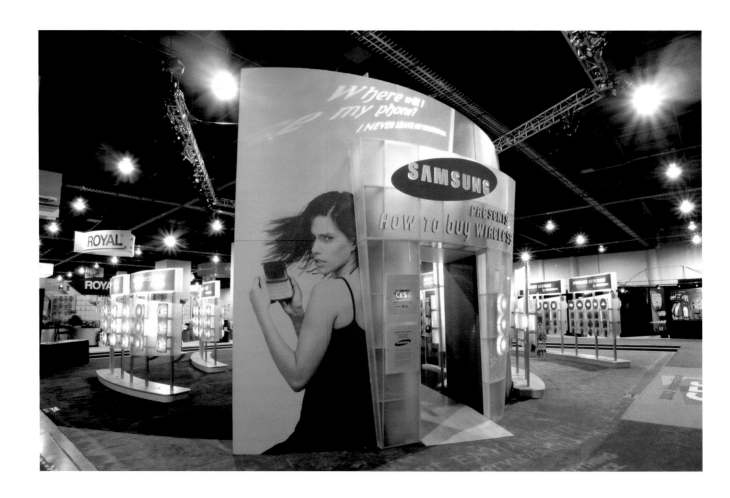

ULTIMATE
WIRELESS
SUPERSTORE

CES—*Las Vegas, NV*

EXHIBIT DESIGN & FABRICATION—*Winntech Design*
 Group, Kansas City, MO

CO-CREATIVE DIRECTOR—*Brian Harvey*

ART DIRECTOR—*Stephanie Malcy*

ARCHITECTURAL DESIGNERS—*Adam Herbig/Carmen*
 Thoma/Hope Spano

GRAPHIC DESIGNERS—*Gretchgen Townsend & Thomas Davies*

KEY SPONSOR PARTICIPANTS—*T-Mobile/Palm/BellSouth/*
 Plantronics/Cellular Innovations/CellStar/Unisonic/USA
 Wireless/Octilla/GES/Samsung

PHOTOGRAPHY—*Alistair Tutton, Winntech*

In a space of 50 ft. x 50 ft. the Winntech Design Group
was invited by the Consumer Electronics Association to
design and execute a booth "dedicated entirely to the wire-
less division of the consumer electronics industry." The
result was the Ultimate Wireless Superstore which was
conceived to "redefine the manner in which wireless prod-
ucts are currently merchandised." Sections of the display
were "auctioned off" to product manufacturers, service
providers and third party vendors of the wireless commu-
nity and they became the sponsors and helped to offset the
cost of the development of the booth. (See the key spon-
sor participants listed with the design credits.)

Ed Legum, a cellular industry consultant, assisted
Winntech's designers in generating the core design. The
concept was to create a retail-type setting that would
help "wireless customers navigate the 'sea of confusion'"
represented by the numerous products, services and
accessories. Winntech "sought to deliver clarity (a guided
linear pathway) through the maze of confusion (a mas-
sive 20 ft. serpentine wall that tapered down to 8 ft.)."
Facing the aisle was the start of the sweeping wall which
carried giant graphics printed on the stretched fabric sur-

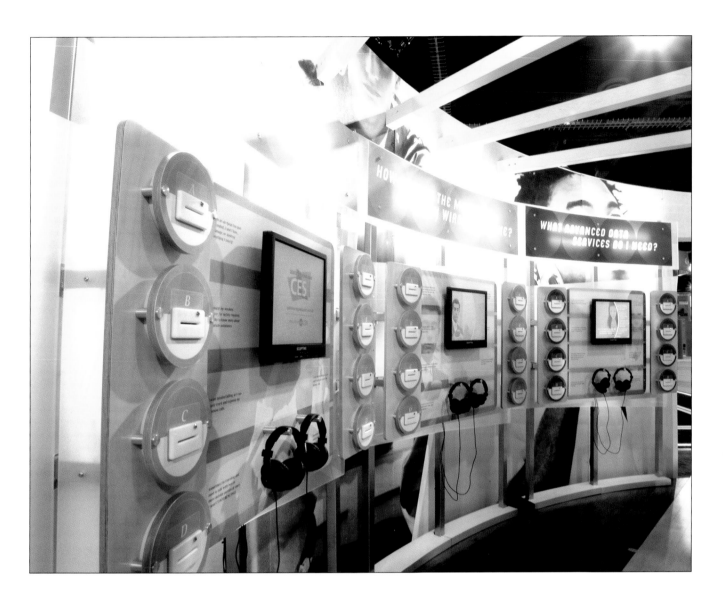

face. An opening in the curve, outlined by a grid with a translucent covering over it, invited attendees onto the pathway. The theme-"How To Buy Wireless" was printed over the doorway.

Located on the other side of the entrance were six interactive Q & A stations equipped with 19 in. LCD screens. By sweeping a cellular phone-shaped key card through the corresponding answer slots, visitors could create their own, unique "wireless profile." At the end of the pathway the attendee received a personalized print-out of a map of the space with special, individually-selected display sections highlighted where the attendee would find "solutions" appropriate for his or her needs. By visiting the highlighted areas the visitors found "a

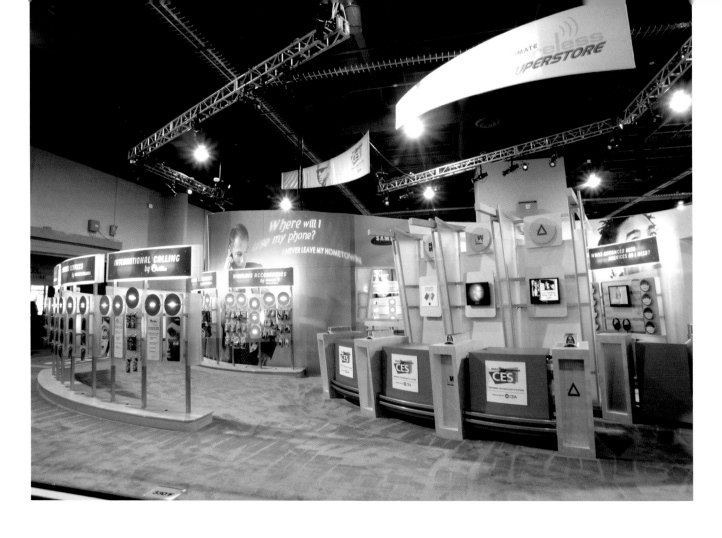

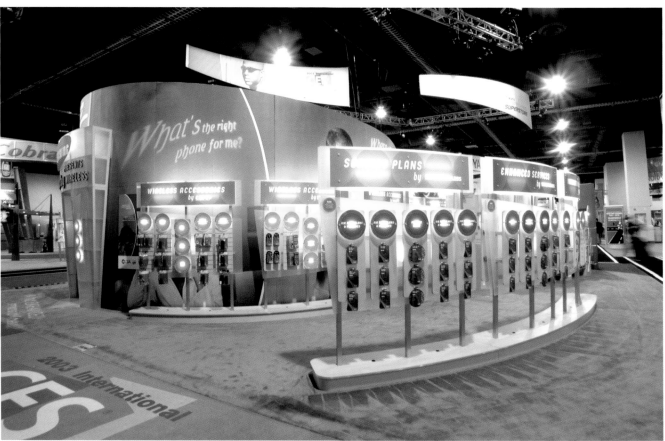

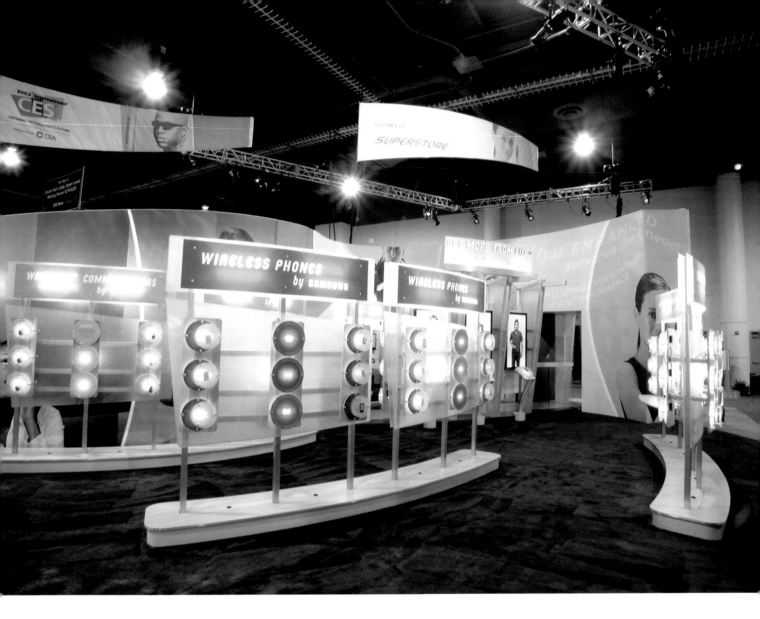

clear visual hierarchy that delivered category, sub-category and product specific information."

"By controlling the physical, visual and virtual attributes of the exhibit entirely, Winntech was able to ensure that this complete 'immersion event' would leave attendees enraptured, enthused, educated and entertained."

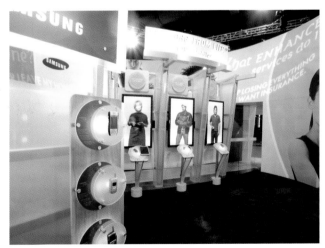

B & N
INDUSTRIES

GLOBALSHOP—*Chicago, IL*

EXHIBIT DESIGNER & FABRICATOR—*B & N Industries,*
Kevin McPhee / Pirkko Luicchesi / Daniel Williams /
Richard Bray / Brad Somberg

EXHIBIT FABRICATION TEAM—*ViewRite Manufacturing &*
Moss, Inc.

PROPS & DECOR—*B & N Industries design team*

PHOTOGRAPHY—*Kevin McPhee of B & N & mmp/rvc*

If it was anything that distinguished the 2500 sq. ft. space occupied by B & N Industries at GlobalShop in Chicago, it was the super, super graphics. In an industry where showmanship is everything, it was the dynamic impact of the over 20 ft. tall zig-zagging graphics that served to identify the area, encompass the space and also visually separate the presentation of B & N's systems, fixtures and modules from the surrounding exhibitors. Designed by Kevin McPhee and his team, all at B & N, the concept for the exhibit was to present several new systems and fixtures in vignette settings so that prospective buyers could see how these assorted fixtures and systems function and look when in use.

The "accordion folded" graphics with greatly over-scaled images of garments served as "walls" with defini-

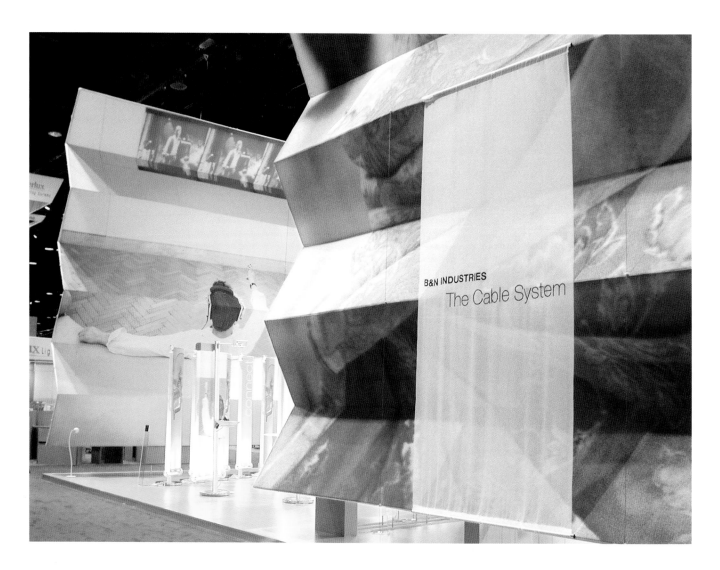

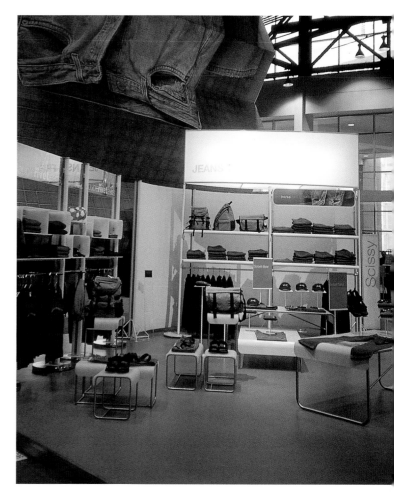

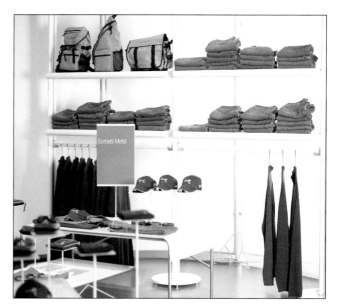

tive opening on two sides and "look-through" openings on the other two. Sheer fabric panels, attached to the suspended folded graphics, identified some of the new lines featured within. The interior space was open and bright with brilliantly illuminated areas fully clothed and dressed to suggest areas in specialty stores. Centered in the space was the circular reception/information desk which was highlighted by an internally illuminated stretch fabric "column" that mushroomed up from the center. The desk was also constructed with a metal armature covered with the stretch fabric and back illuminated so that the entire unit seemed to glow. Some of the internal "partitions" as well were fabricated by Moss, Inc. of stretch fabric over metal frames so that throughout the space there was an overall lightweight, glowing and open feeling.

Clusters of the manufacturer's fixtures were set out and dressed in coordinated merchandise so that the

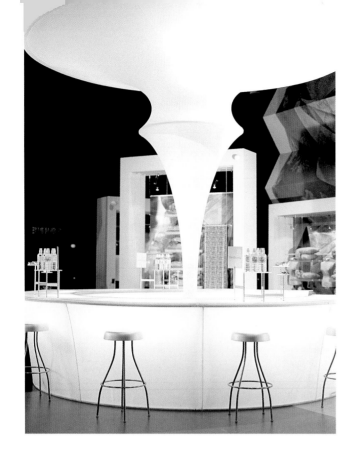

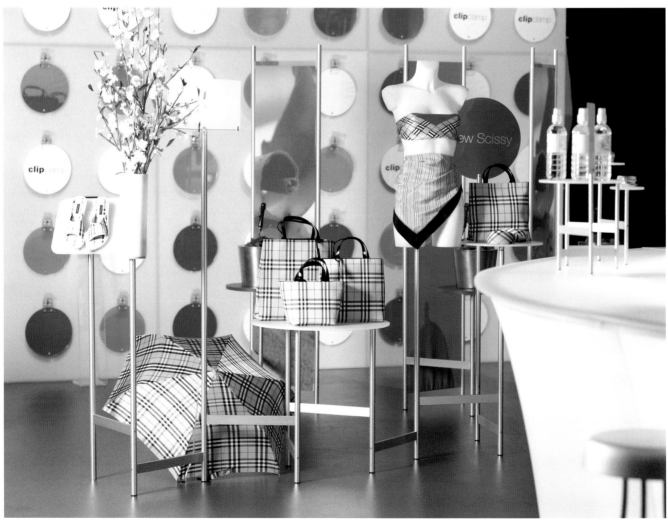

attendee could quickly see how the assorted fixtures and fittings went together. Especially effective was the major "Jeans" department which combined several wall and floor systems set against a fabric partition and dramatized by the blue jean supergraphic above the space. Color coordinated, too, were the signs incorporated into each grouping that identified the system/fixture.

When asked what made this "a successful exhibit," Kevin McPhee said, "The large and impactful graphics, the new use of light and fabric retail interiors and the high energy of the hip music."

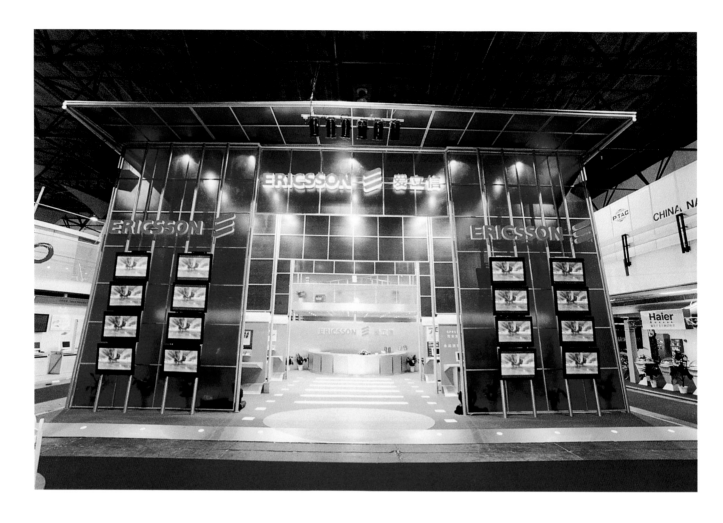

ERICSSON

PT / EXPOCOMM, CIEC—*Beijing, China*
EXHIBIT DESIGN & CONSTRUCTION—*Kingsmen, Singapore*
PHOTOGRAPHY—*Courtesy of Kingsmen*

There was no way that anyone at the PT/EXPOCOMM in Beijing could not have seen the looming, blue polycarbonate and acrylic structure that filled the 3175 sq. ft. space. Designed and constructed by Kingsmen—it took 80 personnel to build the exhibit—this multi-story office within an exhibition hall was "one of a kind."

Facing the attendees on the aisle were two 30 ft. tall "walls" of blue plastic contained within a grid of satin brushed, round metal pipes. This pair framed the entrance into the vast exhibit beyond which was filled with interactive demo stations set against yellow and orange partitions. The entire structure—including the 360 sq. meter ceiling—and the inclined walls resembled a classic Egyptian mastaba recreated from modern materials for a modern audience, not unlike a stage set for Disney's "AIDA." Adding to the drama and spectacle of the facade was the tier upon tier of giant plasma screens—16 in all—that projected and animated Ericsson's message.

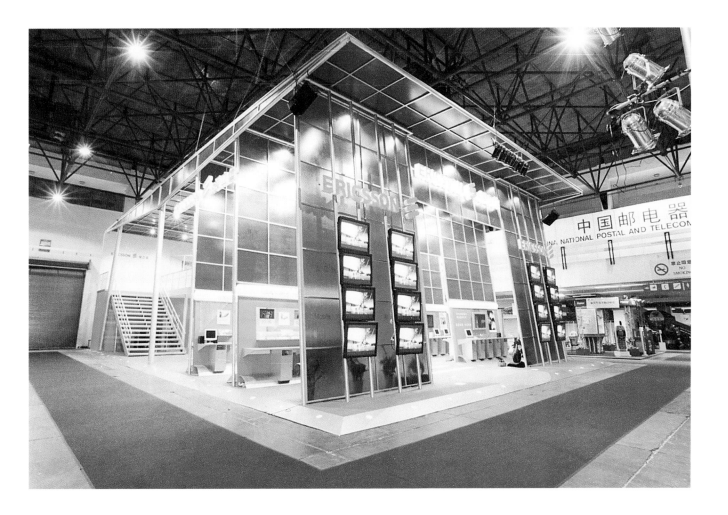

In a theatrical progression—almost like layers in a pop-up children's book—the interior walls followed the design of the facade, each tilted back slightly to further emphasize the "forced perspective" look of the concept. Centrally located at the far end, on ground level, was the heroically-proportioned reception/information desk. Behind the white partition that backed up the desk was a large area set aside for presentations and a mezzanine directly above it served for hospitality and one-on-one conversations with prospective buyers. This upper level was reached by the wide staircase at the rear of the exhibit space that also connected with the main presentation area.

The exhibit's design succeeded in " bringing across the high tech and 'millennium' image associated with Ericsson as well as asserting Ericsson's commitment to always be at the foremost of its competitors."

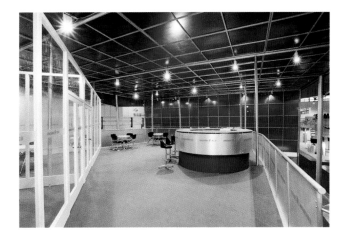

FUJI - XEROX

CEBIT ASIA CONFERENCE—*Shanghai, China, 2001*
EXHIBIT DESIGN & CONSTRUCTION—*Kingsmen, Shanghai*
PHOTOGRAPHY—*Courtesy of Kingsmen*

Kingsmen, a noted Singapore retail store designer/exhibit designer and construction firm established an office in Shanghai to accommodate the burgeoning exhibit trade in China. This design created for Fuji-Xerox was displayed in a 3170 sq. ft. space at the Ce BIT Asia Conference.

The client needed to display a wide range of product lines and still allow visitors to have "hands-on experiences" with the company's copiers, printers and digital network publishing machines. To create the desired excitement and theater that would attract attendees, this exhibit featured a unique graphic wall made up of PVC balls embellished with the Fuji-Xerox logo. The wide sweeping partition filled with glowing balls also added an interesting form of illumination to the display space.

Fuji-Xerox's signature colors of red and white and the "X" logo dominated the scene from the giant round red circles inset into the floor to the perforated white metal "umbrellas" accented with the brilliant red "X." These tilted half-domes served to highlight some of the workstations. Spotlights were targeted at these units and a soft white glow was reflected off them to provide a gentle, low lit ambiance that complemented the illumination on the monitors and screens on the tables.

FORD MOTORS

SINGAPORE MOTOR SHOW—*Singapore*
EXHIBIT DESIGN & FABRICATION—*Kingsmen, Singapore*
PHOTOGRAPHY—*Courtesy of Kingsmen*

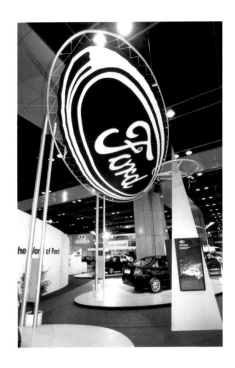

This 3170 sq. ft. stand was not only one of the largest at the Singapore Motor Show but it was located near the main entrance. Kingsmen took full advantage of the choice location to create this soaring and open exhibit design for the Ford Company.

Using a commercial metal truss system to produce rectangular bridges that spanned the area, the designers created a series of individual spaces where the various Ford auto lines could each get star treatment. Theatrical lighting was suspended off these metallic spans as well as dimensional letters with the product names. Heroic-sized graphics and wall-projected visuals added excitement to the space. Curved wall partitions, pyramid-shaped sign holders and a giant Ford logo sign in an elliptical metal frame that complemented the oval shaped platforms on which the autos were placed, all added to the total look of the exhibit.

ELI LILLY & CO.

EASD—*Glasgow, UK*

EXHIBIT DESIGN—*Hamilton Exhibits, Indianapolis, IN*

DESIGNER—*Jeffrey M. Lake*

EXHIBIT FABRICATION—*Silver Knight*

A/V—*Absolute Amusements*

PHOTOGRAPHY—*Courtesy of Hamilton Exhibits*

For the 3325 sq. ft. exhibit space at the EASD Conference in Glasgow, Scotland, Hamilton Exhibits who has worked with Eli Lilly & Company on other exhibits prepared this "Futuristic European" design to promote Lilly's position as an innovative global leader and especially in diabetes care.

High end laminates and metals were used throughout as well as translucent materials to further the open feeling of the space. An inlaid wood circulation path, set into the floor of the space, encouraged traffic to move through the space to the assorted kiosks equipped with inset product viewing boxes. Sixty-inch plasma screens, stationed throughout the stand, showed videos and added a sense of excitement and movement that was echoed by the sweeping, floating light rings overhead that "provided a bright and positive atmosphere." The 3D logos and the metal

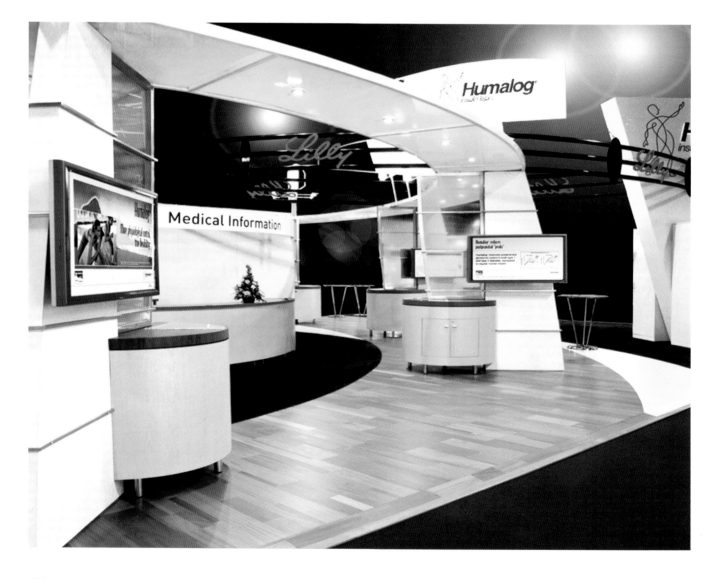

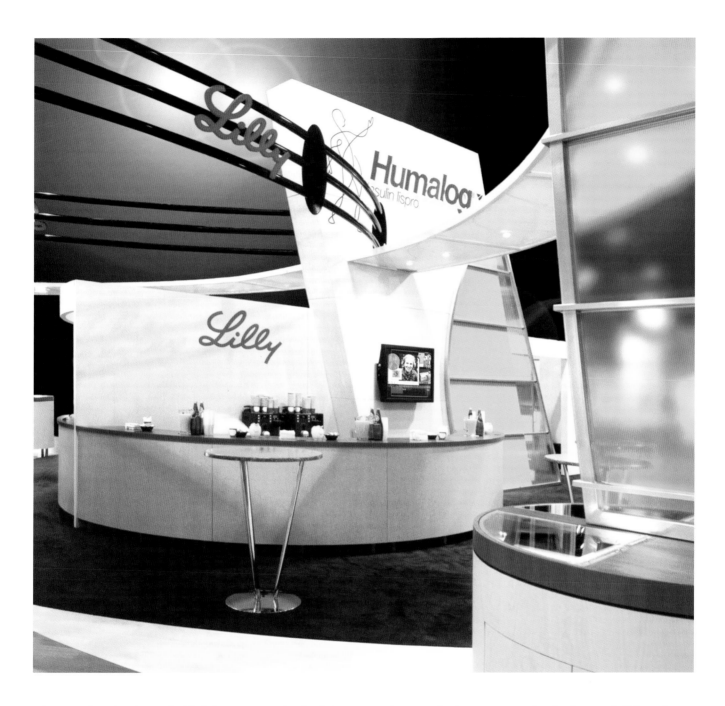

tubing used in the design "added dimension and color." Set upon a black carpet was a bistro that was heavily attended. Over 7000 cappuccinos were served in two days and it was the place for casual one-on-one talks and deal making.

To get the attendees to spend more time at the stand and to return for second and third visits, in addition to the medical education area there were "fun" features such as a custom designed racing game which attracted visitors while further reinforcing the company's brand logos. There was also a photography platform where guests were photographed against a graphic background. When the guest returned he or she would receive the photo as a take-away gift.

In addition to being a popular stand, the open design encouraged attendees to move about freely—learn, sample, enjoy—all that was offered under the sweeping, circular stretch fabric and aluminum framed "ceiling" that unified the various modules and stations into a pleasing and welcoming whole.

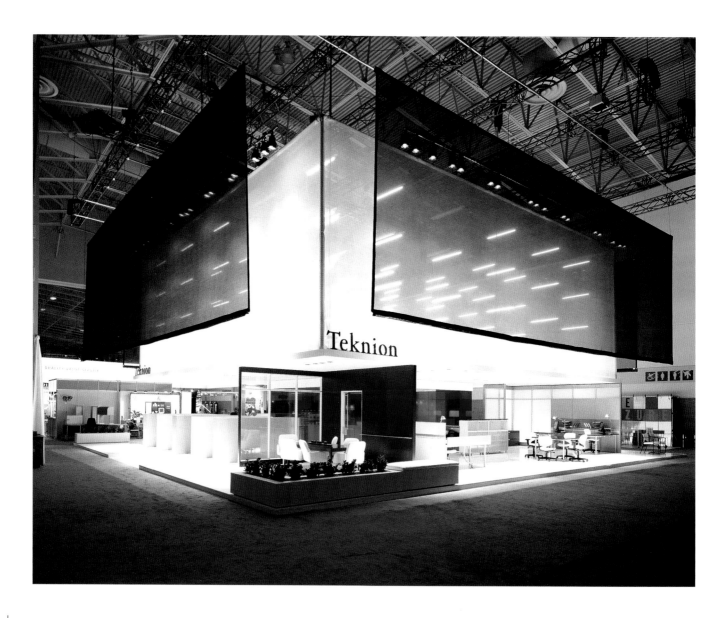

TEKNION

IIDEX/NEOCON—*Toronto, ON 2001*

EXHIBIT DESIGN—*Burdifilek, Toronto, ON*
 Diego Burdi / Paul Filek / Tom Yip

EXHIBIT FABRICATOR—*Taylor Manufacturing,*
 Mississauga, ON

PROPS & DECORATIVES—*Teknion Furniture Systems,*
 Teatro Verde & Fluid Living

PHOTOGRAPHY—*Kevin Viner*

For the International Interior Design Expo/NeoCon 2001, the design firm of Burdifilek created this dramatic 3600 sq. ft. stand for Teknion Furniture Systems. Suspended from the ceiling of the exhibit hall was a 60 ft. x 60 ft. white mesh box partially screened by black scrim curtains. With its interior floating lines of fluorescent lamps it seemed "to imitate a Mies-ian downtown office building." A central boardroom, dominated the white floor and it was enclosed by red glass panels and it served for the main meeting room in the exhibit. "A low ceiling height complete with suspended T-bar ceiling, sparse decoration, recessed PAR lamp fixtures and a simple rectilinear plan, all help to further convey the sense of a modernist aesthetic." Further, according to the designers, "Instead of designing the floor space alone, the exhibit was

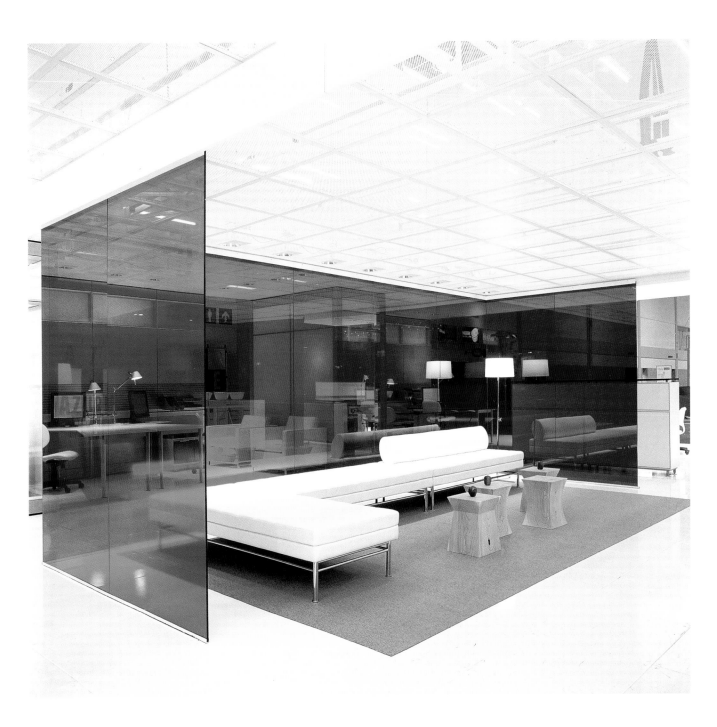

designed using three dimensional space. The suspended mesh box is an element on its own and can be recognized from anywhere on the entire show floor."

The overall clean and modernist approach to the design placed the product on display in context and emphasized the beauty and architectural nature of the product.

TEKNION

IIDEX/NEOCON—*Toronto, ON 2002*

EXHIBIT DESIGNER—*Burdifilek, Toronto, ON*
 Diego Burdi / Paul Filek / Tom Yip

EXHIBIT FABRICATOR—*Taylor Group Manufacting,*
 Mississauga, ON

PROPS & DECORATIVES—*Tekniom Furniture Systems,*
 Teatro Verde & Caban

PHOTOGRAPHY—*Kevin Viner*

To promote Teknion's Furniture Systems, fabrics and finishes at the 2002 IIDEX/NeoCon show in Toronto, the Burdifilek design team portrayed the "display elements in an art-installation manner" which looked quite different from the Mies inspired look of the previous year.

The simple elements included a suspended white ceiling filled with row upon row of warm PAR spotlights and MR16 lamps floating over a sleek, black vinyl rubber platform floor with a giant glossy black monolithic drum column rising up from one corner. "Each have their own textural and volumetric value, and created the booth's highly sleek and polished mood."

Getting special attention was the central bank of 96 vertical fabric wrapped columns—color gradated—which

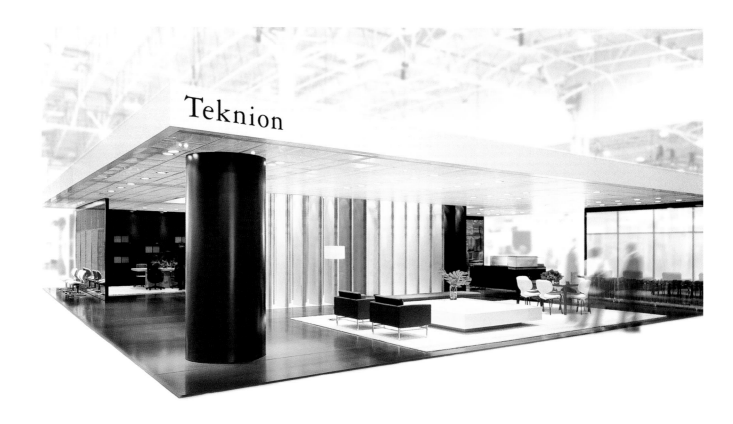

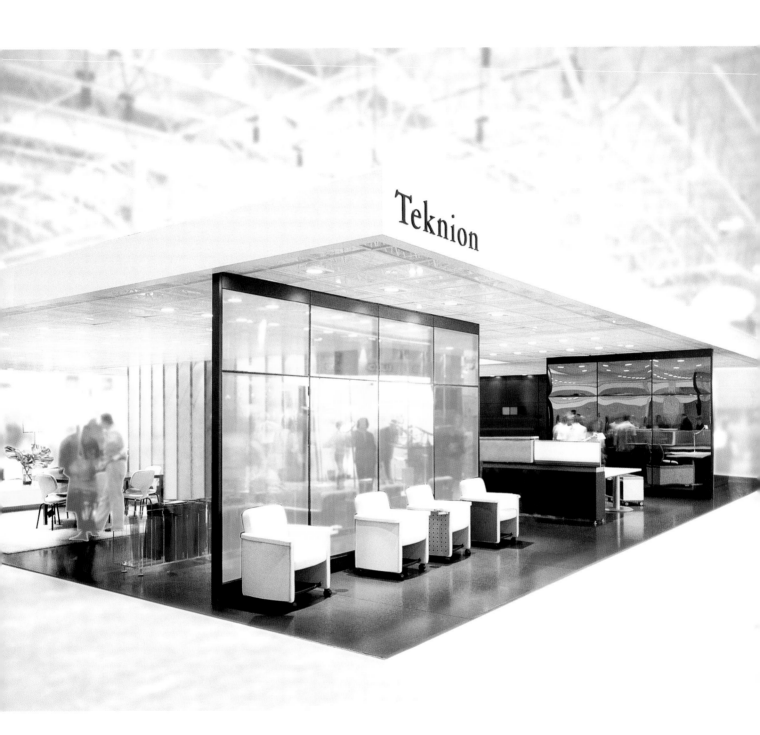

Teknion

"functionally acted to display Teknion's range of fabrics and create a point of memory at the same time." The furniture was upholstered in white or chocolate brown fabrics and leathers to complement or contrast with the overall colors of the booth—"thereby creating a strong graphic statement." Throughout, the exhibit was brand focused; groupings of systems and lounge furnishings were all by Teknion or custom made by Teknion.

SONY ERICSSON

CTIA—*Orlando, FL. 2002*

EXHIBIT DESIGN—*Lorenc + Yoo Design, Roswell, GA*
Jan L:orenc / Chung Yoo / Sakchai Rangsiyakorn /
Steve McCall / David Park / Mark Malaer / S
dusie Caldwell / Ken Boyd

EXHIBIT FABRICATION—*Geograph Industries, Harrison, OH*

LIGHTING DESIGN—*Ramon Luminence Design*

PHOTOGRAPHY—*Rion Rizzo, Creative Sources, Atlanta. GA*

"Designed as a monument within the 2002 CTIA Orlando Convention Center, the Sony Ericsson exhibit stands in stark white contrast to the visually hyperactive booths nearby. Its sinuous planes bend gracefully, spelling out the two capital letters of the newly-formed company it represents. Simultaneously weighty and massive yet ethereal and fluid, the undulating 'S' and 'E' letters visually symbolize the two industry titans' prominent positions of strength and futuristic outlook. The shared

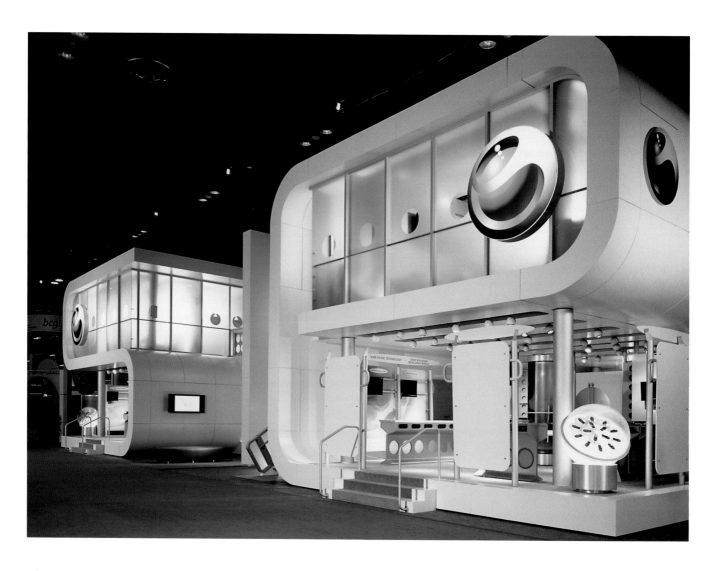

geometry of the letters allow for interlocking of their forms along the centerline of the exhibit, so the 'S' and 'E' read properly from each exhibit aisle."

Thus did Lorenc + Yoo, creators of this exhibit describe their concept for the structures that filled the 4500 sq. ft. space and helped to launch the new Sony-Ericsson brand. Raised almost two feet off the exhibit hall floor, visitors enter the lower of the two levels with a sense of expectation. The linear slotted ceiling "tightened the sense of space" and "created a focused environment for the small electronic devices" being shown. This first level was reserved for reception and product demonstration areas. Circular acrylic desks showcased the high tech devices against the curved wall and bent planes with circular punches which formed demonstration counters. Two six-person press rooms were designed "like oversized one-eyed dice," with each wall containing one 36 in. frosted plexiglass circular window.

Meetings were held on the second level. There was one large space (for 16 persons) and two smaller ones (eight persons each) and connected by an upper reception bridge, the two sided conference level was designed for private presentations. The exterior walls were translucent plexiglass punctuated by a linear series of clear porthole windows. Inside, on a perforated aluminum wall, cellular devices were profiled and it complemented the sweep of the outer white wall. A 1960's inspired "break-out" room was abstracted and simplified from old diner

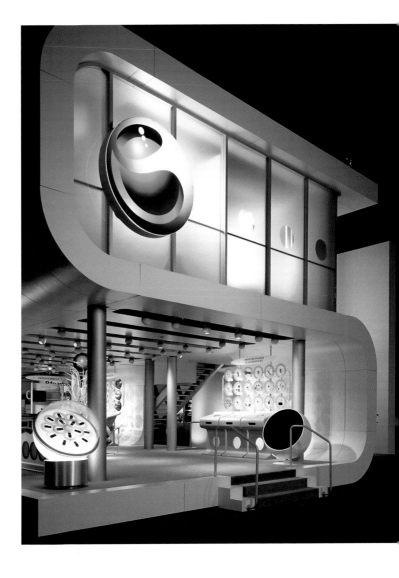

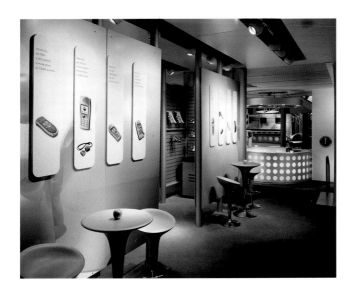

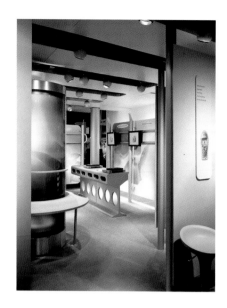
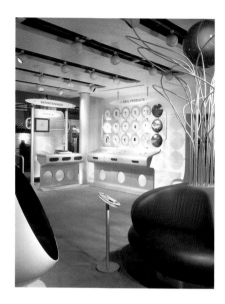
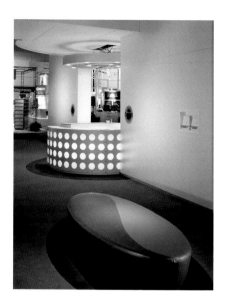
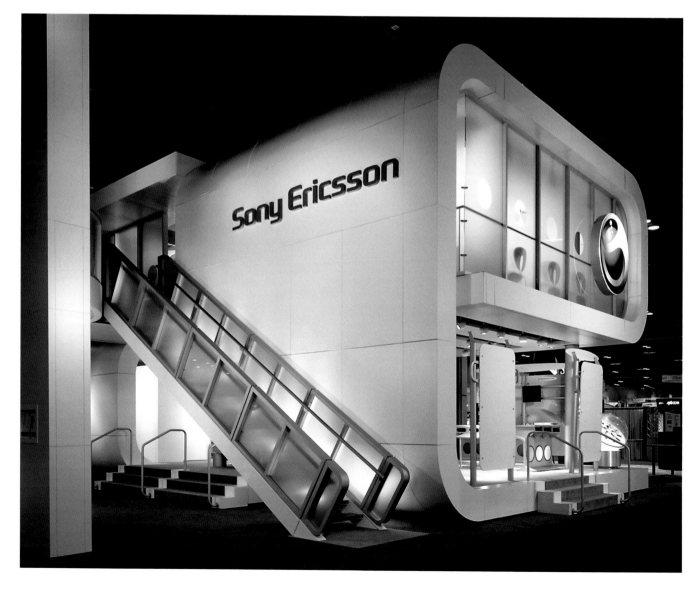

models and it was furnished with a circular banquette and lava lamps.

The simple color scheme was bold and meant for visual impact. Predominantly white, it was accented with the new company's identity colors. Apple green and yellow were used on surfaces in the conference rooms and perforated silver metal faced the internally illuminated reception desk. Green translucent plexiglass, set into the window openings, helped to clarify the 'S' and 'E' letters. Graphics were intentionally restrained "thereby supporting the company's logo."

"Its sinuous modern composition was designed to literally and figuratively transport visitors to the new world of Sony Ericsson."

ZAMIAS/
FIRST UNION

ICSC SHOW—*Las Vegas, NV 2000*

EXHIBIT DESIGN— *Lorenc + Yoo Design, Roswell, GA*
Jan Lorenc / David Park / Susie Caldwell /
Steve McCall / Veda Sammy

EXHIBIT FABRICATOR—*Geograph Industries, Harrison, OH*

LIGHTING DESIGN—*Ramon Luminence Design*

PHOTOGRAPHY—*Rion Rizzo, Creative Sources, Atlanta, GA*

The exhibit design that was originally produced for First Union and then taken over by Zamias Services, Inc.—an owner/developer of secondary markets throughout the U.S.—was inspired by an agora or classic Greek marketplace. As conceived by Lorenc + Yoo Design, "this 'modern classic' theme gives visitors the impression of walking

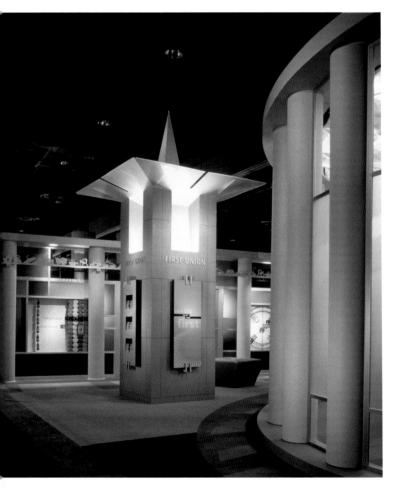

through a marketplace, surrounded by display windows filled with items for sale, while a graphic wall frieze tells the company's story."

The sweep of contemporary yellow columns (Zolatone painted Sonatubes) directed visitors at the ICSC Show into Zamias' 5200 sq. ft. space. Panels of translucent plexiglass suspended between the columns provided a sense of privacy for the conference rooms located behind that curve. On the other side of the open entrance was another colonnade of yellow columns with Mondrian-inspired panels and product presented in the spaces between the columns. Passing through a forward seating area on the gray and yellow patterned carpet visitors arrived at a square information desk which was set beneath a square yellow "donut-shaped" roof supported on angled gray uprights.

Inside the space the agora feeling was even more evident since there were rows of columns on either of the long sides of the stand with ottomans down the middle of the space for seating. The focus here was on the marketing efforts for leasing opportunities at existing retail properties, and to present Zamias as a fully integrated management firm. This message was delivered to potential and existing clients who found themselves gently surrounded by subtle messages and clever product displays shown in the "windows" that lined the space.

In addition to the unique rounded conference rooms another highlight of the exhibit design was the café where hospitality was provided. Visitors were invited to sit, relax, enjoy the food catered by Pig & Whistle in the out-of-doors café feeling generated by the open white canvas umbrellas over the silvery metal tables. Food and conversation were mixed with deals made in this open space.

Lorenc + Yoo also was responsible for the interior lit and opaque graphics as well as the collages and exhibits in the shadow boxes. The custom patterned carpet in gray, yellow and blue added to the total, tied-together look of the space.

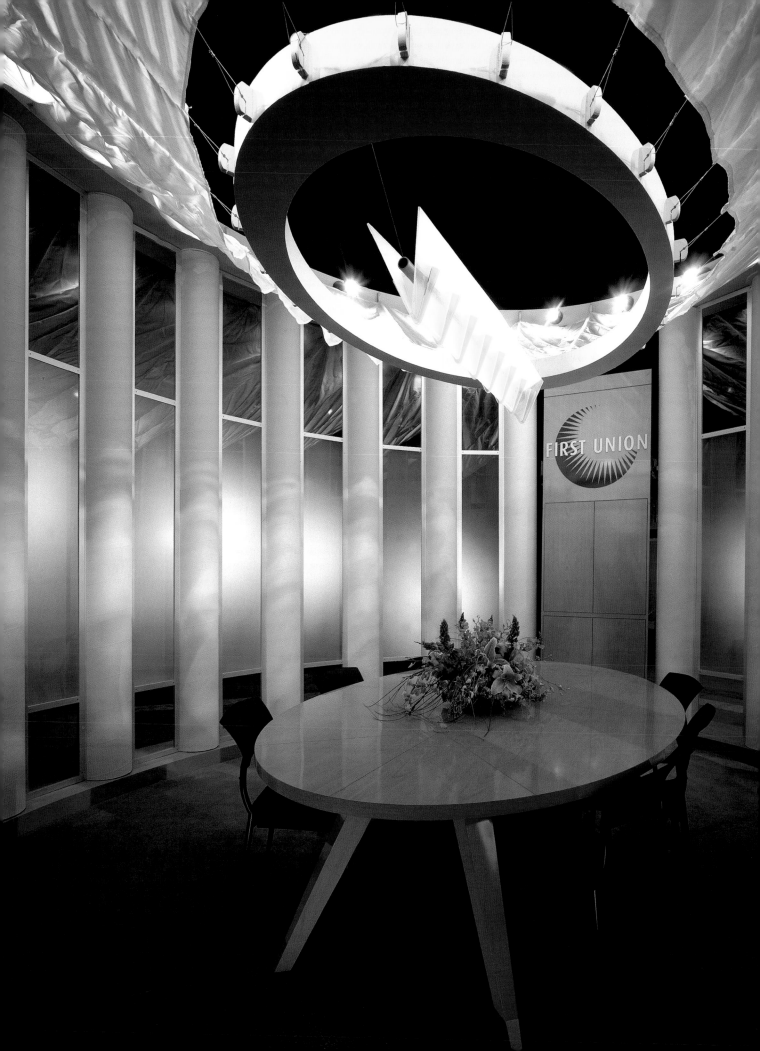

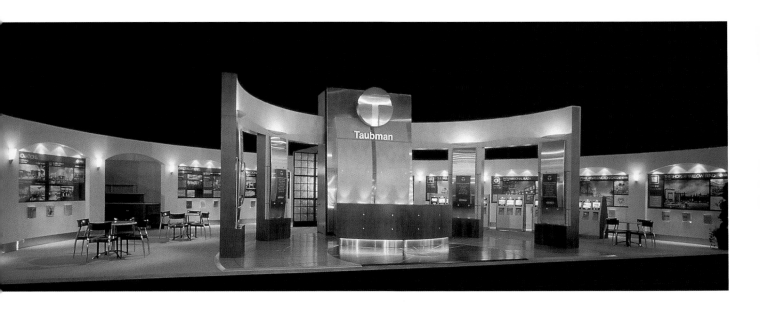

TAUBMAN

ICSC SHOW—*Las Vegas, NV 2001*

EXHIBIT DESIGNER/FABRICATOR —*T L Horton Design, Dallas, TX*

DESIGNER—*Steven Levesque*

PHOTOGRAPHY—*Joe Aker*

The Taubman Company is an eminent retail developer, owner and manager of regional malls. For their appearance at the ICSC Show in Las Vegas they wished to create "a sophisticated presence" with an exhibit that would embody "the elegant and solid attributes of the company itself while convincingly express the high quality and enduring architecture which they are noted for in the shopping center industry."

T L Horton Design was challenged to develop in the 110 ft. x 50 ft. deep space a "classic architectural style

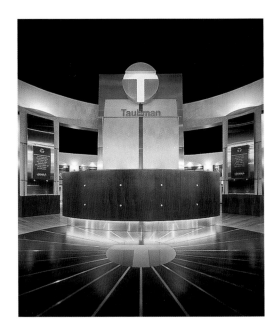

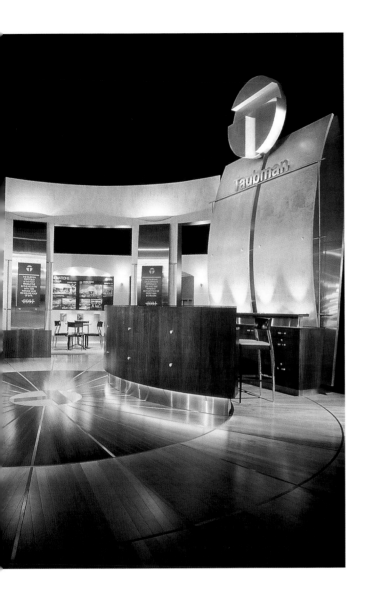

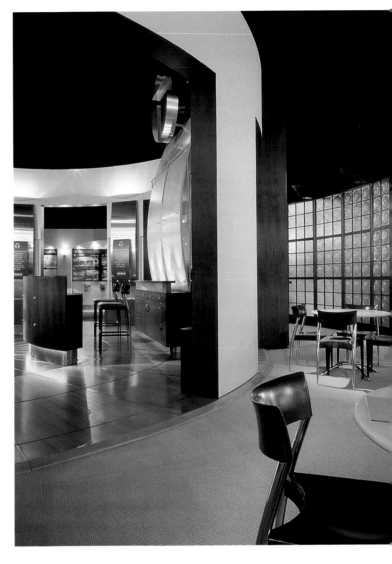

which would make it clear that they (Taubman) sit in the upper end of the spectrum of shopping center prestige." The client needed 30 meeting areas—"to be utilized in a controlled manner," several casual seating areas and a large reception zone. The main focus of the exhibit was the central tower or "foyer." A 30 ft. circular wood floor (walnut and maple) with radiating stainless steel inlays was the groundwork for the foyer which incorporated the reception desk with its glowing counter top. The company's logo was executed in brushed stainless steel and appeared on the tower and inlaid in the floor. "Subtle

curves were introduced lending an uplifting sense of space through stainless steel and maple panels within the foyer "and custom acrylic panels framed in solid walnut created walls that divided the space with a repeated circular motif. These offered privacy while enhancing the architectural delineation of the meeting spaces.

Clean lines, architectural elegance, high quality architectural materials (virtually no laminates were used during construction) and accent lighting that played a major role in illuminating and accentuating the forms, made this exhibit a resounding success for the client.

DEUTSCHE POST

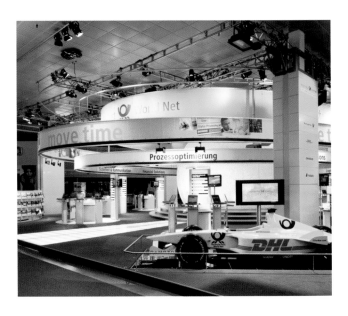

CEBIT—*Hanover, Germany 2002*

EXHIBIT DESIGN—*Pim Jeurissen of Raumtechnik Messebau,*
A George P. Johnson Company

PHOTOGRAPHY—*Andreas Keller, Altdorf, Germany*

Deutsche Post World Net (DPWN) is actually four
brands under a single umbrella—Deutsche Post, DHL,
Danzas and Postbank. The company's overall marketing
goal was to reposition its brand profile from that of a sin-
gle purpose mail service to that of a completely integrated
systems supplier. For the Center for Office and
Information Technology Show they commissioned
Raumtechnik Messebau—a partner of the George P.

Johnson exhibit design firm— to create an extensive and arresting display to fill the almost 7000 sq. ft. of space. The exhibit had to represent the company through "a deliberately branded architecture with an efficient implementation."

The revolving globe acted as the dramatic centerpiece of the entire stand and the "Time Planet" feature attracted visitors while it "tangibly represented the corporation's integrated services." Deutsche Post's very visible signature color took over the entire space. Shiny yellow panels created the tower-like columns, the numerous workstations, and the interactive platforms in the exhibit. The yellow was combined with brushed stainless steel constructions. A series of yellow "planetary rings" floated over one another as they rose to the hall's ceiling.

The designers devised a modular "move time" theme that was visually played out through a time zone concept which moved visitors through the "time" and "space" factors that were required to calculate velocity. In the Time Gallery a film depicting a journey from earth into space was projected on the floor. The exhibit stand was

also made more "compelling" through the use of topical videos that played throughout the conference on the numerous plasma monitors placed around the exhibit. The images were enhanced through the intelligent use of typographic and other visual elements which resulted in "a striking combination of hard facts, interesting information and entertainment."

The double deck structure used wood, steel and glass in its construction and the Time Planet was made of steel and fiberglass and sat on a custom turntable.

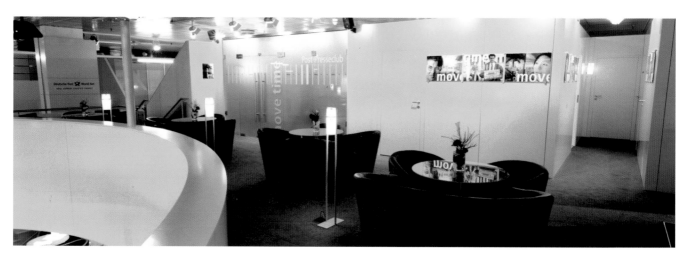

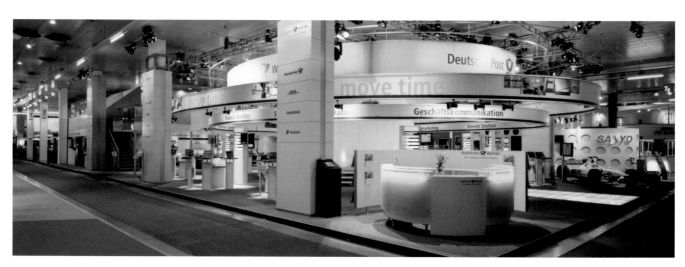

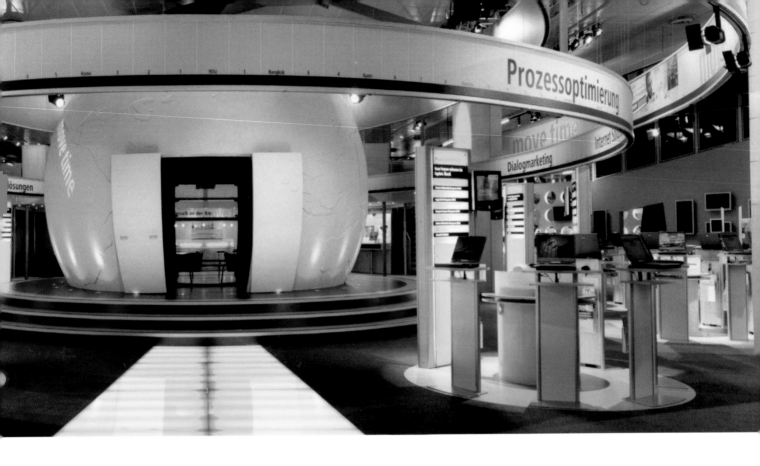

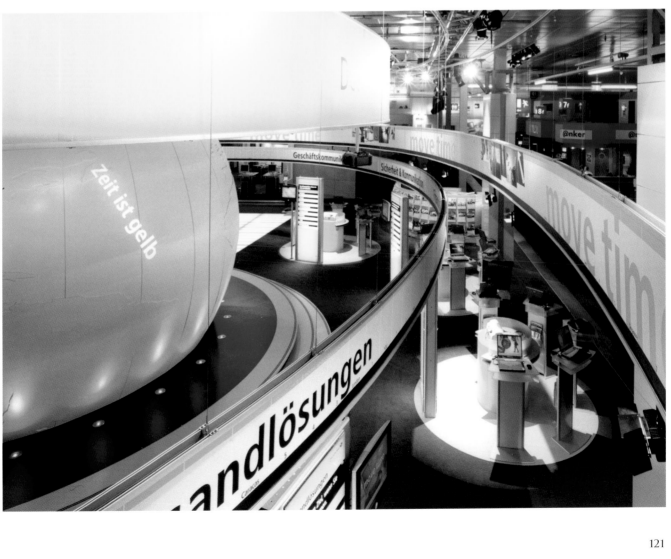

SCANIA TRUCKS

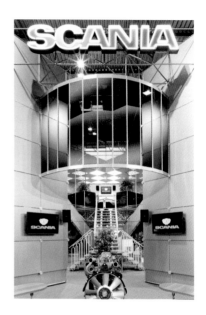

AUTOTEC—*Brno, Czech Republic 2002*

EXHIBIT DESIGN & FABRICATION—*MIBA, Prague, Syma's partner in the Czech Republic*

PHOTOGRAPHY—*Courtesy of SYMA Systems, Switzerland*

In collaboration with VVD, Miba of Prague—a partner of SYMA systems in the Czech Republic—realized this two story + towering mirror paneled architectural spectacular in a space of 6865 sq. ft. at the Autotec show in Brno. Scania, the Swedish manufacturer of heavy duty, heavy goods hauling trucks made its presentation in this long display space which showed off to the attendees a variety of the company's trucks. It was, however, the gigantic entry portal/facade into the soaring edifice that drew the visitors to the stand. The reception/information desk in Scania's signature blue color was located up front and just off the aisle. Sharing that ground level with the trucks were the signs and graphics used to explain and play up the products on display.

The structure was built on-site with components of SYMA's Orbit 30 and 40 systems. Plastic panels were bolted onto the framework of the facade and the curved oriel window over the entry was fitted with tall panels of gray tinted glass. The two side walls of the building angled forward and out and here the applied mirrored panels were used so that from anywhere in the exhibit hall people could get different views of the Scania trucks lined up on the white floor. The mirrors also played up the all-angle viewing of the trucks.

Inside the structure a double staircase met part way up and became a single stairway to the second level where there were meeting rooms and a hospitality suite.

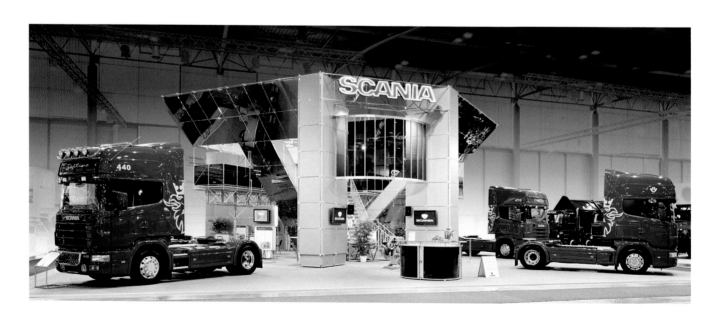

AMERICAN ISUZU MOTORS

DETROIT AUTO SHOW—*Detroit, MI*
EXHIBIT DESIGN—*Access, Duluth, GA.*
 EXHIBIT DESIGNER—*Darren Pasdernick*
 GRAPHIC DESIGNER—*Ken Szpinder*
PHOTOGRAPHY—*Michael Yag*

Lightweight and easy to install materials plus the stream-lined new design by Access helped to create the desired buzz for American Isuzu Motors at the Detroit Auto Show. The design provided "a simple, elegant presence and an interactive backdrop for Isuzu's line of SUV products."

What made this exhibit stand out in its 9020 sq. ft. space was the internal glow and the overall flush of illumination that emanated from the aluminum framed, curved towers that were covered with Lumacite—a rice paper-like textured plastic material. This "added a warm, elegant tactile texture" and it also provided an internally illuminated surface for the oversized, lifestyle graphics printed by the translucent ink jet printing process. Also—"adding an increase in the sense of space" were the fabric canopies that carried the spotlights that accentuated the SUVs on the exhibit hall floor. Some of the vehicles were raised up on turntables that added even more to the excitement of the space.

The aluminum framework—"the backbone of the exhibit"—is functional and flexible and the straightforward grid pattern makes it possible to expand or reduce the modules as needed for the specific show, space size or venue.

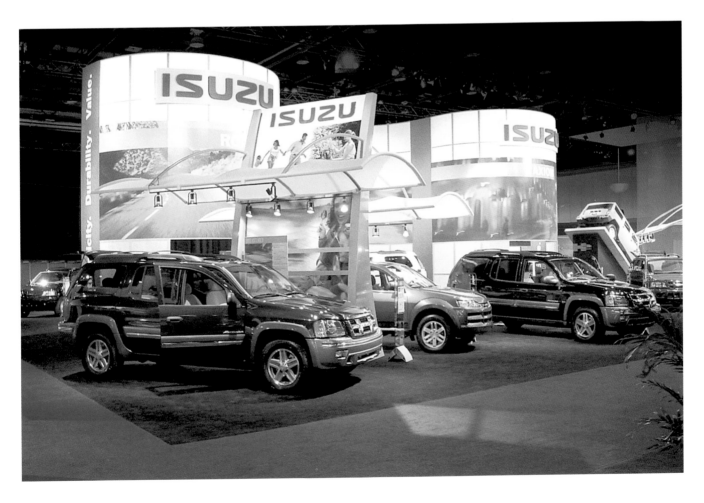

CERAMIC
TILES OF
ITALY

CERSAIE SHOW—*Bologna, Italy*
EXHIBIT DESIGN—*Mauk Design, San Francisco, CA*
Mitchell Mauk / Laurence Raines / Ingrid Ballmann /
Christiane Forsting
PHOTOGRAPHY—*Courtesy of Mauk Design*

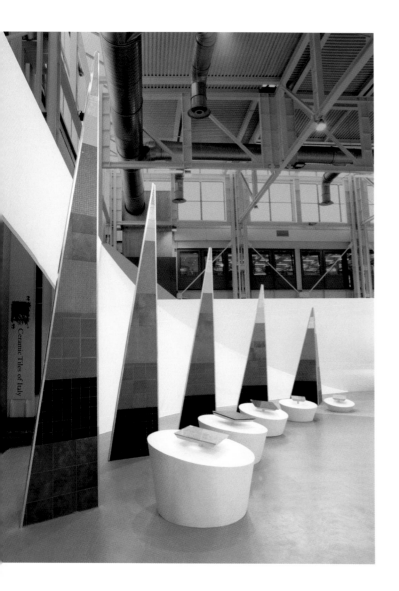

The Cersaie Show, in Italy, had booths representing over 1000 top manufacturers of ceramic tiles and bathroom furnishing industries from more than 30 countries. Mauk Design was asked by Assopiastrelle, the Association of Italian Tile Manufacturers, to design their 8365 sq. ft. space at that show.

The inspiration for the design was taken from the process of making tiles. It requires the basic elements of fire, earth and water. The tiles were shown off by "using them in the creation of innovatively shaped displays which were visually exciting and also expressed the three basic elements." In a range of blues, three amorphous build-ups of soft looking sculpted forms were introduced to express the element of water while three sided conical shapes of assorted heights were covered with tiles ranging in color from deep red browns through the reds and oranges to yellow. These represented fire. A cluster of translucent plexiglass cylinders containing earth-hued tiles represented the element of earth.

In the center of the space was a reception desk and publication display area. There was also a demonstration zone that could accommodate 20 visitors who were learning more about the laying of tile. In another part of the stand one could immerse oneself in the history of tile as well as the processes and techniques used in making tiles.

The space was semi-enclosed by 10 ft. partitions and located around the shiny floor marked off in beige, blue, gray and green were molded tables and chairs where visitors could rest a while or meet with sales personnel.

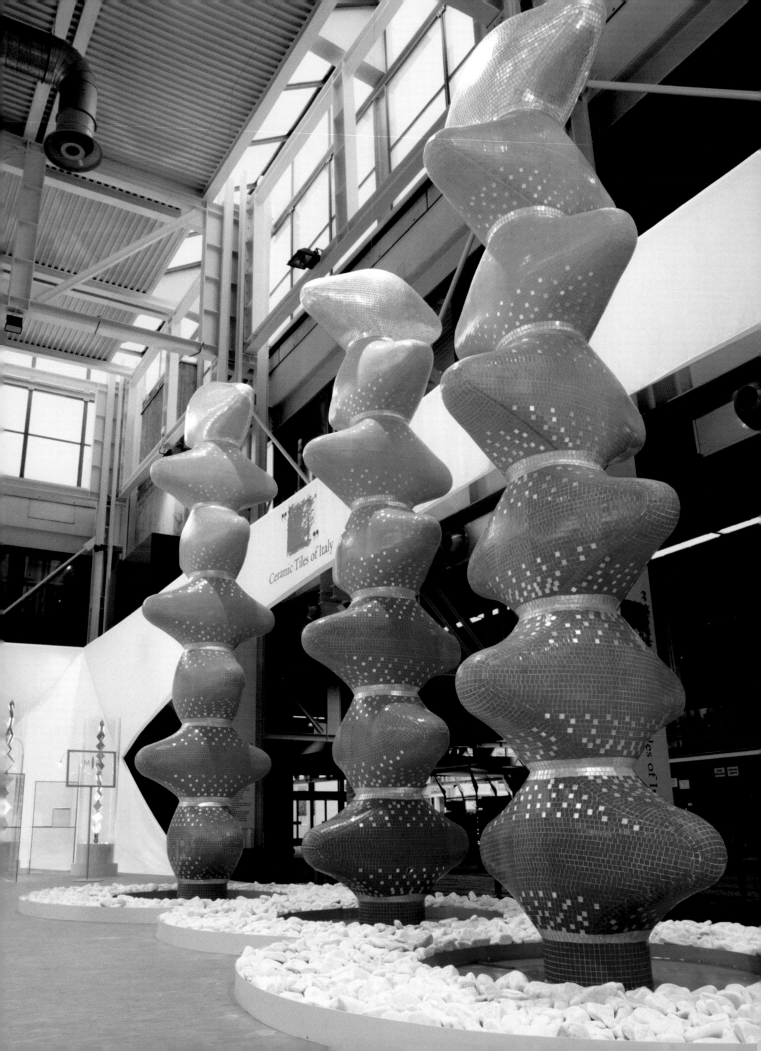

ACURA

NORTH AMERICAN INT'L AUTO SHOW—*Detroit, MI*

DESIGN & FABRICATION—*The George P. Johnson Company,*
Auburn Hills, MI
Geoffrey Nye

PHOTOGRAPHY—*Neil Tyson, Sterling Heights, MI*

"Perhaps the greatest challenge in the design of this motor show stand was to convey a strong sense of the three primary Acura brand attributes of Performance, Technology and Luxury. Acura needed to stand out, and do so economically."

Armed with this information, the designers at the George P. Johnson Company set out to design the 9300 sq. ft. stand for the American Honda Motor Company's Acura presentation at the North American Int'l Motor Show in Detroit. The design inspiration came from observing nature. "The natural flow of water over smooth rocks in a waterfall can be detected in the cascading elevated platforms of the stand while the undulating currents of a river are inherent in the weave of the hanging rear wall." The natural influences were blended and "married atop the technical materials and precision construction—to create a balance not unlike that of the brand attributes of "luxury and performance."

The simple, minimalist environment complemented

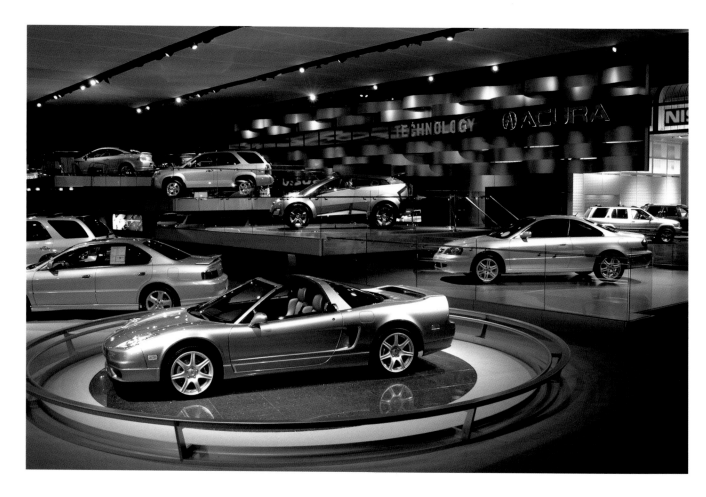

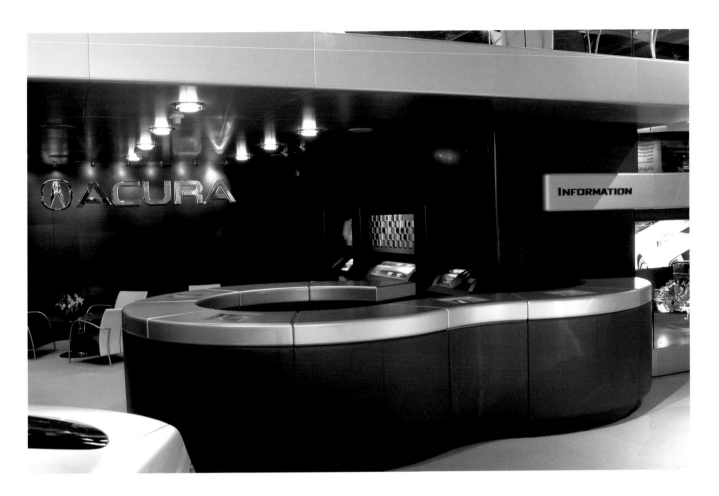

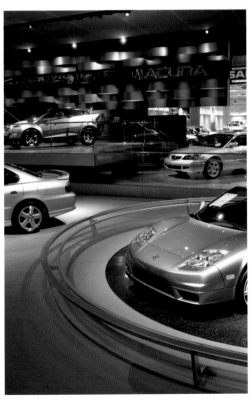

the materials and the sophisticated rendition of the concept. "Simplicity allowed the vehicles to remain the focus while the clean, finely crafted architecture created a strong bridge to the product and the brand." The autos were displayed like sculpture in a gallery "bathed in bright pools of light." The designers selected monochromatic colored vehicles to "convey a strength and confidence that stands apart from the architecture and allows one to examine their (the autos) unique attributes and familial qualities without the influence of pigment."

Motion graphics and a band of 15, 50 in. plasma screens created a "vibrant pulse of blue liquid energy that streamed across the weave wall." On a timed cue, the flow of the motion graphics was interrupted by a fast pace action video which spoke of technology and performance. This was supported by high energy music. The architecture of the stand was complemented by the series of white aisle-to-aisle canopies that carried integrated product and theatrical lighting.

NISSAN

AUTO CINA—*Beijing, China 2002*

DESIGN—*The George P. Johnson Company, Auburn Hills, MI*

FABRICATION—*SYMA, Beijing, China*

PHOTOGRAPHY—*Courtesy of SYMA Systems, Switzerland*

The impressive exhibit space designed by the George P. Johnson Company and executed by SYMA Systems' Beijing office not only took over 10,000 sq. ft at the 2002 China Motor Show in Beijing but won over the attendees and the press. The imposing stand, created to display Nissan's newest collection of autos, "bathed and surrounded them in a brilliant white light."

The integral "whiteness of the stand" stimulated visitors and created a cheerful mood in the exhibition hall. The focal point of the display was a circular "drum";

part of the white plastic construction that served to highlight the Nissan car on a revolving platform raised up off the high gloss white floor. Four high tech vertical supports created a multiple entrance into the exhibit space. A textured fascia connected the uprights and the Nissan brand name in the firm's red/orange color—in dimensional letters— was attached to that band and it could be seen throughout the vast exhibit hall.

A mezzanine was constructed at one end of the space and could be reached by the white and steel staircase.

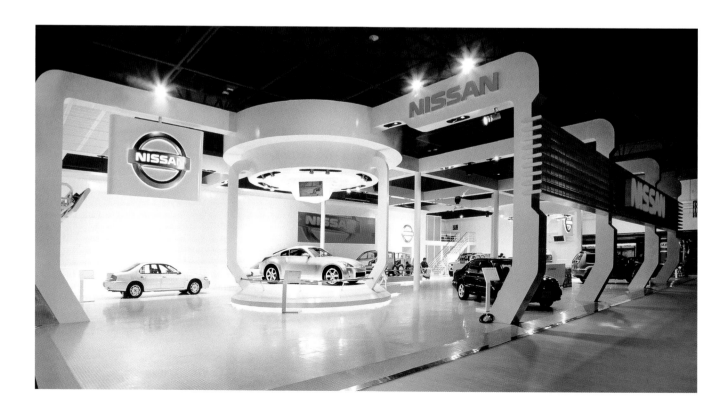

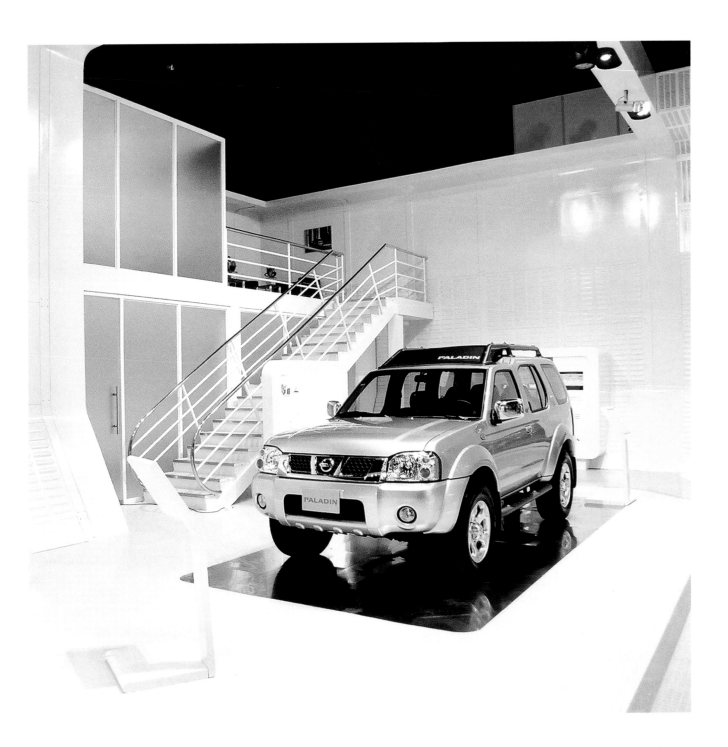

The long, narrow mezzanine was fitted with lightweight molded chairs and tables and a long banquette—all finished in white. This area was set aside for hospitality and conferencing. Floor-to-ceiling frosted glass panels allowed the light from the exhibit hall in but kept the noise and floor dazzle out.

The stand was constructed by SYMA Systems of Beijing using a variety of SYMA systems and the result "expressed the high tech character of Nissan cars in an impressive manner."

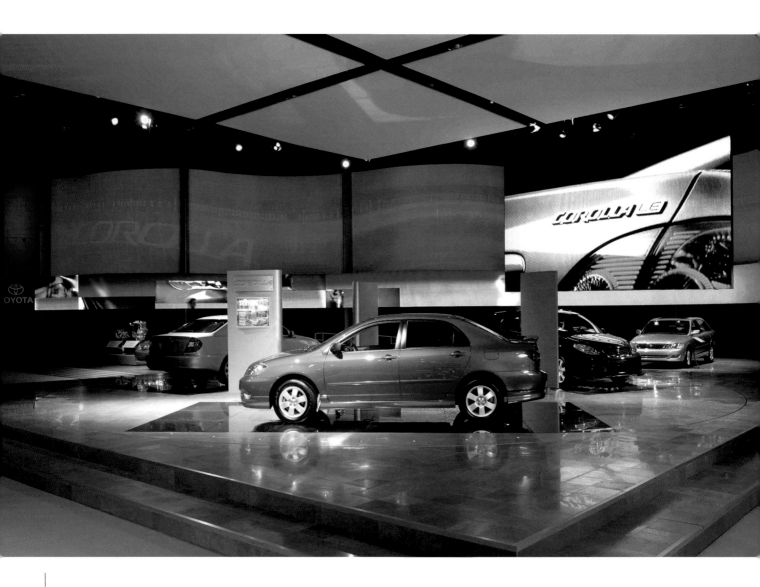

TOYOTA

NORTH AMERICAN INT'L AUTO SHOW—*Detroit, MI*

EXHIBIT DESIGN/FABRICATION—*The George P. Johnson*
Company, Auburn Hills, MI

David Yuen / Joseph Grace

PHOTOGRAPHY—*Neil Tyson, Sterling Heights, MI*

"Toyota wanted to step beyond its traditional auto show presence and launch a completely new display with integrated multimedia features intended to bring to life its new— 'Get the Feeling'—position. The objective of the exhibit was to extend this emotion into all elements of the automaker's presence on the floor."

With this objective foremost, the designers at George P. Johnson Company created this exhibit that filled an 18,000 sq. ft. space on the floor of the NAIAS Show, 2000, in Detroit. The concept was a "Media-scape" presentation which contained four elements synced together to affect distinct yet complementary environmental aspects. A serpentine fabric wall—150 ft. long x 25 ft. high—snaked through the space and served as the signature feature of the space. In addition to the static

images printed onto the fabric there was also moving graphic imagery. A 4 ft. high x 150 ft. long LED band was cantilevered out in front of the aforementioned curved curtain wall and here was presented imagery and brand messaging for the new Corolla and Camry vehicles.

Featured Toyota messages were played out on a third 16 ft. x 26 ft. LED suspended from the ceiling. A 44 ft. diameter turntable presented three automobiles positioned at 120 degree increments and it was designed to move in sync with other "experience elements." The combination of these elements touched almost every sense and created a highly dynamic and engaging presence on the show floor."

The fabrication of the stand which included chrome and glass as well as the fabric units, tied in effectively with the "Get the Feeling" ad campaign. The Toyota brand and product experience was relayed via "a dynamic mixture of motion graphics, compiled video, custom sound design and music—all brought to life over a vast expanse of 160 ft."

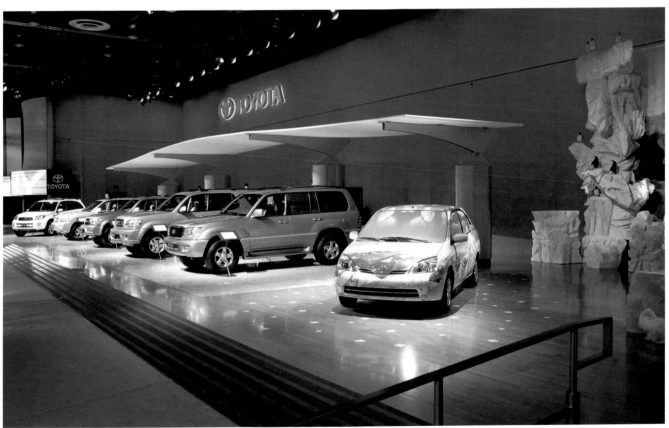

ROLAND

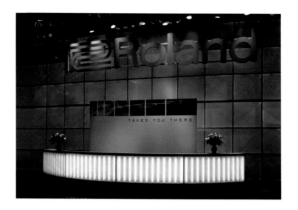

NATIONAL ASSOCIATION OF MUSIC MERCHANTS

EXHIBIT DESIGN & FABRICATION—*The George P. Johnson
Company, Auburn Hills, MI*

PHOTOGRAPHY—*Rob Miller*

With musical instruments as the product to display and
the need for interaction between guests and product
specialists, the challenge for The George P. Johnson
Company in designing the exhibit for the Roland
Corporation was "to create an environment that buyers

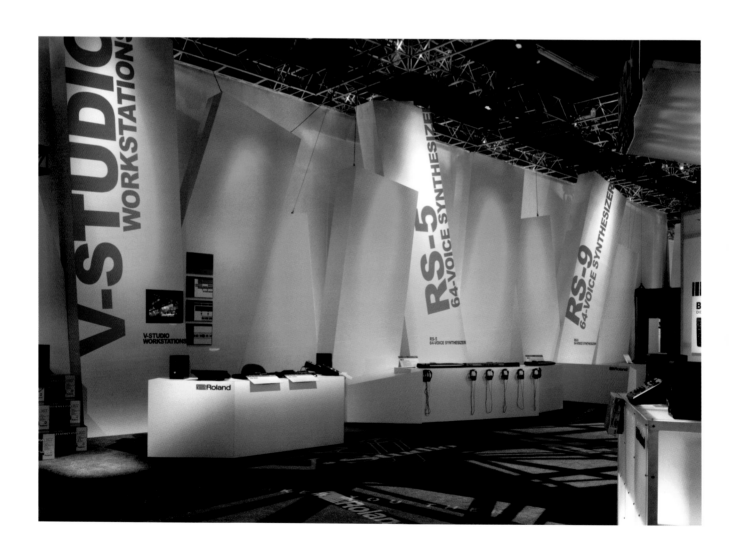

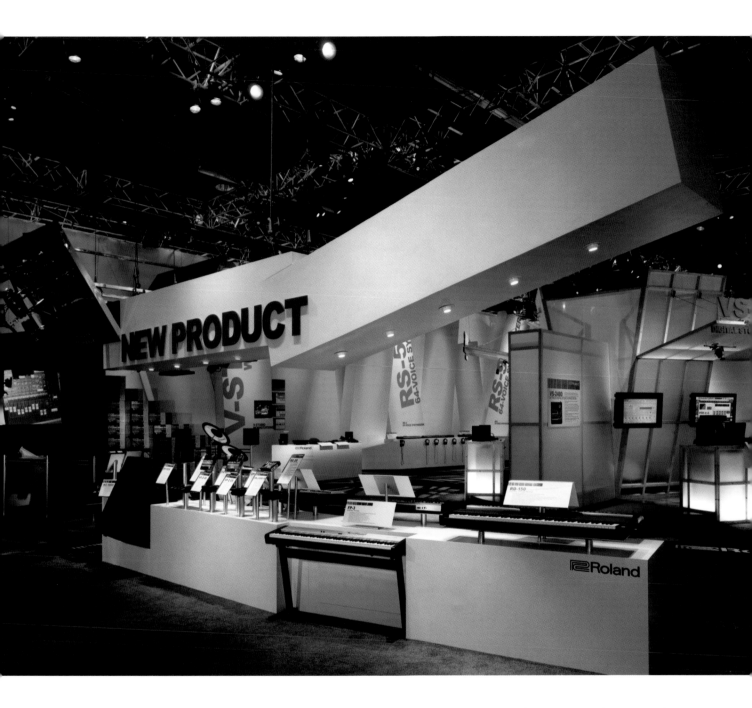

would be drawn to, interact with and leave with a posi- tive learning experience." To produce "an intimate, quiet and comfortable atmosphere" in the 19,000 sq. ft. space in a large, raw, industrial space surrounded by similarly-designed products called for real exhibit design magic.

The solution was to create two distinct areas: one for the Roland MI (Musical Instruments) and the other for the Boss brand. Roland MI was designed "as a distin- guished, minimalist setting "to showcase the product line dominated by keyboards, synthesizers and digital record- ing equipment." To affect the desired setting, the design- ers combined large scale, unadorned architectural forms with metallic and translucent fabric into a mostly white ambiance. The product display was supported by over- sized graphics and elaborate theatrical lighting. "The product stood out in contrast, due to its personal scale, dark colors and complex interface."

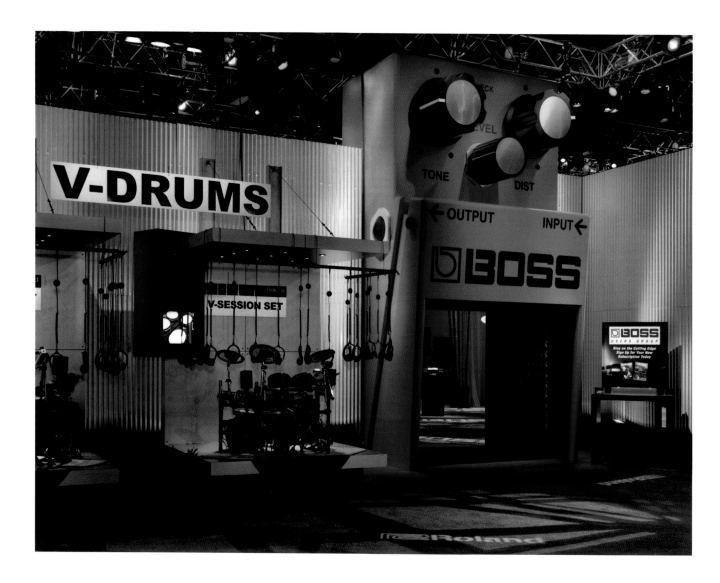

The Boss area took on the atmosphere of an intimate, low-key, cocktail lounge—"appropriate to the visceral and esoteric nature of the guitar effects product line."

Here, in a predominantly red environment, the designers used rich fabrics and eclectic decor under the low level of lighting to "create a seductive setting." This is where buyers were able "to experience the product on a personal level in an end-use environment" rather than a traditional trade show, sales-oriented setting.

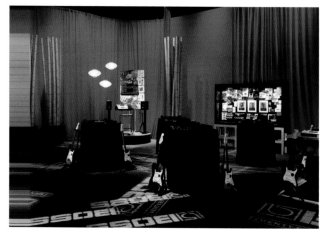

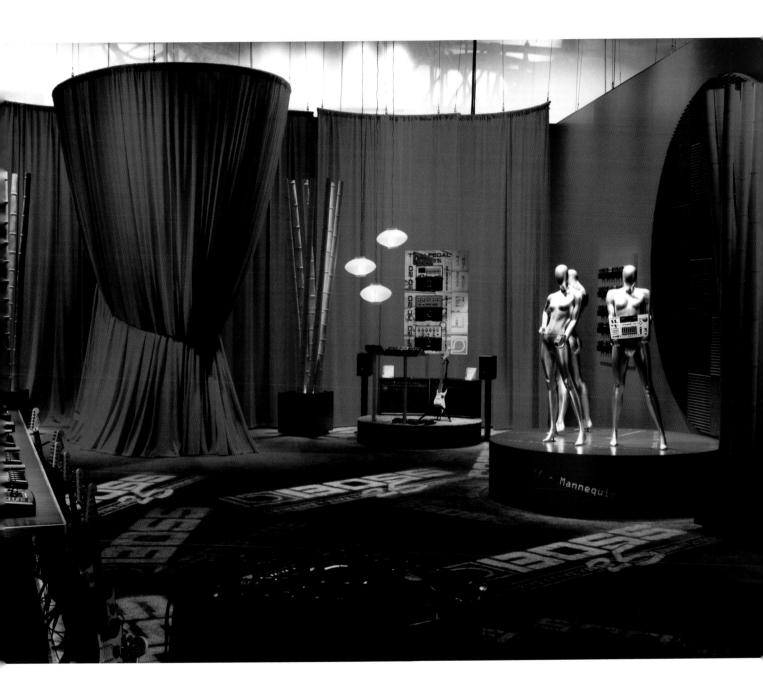

SONY PLAYSTATION

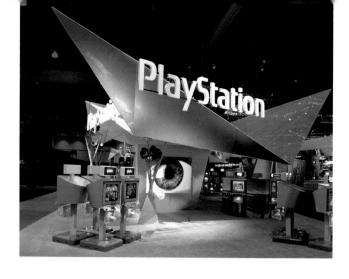

E3 EXHIBIT—*Los Angeles, CA 2001*
EXHIBIT DESIGN—*Mauk Design, San Francisco, CA*
PHOTOGRAPHY—*Andy Caulfield, Needham Heights, MA*

For the three-day run of the E3 Show where manufacturers and distributors of electronic games, programs, and all sorts of exciting and fun devices for the entertainment field come together to show off their newest, brightest, and most scintillating best, Mauk Design was once again challenged to come up with an over-the-top, awe-inspiring and unforgettable experience for the attendees at the Sony PlayStation booth.

The vast 38,000 sq. ft. space—a major presence at the show—combined 24 meeting rooms and two open the-aters with 170 game kiosks where visitors could actually try and play with Sony's newest PlayStation games and systems. A 26 ft. inflated sphere was the focal centerpiece of the layout and from here floated geometric, stretched a fabric "ceiling" kept rigid by the aluminum frames. These abstract shapes created a kaleidoscope of forms overhead and also unified the various stations and elements in the design. The sphere itself, became a giant billboard upon which by means of rear projections and lighting, PlayStation's featured game titles appeared.

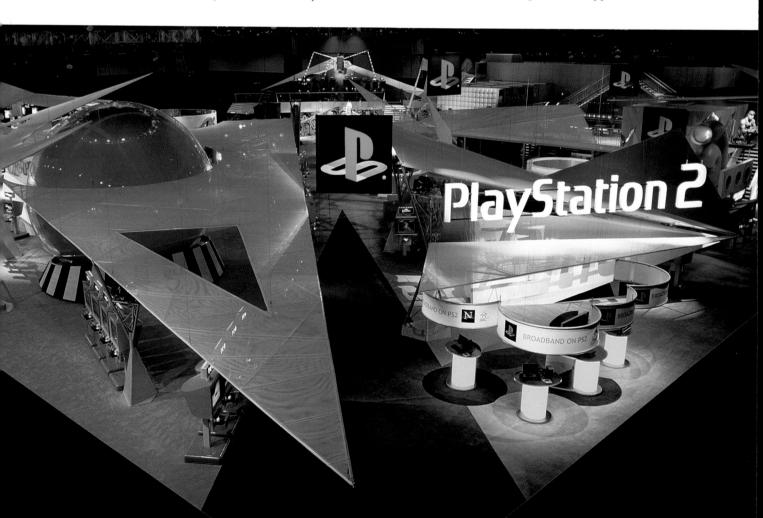

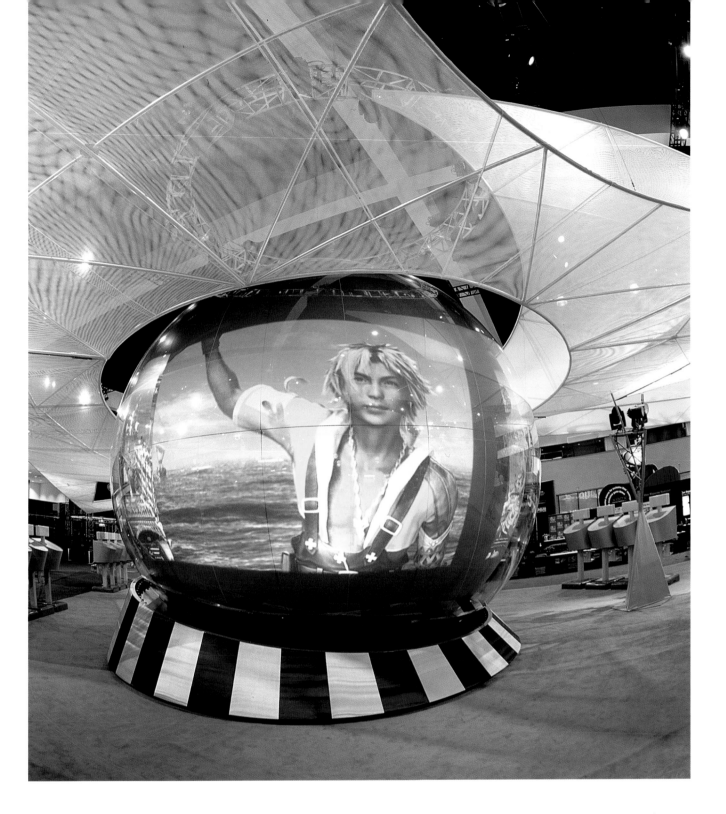

In the back corner of the exhibit there was a 4000 sq. ft. raised platform with glass flooring which was illuminated from below. "This futuristic area reinforced the cutting edge online video gaming" which was featured in the booth.

Blue lighting from overhead light sources "painted" the stretched fabric forms blue and also tinted the pale flooring on the floor. Bright colored accents appeared

throughout though most of the play kiosks were silvery gray. The lighting in the exhibit area was intentionally pitched low to enhance the images on the many monitors and screens around the floor as well as enhance the brilliance of the light projected images and messages and the changing light color show in the central sphere.

SONY
PLAYSTATION

E3 SHOW—*Los Angeles, CA 2002*
EXHIBIT DESIGNER—*Mauk Design, San Francisco, CA*
PHOTOGRAPHY—*Andy Caulfield, Needam Heights, MA*

"Can you top this?" That seems to be the question asked of the designers at Mauk Design by their client Sony PlayStation. Each year Sony PlayStation captures and holds center stage at the E3 Show and every year Mauk Design has to come up with a new, more unique, more theatrical, more spectacular, more eye-popping and more enveloping exhibit than their success of the year before.

For the E3 Show, 2002, some of the previous year's elements were recycled into this design in new ways and the designers had to still allow for the two dozen meeting rooms and 160 play stations where visitors could sample the new games and programs. What distinguished this design was the dramatic staircases—one at either end—enveloped by the angled "walls" of translucent blue plastic panels that echoed the dynamic sense of movement generated by the multi-paneled stylized "torches" up in front.

Giant (truly giant) screens angled forward off the mezzanine level of the two level structure and they tilted towards the front of the exhibit area. A constant play of performers and action scenes out of the current crop of PlayStation adventures appeared on these 16 ft. wide x

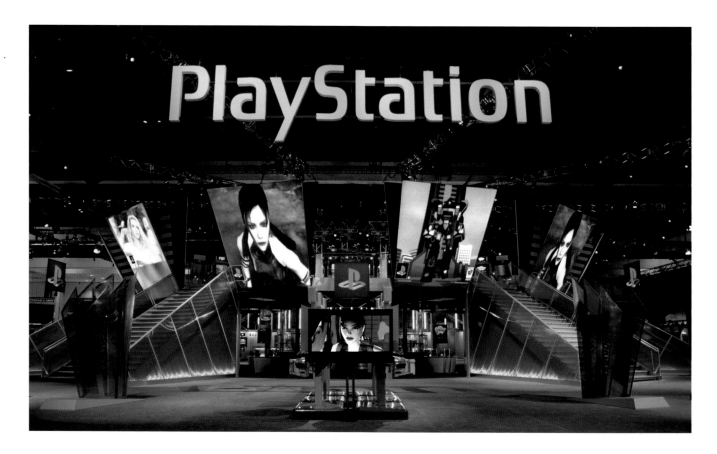

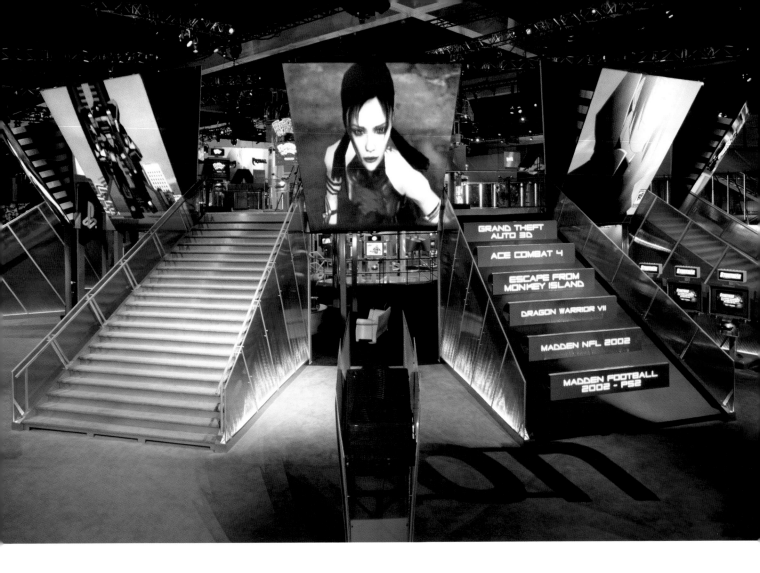

GRAND THEFT
AUTO 3D

ACE COMBAT 4

ESCAPE FROM
MONKEY ISLAND

DRAGON WARRIOR VII

MADDEN NFL 2002

MADDEN FOOTBALL
2002 - PS2

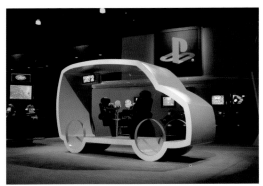

20 ft. tall screens. Up close to the aisle and at eye level was another set of screens relaying similar images and messages.

Another of the special features in this year's exhibit was the "cone shaped still life" washed in blue light. It served as a theater on the floor. The wide sweeping curved rear wall of the stand supported numerous metallic toned pipes which ranged in a rainbow of colors. A gigantic sweep of stretched fabric in an aluminum frame served as a "ceiling" over this wall and also carried a PlayStation logo up over the tumult and excitement of the floor. Here, too, many areas on the exhibit floor were kept low-lit to enhance the visibility and color of the images on the monitors and screens.

SIRIUS CO.

A TRAVELING EXHIBIT

EXHIBIT DESIGNED & FABRICATED—*Winntech Design Group, Kansas City, MO*

CO-CREATIVE DIRECTOR—*Brian Harvey*

ARCHITECTURAL DESIGNERS—*Adam Herbig / Don Gore / Carmen Thoma*

GRAPHIC DESIGN—*Momentum Marketing*

INTERACTIVE TECHNOLOGY DESIGN—*Winntech Digital Services*

PHOTOGRAPHY—*Winntech Design Group*

To launch the Sirius Satellite Radio at various store openings and race events across the United States, the Sirius Company asked the Winntech Design Group to create a mobile exhibit. The end result of the project were three identical trailers of 1125 sq. ft. each that prominently featured the Sirius brand, various genres that were key to the Sirius presentation and which allowed visitors to interactively experience the Sirius Satellite radio stations.

The exhibits were divided into three areas—the DJ booth, the individual listening stations in the body of the trailer and the genre specific car stations which were on

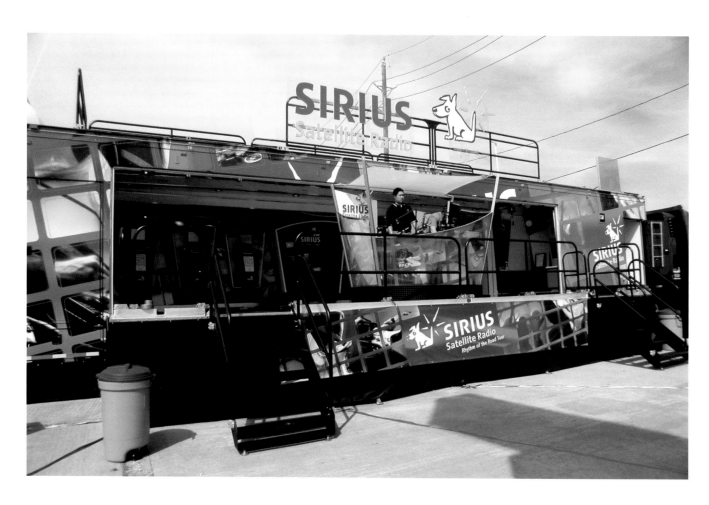

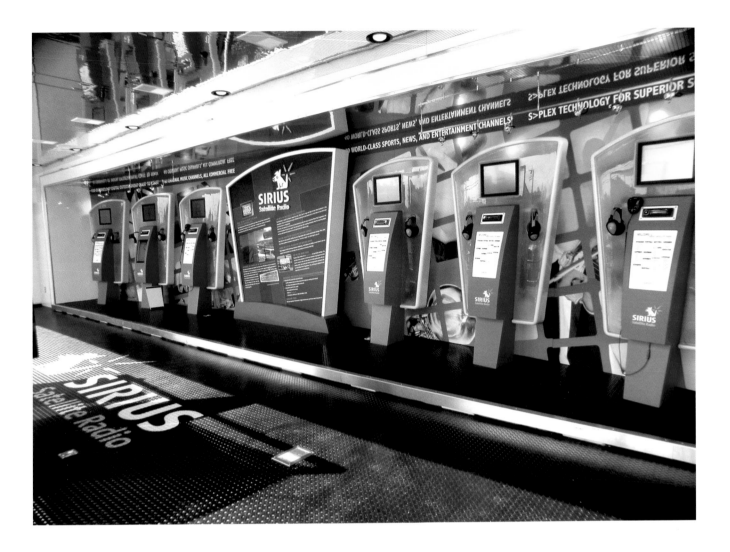

special car platforms spaced around the main trailer. The focal point inside the long trailer was the DJ booth which "allowed the visitors to experience the drama of live radio in the remote setting." There were a series of high tech listening stations within the main exhibit area which incorporated live satellite feed, head phones and touch screens through which the visitor could select to listen in on any of the 100+ channels of satellite radio. There was also a central information stand inside.

Grouped around this walk-in, walk-through and walk-out exhibit were the car platforms highlighted by stretched fabric sun/rain shields. The platforms promoted four distinct genres—rock, country, pop and sports. Each platform carried graphics illustrating the particular type of music or word as well as listening stations that featured satellite radio stations relevant to that genre.

ALCATEL SOLUTIONS CENTER

ALCATEL MARKETING CENTER—*Plano, TX*

DESIGNER: EXHIBITGROUP—*Giltspur, Dallas, TX*

DESIGNER—*Scott Beckham*

DESIGN TEAM—*Scott Beckham / Larry Dolan*

FABRICATION—*Exhibitgroup/Giltspur, Dallas, TX*

LIGHTING DESIGN—*Dall Brown*

AUDIO/VISUAL DESIGN—*Whitlock Group*

PHOTOGRAPHY—*Chuck Smith*

The challenge presented to Exhibitgroup/Giltspur by Alcatel was to create an exhibit in a 2500 sq. ft. space in the company's headquarters in Plano, TX that would showcase Alcatel's telecommunications products as well as demonstrate their capabilities as an innovator for their customers in the marketplace.

The result, shown here, is a "controlled, flexible and expandable demonstration environment experience which was created utilizing interactive programming and friendly, hands-on end-user ability." The clean, sharp and cool blue environment is introduced by a sweeping curved

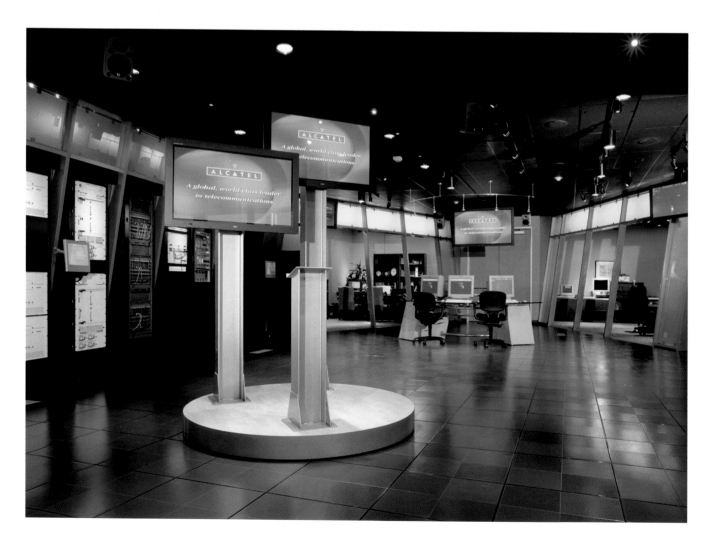

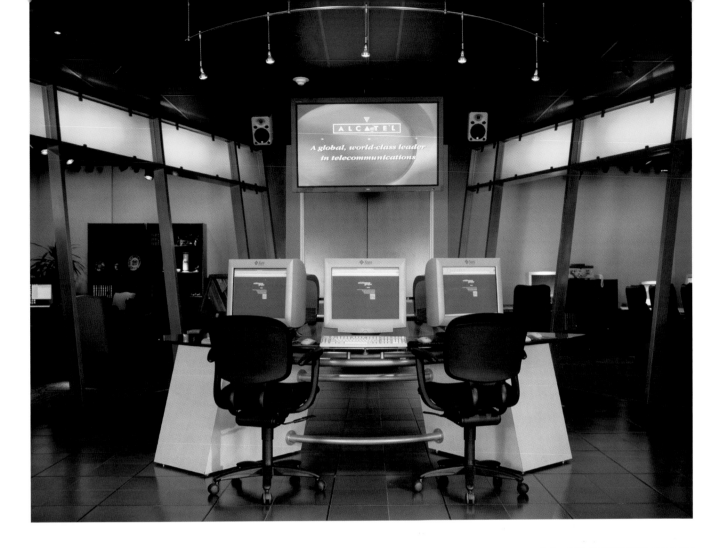

wall of red that carries the Alcatel brand logo across it. In front of it is a wood faced and frosted glass information/reception desk that echoes the curve of the signature wall behind it. In the exhibit area the blue ambiance sits back and allows the screens and illuminated surfaces to take over.

Twenty-five full size computer racks are housed here and they showcase the client's product. The space also functions as a demo lab: there is a visual presentation of both video and live equipment demonstrations interacting to show off the total solutions available from Alcatel. "All this is highlighted by the latest theatrical technologies of digital lighting, sliding LCD glass doors, and touch screen plasmas."

Though the exhibit area is primarily a marketing center focused on customer solutions for selling purposes to the top level executives, there are also vignettes of home and office settings to explain "the product demonstrations in a compelling manner."

ANTRON
CORPORATION

ANTRON RESOURCE CENTER—*Chicago, IL*

EXHIBIT DESIGN—*Perkins & Will / Eva Maddox Branded Environments, Chicago, IL*

 PRINCIPAL IN CHARGE—*Eva Maddox*

 DESIGN DIRECTOR—*Eileen Jones*

 PROJECT MANAGER/LIGHTING—*Patrick Grzybek*

 SENIOR DESIGNER—*Greg Keffer*

 DESIGNERS—*Anna Kania & Melissa Kleve*

EXHIBIT FABRICATION—*Exhibit Partners, Jim Kursar, President*

PHOTOGRAPHY—*Steve Hall, Hedrich Blessing, Chicago, IL*

The Antron Corporation Resource Center in Chicago was designed to "accommodate year round education and brand communication programs of attributes, benefits, and features of the premier group of Antron branded carpet fibers."

For NeoCon 2001, the parent DuPont Company's primary objective was to launch the new Antron styling fiber enhancements to the trade who would be visiting the various venues and showrooms during the Show. Eva Maddox of Perkins & Will / Eva Maddox Branded Environments was brought in to redo 2800 sq. ft. of the 3500 sq. ft. space which had modular walls covered with DuPont's Corian panels. Within that space she would create a display which would demonstrate Antron's "continued commitment to product innovation and style leadership."

Overscaled three dimensional forms were wrapped in the four new fiber styles and visitors were invited to interact with the fibers which were made accessible and touchable. Using technologically advanced means, messages about the products were integrated inside the fiber-wrapped sculptural forms. The Antron Mill Collection was a presentation of mill carpet products used the Antron fiber and the new mill styles which featured the styling fiber enhancements.

Throughout the cool, open, white environment, style messages from style leaders in various business professions were showcased and environmental graphic applications supported the brand communication efforts of

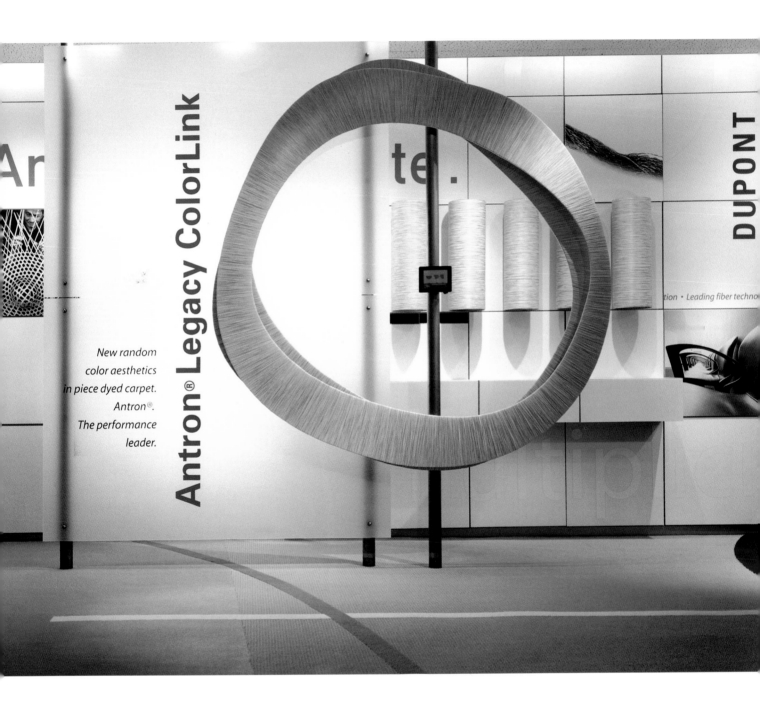

the company. These "messages" appeared on assorted size plasma screens which were integrated into the exhibit design and they also served to lead visitors through the space.

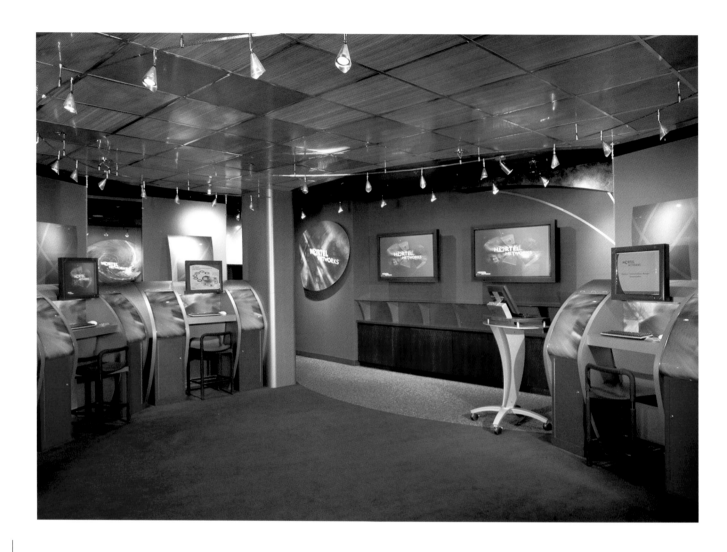

NORTEL EBC

NORTEL NETWORK EXECUTIVE BRIEFING CENTER—
Richardson, TX

EXHIBITOR DESIGNER/FABRICATOR—
Exhibitgroup/Giltspur, Dallas, TX division

DESIGNER—*Karl Baesman*

LIGHTING DESIGN—*Dall Brown*

PHOTOGRAPHY—*Chuck Smith*

Nortel Networks commissioned Exhibigroup/ Giltspur of Dallas to design and install a 3000 sq. ft. exhibit in their Richardson, TX base. The semi-permanent display would serve as a briefing center for high level visitors. The main objective was to communicate Nortel's brand message— "Building a new high performance internet"—while providing an exciting and interactive experience at the EBC (Executive Briefing Center).

The solution, illustrated here, is a technical yet personal experience with individual stations set up to encourage one-on-one interaction. To create the desired ambiance, the designers introduced perforated chrome metal ceilings, glowing lids on the demo cabinets and other unique materials. The all-important demo units were designed with distinctive curves to bring them more in line with the Nortel Networks' brand identity. The lids are bent plexi and conform with the demos main curve. They are

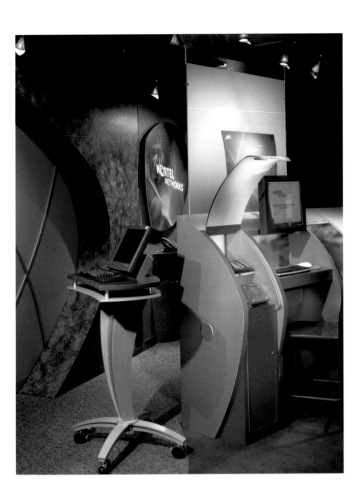

laminated with duraton graphics that are illuminated by the aforementioned interior lighting.

The curving arcs that are etched across the plexi panels set off from the signature blue perimeter walls "provide a direct link to the Nortel Networks brand while also creating a uniform sense of movement." The cutting edge environment is highlighted with "high energy graphics" and with the custom lighting that creates "an overall air of excitement, motion and forward thinking." The dramatic lighting was accomplished with a high-end, custom trac-lighting system. Spots effectively highlight individual demo stations and "keep one-on-one presentations to a more personal level."

This updated design not only reflects the look and feel of the current trade show exhibit (also designed by Exhibitgroup/Giltspur) but it has set the precedent for EBCs in other Nortel Networks facilities worldwide.

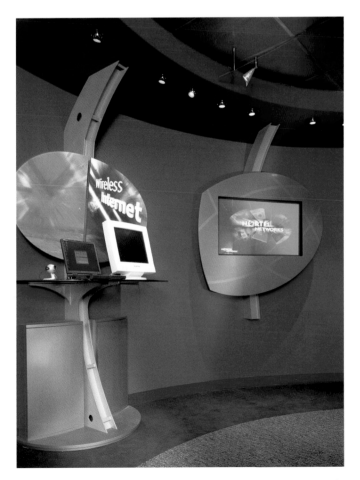

TOYOTA

ARUNDEL MILLS MALL

EXHIBIT DESIGN & FABRICATION—*The George P. Johnson Company, Auburn Hills, MI*
Marcos Anaya & Kimberly Kerner

PHOTOGRAPHY—*Bill Fitz Patrick*

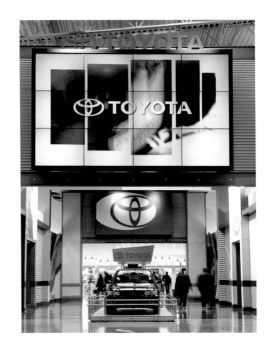

When Muhammad did not go to the mountain—the mountain went to Muhammad. When shoppers do not come to you it seems logical to go where the shoppers are. That is what the Toyota Motor Corporation did when they asked the George P. Johnson Company to create a movable exhibit that could be used in the open entrance-way or show spaces of malls/shopping centers.

To "allow people to gather information and learn about the product outside of a traditional dealership"—where there could be a sense of high pressure salesmanship—and to create a "user-friendly" environment for the vehicles, the designers had to satisfy the desires of the client as well as the mall management as to how that 3200 sq. ft. space would be used. "A more whimsical graphic package addressed both the projected audience and the developing mall architecture. Industrial details on the vehicle platforms reference a rich regional history in steel production—again speaking to an audience rooted in that culture."

The series of industrial styled platforms with thick, translucent plastic tops that can be illuminated from below, "fit naturally" into the allotted space. Signage, information and a plasma screen at eye level provided color and action-as well as the information to the mall visitors. A giant logo in green and white appeared over the entrance into the actual mall while a multi-paneled plasma screen soared over the actual display of cars. The twelve screens gave live action impetus to the stationary vehicles below. The Mondrian inspired wall graphics was finished in Toyota green, orange, deep blue and white and the overall geometric patterning of the surrounding walls was interrupted by graphic artwork and logos in the same palette of colors.

"Simultaneously, the displays needed to uphold Toyota corporate requirements regarding branding, flexibility, public safety and budget. Finally, the public needed to receive the Toyota environment in the spirit in which it was intended."

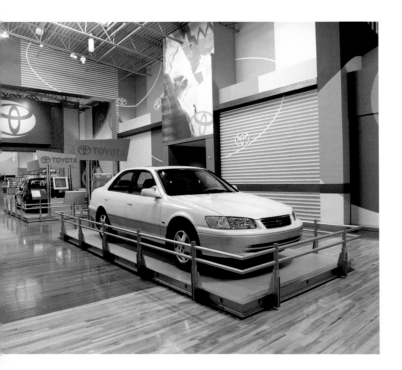

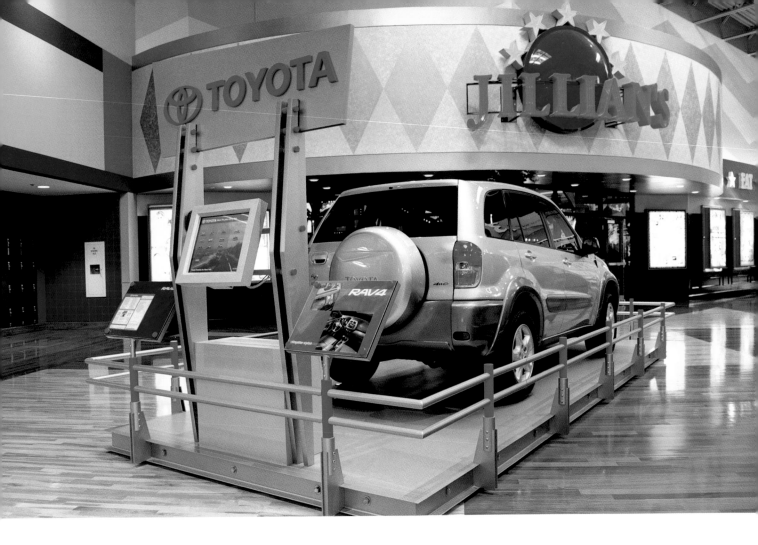
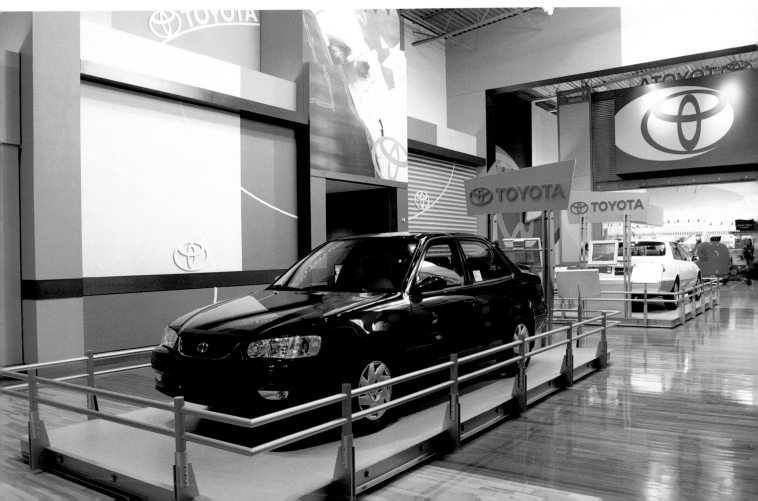

IBM

INNOVATIONS AT DISNEYWORLD—*Orlando, FL*
EXHIBIT DESIGNER—*Thinc Design, New York, NY*
 Tom Hennes / Jim Goldschmidt / Linus Lam
EXHIBIT FABRICATOR—*Cinnabar*
 William Volker / Deborah Conrad
LIGHTING DESIGNER—*Paul Palazzo*
PHOTOGRAPHY—*Brad Wilson*

For the semi-permanent exhibit installation that took up over 4800 sq. ft. at Innovations at DisneyWorld in Orlando, the Thinc Design team created "Think Place" for the client, IBM.

The principal collaborative activity—the Think-a-ma-jig game made use of a unique projection technique patented by Thinc Design. The centerpiece of the game is a 16 ft. diameter, inverted hemisphere lined with a retro-reflected projection screen. Up to 14 players gather at the individual stations provided where they can see their individual activity on a larger scale since each of the 14 images covers nearly half of the hemisphere. "Yet because the screen reflects each image back only to the player whose console it controls, each image is visible to only a single player, none interferes with the visibility of any other."

What makes this IBM sponsored exhibit so effective is that the Think Place is "100 % Disney" with its invitation to have fun while learning. Visitors are asked to try "not-yet-ready-for-prime time" gadgets developed by IBM's research lab and thus the guests may interact with the next generation of meteorological and scientific

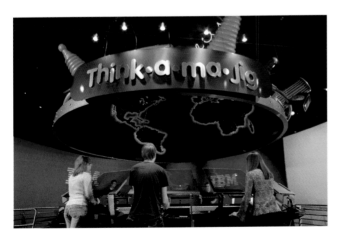

instruments. Through the naming of the venue as well as some of the specific activities such as Think-a-ma-jig and Thinker's Playground " visitors come to appreciate the thoughtfulness that underlies tomorrow's advances and innovations." While some areas have "the edge of coolness, transparency and speed, other areas have the look and feel of a more playful, warmly colored and slower paced environment for exploration."

Think Place was designed to increase IBM's brand presence and it does succeed in showing visitors some of the community building, educational opportunities and scientific advances that are taken for granted because of "IBM's commitment to research and innovation." The fun, colorful and interactive design has been, and still is, a great draw creating several million "impressions" since its installation.

SENTOSA MARITIME EXPERIENCE

SENTOSA ISLAND—*Singapore*

EXHIBIT DESIGN & FABRICATION—*Kingsmen, Singapore*

PHOTOGRAPHY—*Courtesy of Kingsmen*

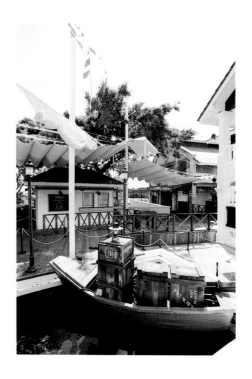

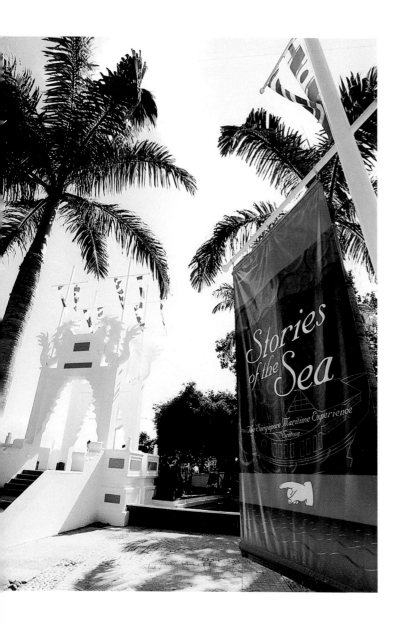

Located on Sentosa Island—just off the Singapore mainland—is the Sentosa Maritime Experience which features "Stories of the Sea." The 5280 sq. ft., two story building and the interior as designed and fabricated by Kingsmen of Singapore, combines an eclectic collection of maritime objects and artifacts with a delightfully-themed ambiance where the romantic, derring-do history of the early Chinese inhabitants of Singapore is unfolded.

The theme begins as the ferry brings visitors to the dock where the "old" wooden boats filled with weathered wood cargo crates set the scene for what is to follow. Visitors then stroll over an ornate bridge under a construction of rampant dragons and pennant flags In the decorative setting of a fantasy Chinese-style tea house—all red gold and filled with dark wood fretwork—visitors can sit and watch a state-of-the-art Object Theater presentation. The fully automated puppet theater tells the story of Admiral Cheng Ho, the famous 14th century Chinese explorer. Ornate red, pink and cerise be-tasseled silk lanterns hang from the cross beamed ceiling. Below the theater is a "Water feature" representing the Singapore River as it was in the past century. Down at this lower level guests can try their skill at loading and unloading the small cargo vessels

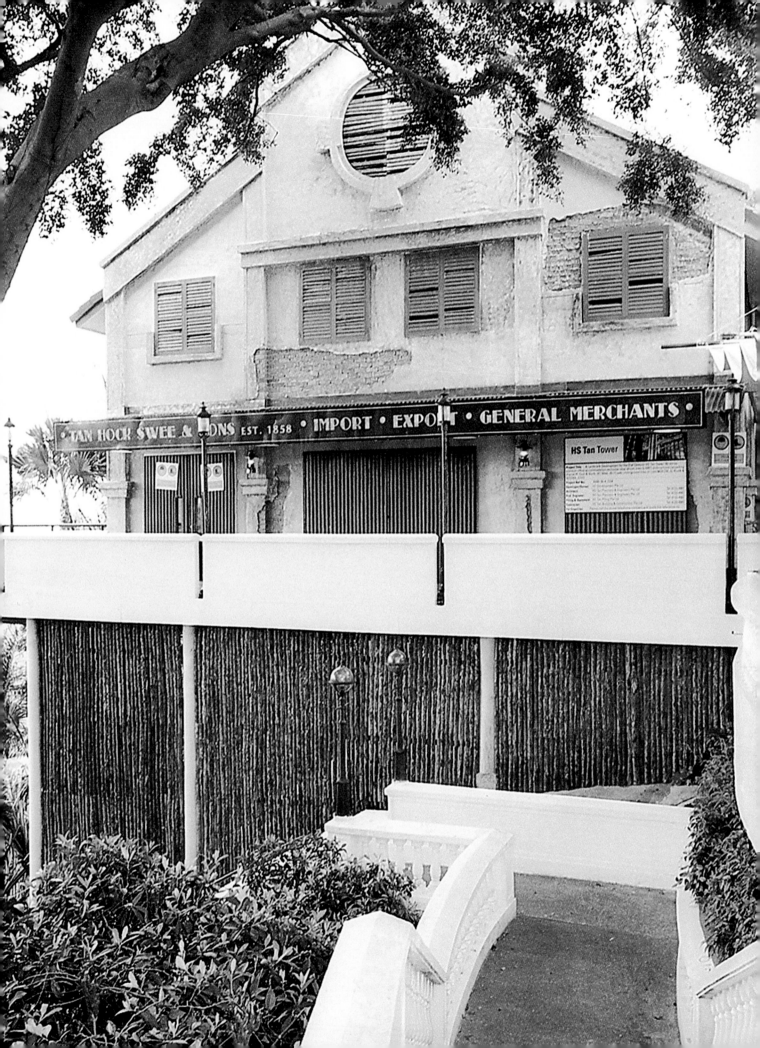

moored nearby as well as the human weight scales of centuries ago now on the wharf. Visitors can also climb aboard a re-creation of a typical commercial vehicle of the 19th century or experience an interactive Spice & Trade display also on the thematic wharf.

One of the adventure highlights is a visit to the Tan Hock Swee Godown at the end of the wharf where there is an amazing collection of maritime treasures which illustrate the maritime history of the region. This is in the weather wracked building that looks as though it wears centuries of aging with its broken shutters, chipped off stucco and ancient brickwork revealed.

The success of the "experience" is the fine detailing and the clever use of theatrical lighting and display techniques in recreating a long-gone period to a new generation brought up on the "realities" of TV, movies and Disneyland.

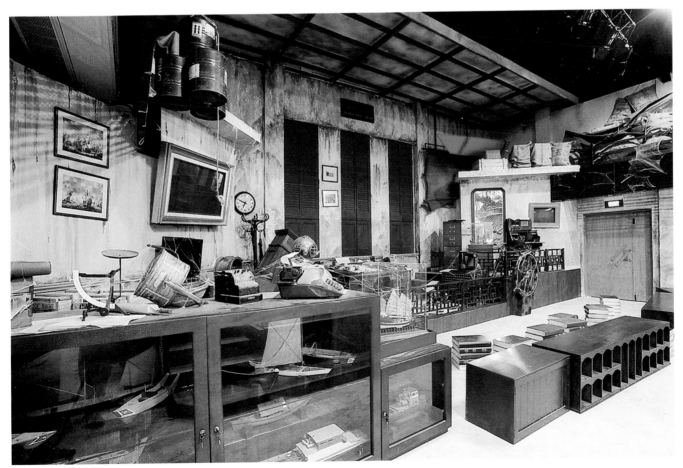

MOTORCYCLE HALL OF FAME

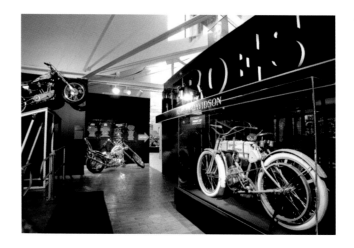

AMERICAN MOTORCYCLIST ASSOC.—*Pickerton, OH*
EXHIBIT DESIGN—*Dean DeShetler of DeShetler Design,*
Columbus, OH
CONTRACT EXHIBIT DESIGNER—*Bill Mahon*
DESIGN DETAILER—*Kenny Mitchell*
EXHIBIT FABRICATION—*Creative Cabinets Ltd.*
PHOTOGRAPHY—*Mark Steele Photography and Dean*
DeShetler / Tom Reed

For the centennial year of the Harley-Davidson Motor
Company, the Motorcycle Hall of Fame, located in an
8100 sq. ft. space in the home office of the American
Motorcyclist Assoc. in Pickerton, OH , chose to research
and display the stories of the many people who achieved
fame riding Harley-Davidson motorcycles. Through dra-
matic graphic design work the exhibit brings the stories of
these heroes from all walks of life to view with photo-
graphs, text, and actual motorcycles. These motorcycles
"are not from a random in-house collection but borrowed
specifically to fit the exhibit script." Some of these vehicles
are quite rare.

Dean DeShetler and Bill Mahon collaborated on the
conceptual design, the flow of the space and the use of
the 3D walls. DeShetler handled the concept, design and
coordination of all graphic and photographic elements
while Mahon was responsible for the design and con-
struction of all the architectural 3D elements and materi-
als. Kenny Mitchell served as a consultant on 3D materi-
als and handled the fabrication drawings.

The viewers become "active participants" as they are
led through the space by the layout and flow of the set-
tings. "The two dimensional and three dimensional
designs have been closely merged so that each mimics the
other and this presents a more sculptural feel." Among
the unique features created for this exhibit is the full size
replica of the 10 ft. x 15 ft. shed where William S.
Hartley and Arthur Davidson created their first motorcy-
cle 100 years ago. A storefront diorama represents
America's oldest Harley-Davidson dealer, A.D. Farrow in
Columbus, OH. There is also a simulated motorcycle
board track racing surface, 54 motorcycles, 150 artifacts

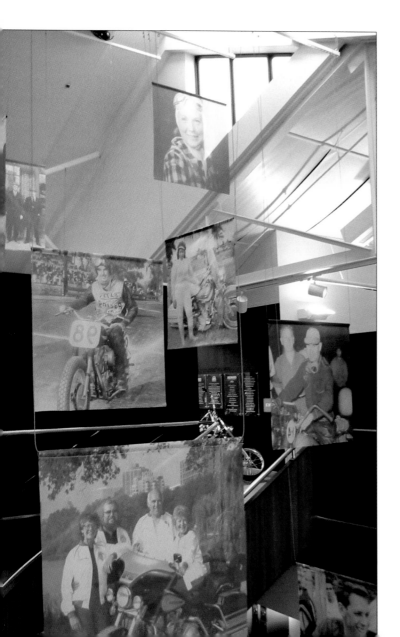

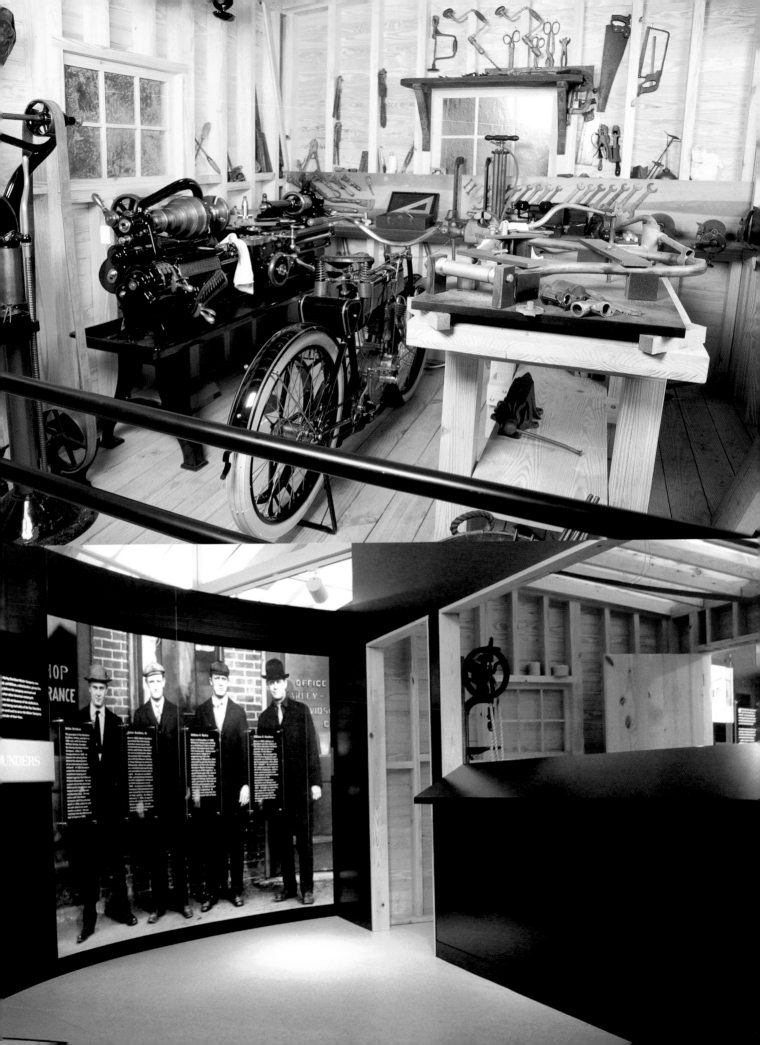

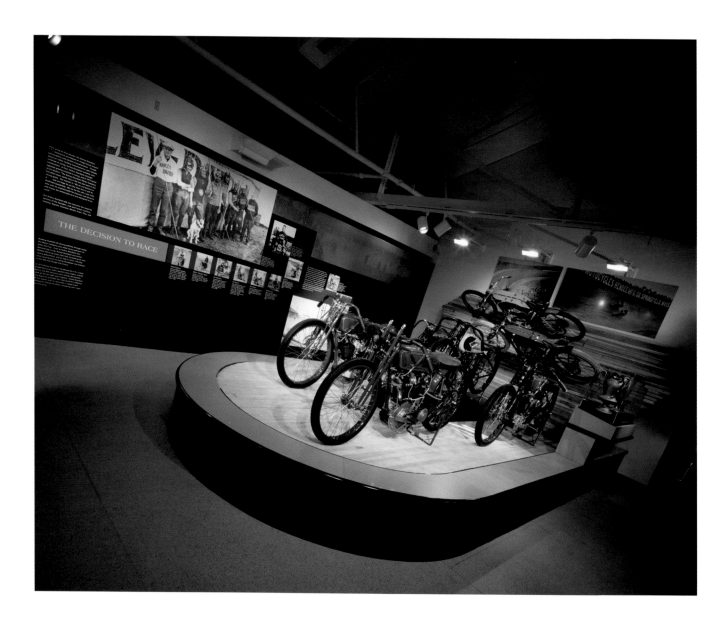

plus photos and more about the 105 heroes. The bikes are placed next to the stories and photos of "the men who tuned them, the women who rode them cross country, and the soldiers who rode them to keep America free,"

The wall graphics were a combination of layers with the first layer using Lambda prints with a semi-matte laminate and an adhesive back . It was mounted directly on to the 4 ft. x 8 ft. wall panels. The second layer of photos were printed using Lambda on metallic paper with a semi-gloss laminate and they were mounted on to 1/8 in. Sintra board. These were adhered to the first level by means of heavy duty, industrial Velcro "partly to give a lift for dimension as well as insure the adherence to the tightly curved walls." The color scheme throughout favored the orange and black Harley-Davidson colors and the accent colors were picked up from the H-D bikes on display.

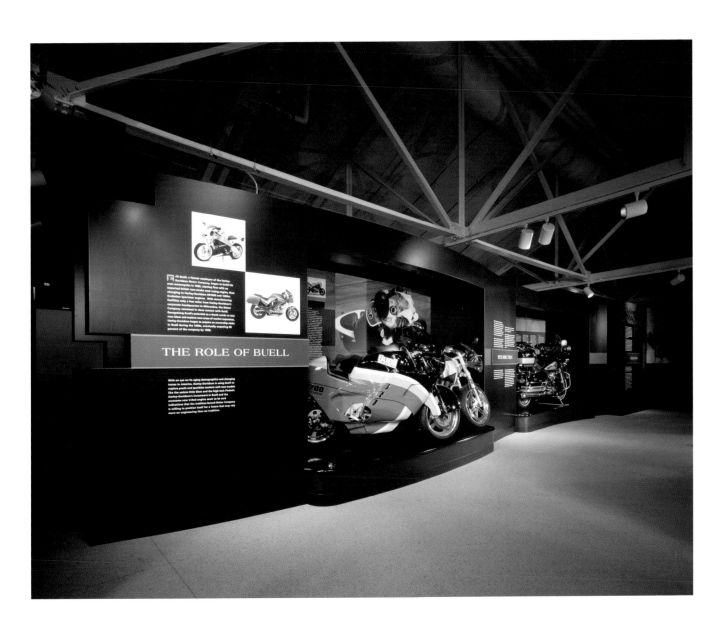

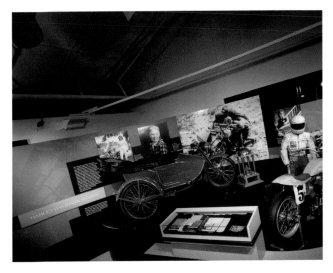

EDS
EXPERIENCE

EDS CORPORATE HEADQUARTERS—*Plano, TX*

ARCHITECTURE AND CONCEPTUAL EXHIBIT DESIGN—
Michael Malone Architects, Dallas,
PRINCIPAL IN CHARGE—*Michael Malone, AIA*
PROJECT MANAGER—*Talmadge Smith*
Rob Romero & Shani Dexon

EXHIBIT CO-DESIGNER—*Pentagram, New York, NY*

CLIENT—*EDS, Plano, TX*
VP GLOBAL MARKETING—*Gail C. Rigler*
Amy L. Malone
DIRECTORY OF EDS MARKETING CENTERS—*Mary
Frances Hoover*
EDS DISPLAY PROJECT MANAGERS—*Pamela Abeyta/
Susie Tobin/Colleen Girton/Sharla Perry/Beth Wallace*
PROJECT MANAGERS—*Julie Savasky/Wendy Lewis Carnegie*

PHOTOGRAPHY—*Jud Haggard Photography, Houston, TX*

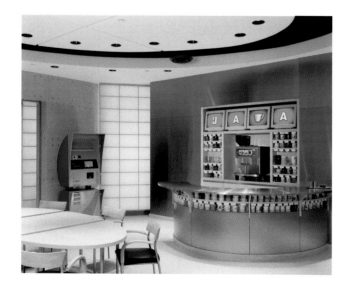

EDS is one of the world leaders in information out-servicing and technology consulting with a great depth of products and offerings. To assist with the sales and presentation process, the EDS Global Marketing Team created the EDS Experience-a three dimensional manifestation of the company and their electronic business model. The 10,000 sq. ft. space in the Plano company headquarters hosts clients and potential clients "in a fully interactive presentation suite with several discreet components." It is designed to accommodate short briefings or multi-day meetings in an environment geared to hospitality and direct access to the EDS headquarter campus.

Michael Malone Architects was selected to design the facilities, and Pentagram, an international graphic and design firm, was brought in as an equal partner in the design and conceptualizing of the displays and graphics. Together with the EDS team they created the displays and presentations that integrated with the architecture— "creating a seamless presentation and consistent message."

The lobby features a plasma monitor that can be customized to welcome the guests and offer the day's programs. A flowing wall of translucent glass has all of the current 10,000 EDS clients etched on it and the space also has projected logos that support the EDS marketing and advertising themes of the moment. The Cyber Café with its computerized barrista bar is located off the lobby. The bar becomes a background for an interactive demonstration which introduces the theme of the electronic marketplace. The area also has net surfing stations and an electronic newsstand.

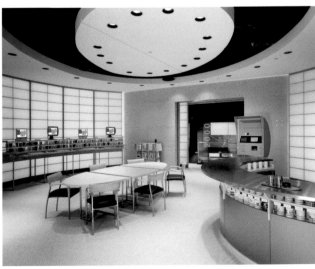

Passing through a large moving portal, visitors enter the viewing gallery which overlooks the control center where on large screens the company's history is presented. The large demonstration gallery is the major display/exhibit area with five main demonstration groupings arranged in "a three-dimensional simulation of the electronic business model." Through a series of real examples from EDS's portfolio of success stories, the interrelationship between suppliers, institutions, customers and alliances is demonstrated in "a cohesive, easily-grasped model that facilitates understanding and sales for the company." Multiple groups can interact in the space simultaneously. All the infrastructure is carried in a metal ring suspended from the ceiling which acts as a

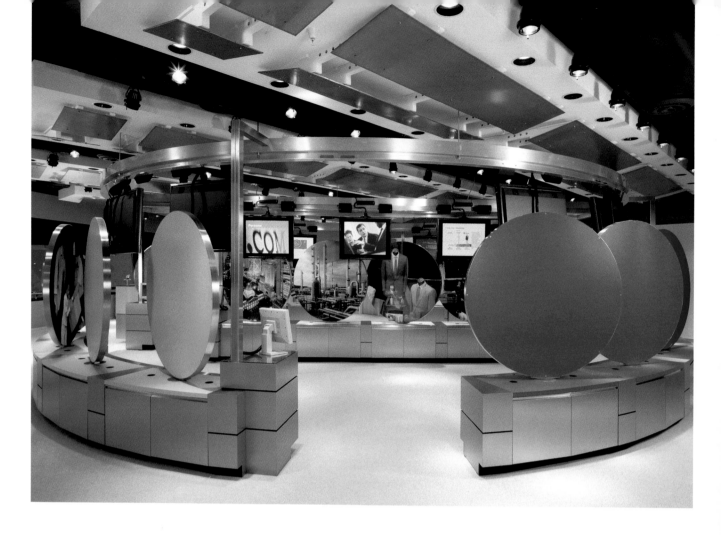

raceway for power and connectivity to the computer demonstrations below. This ring also supports the suspended flat screen monitors used to project the various scenarios.

There are also two state-of-the-art meeting and presentation suites—the Collaboration Rooms—which can seat as many as 12 in a room or can be divided to accommodate smaller groups. The rooms are fully outfitted for both tele- and video-conferencing and have service bars for food and beverages.

Light colors, fabrics and woods were used throughout and the open ceiling structure is painted a dark color that contrasts with the acoustic clouds used where acoustic control or special lighting is required. "This enhances the openness of the facility and the casual nature of the presentations." Graphics are applied via laserjet adhesive vinyl and can be readily changed as needed with new images and messages. As designed the exhibit space can be "changed and adjusted to accommodate a wide variety of needs, uses and guests and can easily be updated and revised as required to help it grow with the company."

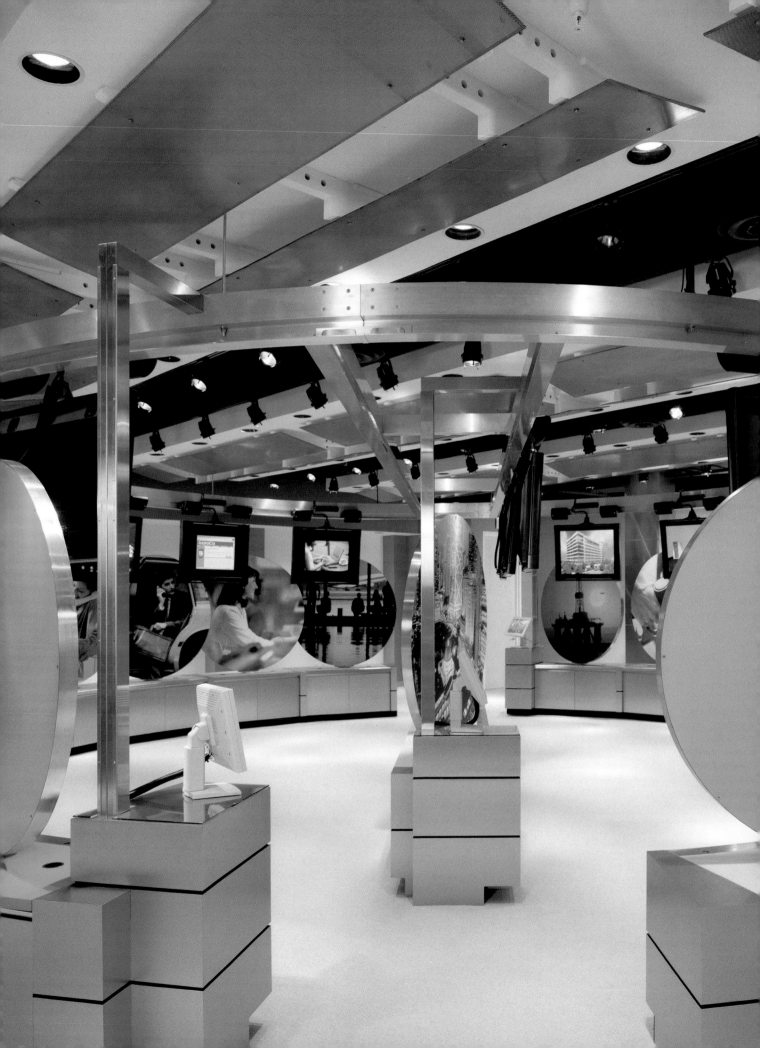

LOCKHEED MARTIN

VISITORS CENTER—*Ft. Worth, TX*

ARCHITECTURE AND CONCEPTUAL DESIGN—*Michael Malone Architects, Dallas:*

PRINCIPAL IN CHARGE / PROJECT DESIGNER—*Michael Malone, AIA*

PROJECT MANAGER—*Rob Romero*

PROJECT ARCHITECTS—*David Droese, AIA/Talmadge Smith*

GRAPHICS / DISPLAY & ENVIRONMENTAL DESIGN—*ArtHouse Design, Denver, CO*

CREATIVE PRINCIPALS—*Marty Gregg & Craig Rouse*

CLIENT'S DESIGN TEAM:

MARKETING MANAGER—*Vern Bennet*

PROJECT MANAGER—*Pat Conn*

PROJECT ENGINEER—*Monty McNair*

FACITITY DIRECTOR—*Thomas Ghesquire*

INTERACTIVE & MULTI-MEDIA DESIGN—*EDS, Plano, TX*

PROJECT DIRECTOR—*Beth Cooper*

CREATIVE DIRECTOR—*James Schlankey*

A/V INTEGRATED MEDIA—*EDS, Plano, TX*

PHOTOGRAPHY—*Jud Haggard Photography, Houston, TX*

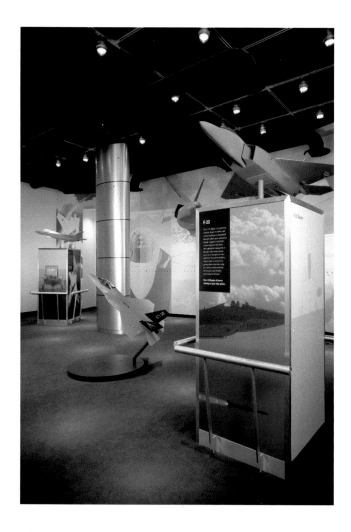

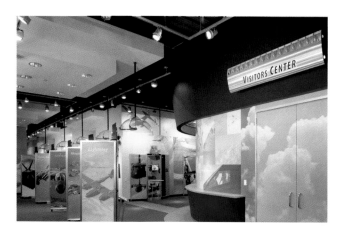

The 15,000 sq. ft. space houses Lockheed Martin's Visitor Center and it also serves other specific functions for the company. The center is constructed within a working aircraft manufacturing plant and is in a new structure with a complete foundation and it isolated from the adjacent environment. The space has a high-tech, futuristic look and suggests that this is "a progressive company with an active role to play in the battlespace of the future."

Open ceilings with exposed structures and ductwork contrast with the sweeping curves and the sharp right angles of walls and ceilings. Graphics are large format and incorporate images of futuristic and experimental aircraft and the palette was selected to be "mysterious and dark." Michael Malone Architects and their creative partners—ArtHouse Design—in conjunction with the team from Lockheed Martin, provided the design of the facility, the displays and the graphics and signage. The project was envisioned by the client to incorporate three "initiatives" that would expand their ability to market their products and services. These included the Visitors Center

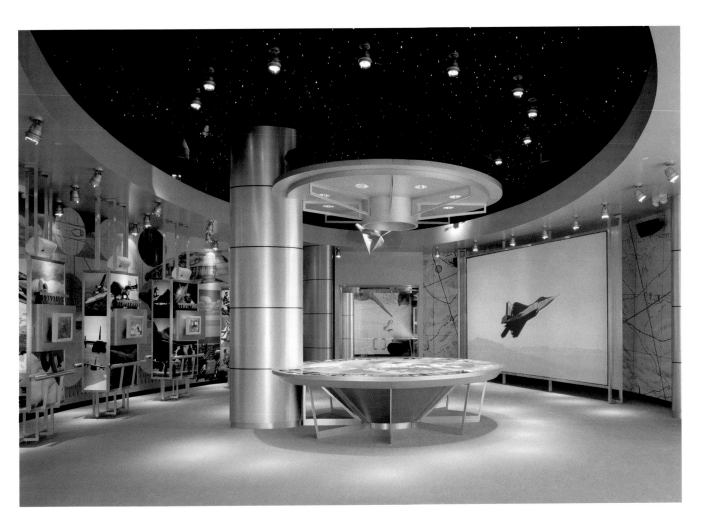

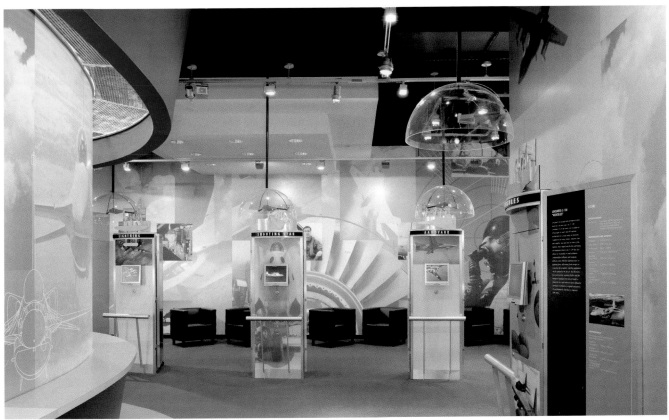

which would introduce the company to new potential
clients by allowing for a concise presentation of the com-
pany's history, legacy and worldwide network of services
and supports. Another initiative would present the
Lockheed Martin Joint Strike Fighter (JSF) program.
This would require a flexible facility that would easily be
updated and changed as the development of the program
progressed. The final requirement was for a permanent
home briefing theater where the VPDI (Virtual Product
Development Initiative) that used virtual reality comput-
er generated visuals could be presented "in a secured and
technologically enhanced and supported environment."

The Visitors Center main gallery was conceived as a
multimedia, sound and light show which presents the
company's place in "the battlespace of the future."
Visitors gather around a glowing table surface that is
actually a projection screen and additional screens sur-
round the walls. The ceiling is a fiber optic field of stars
to explain the role of space based satellites in the guid-

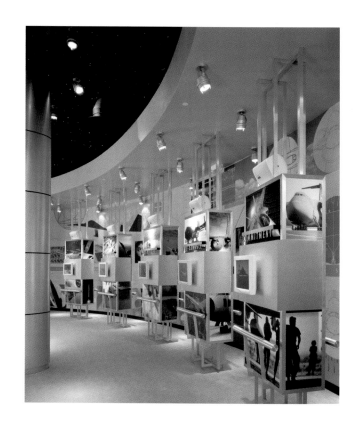

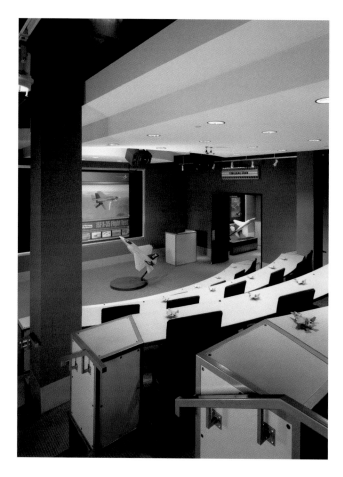

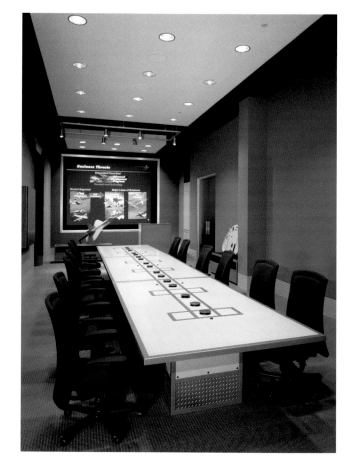

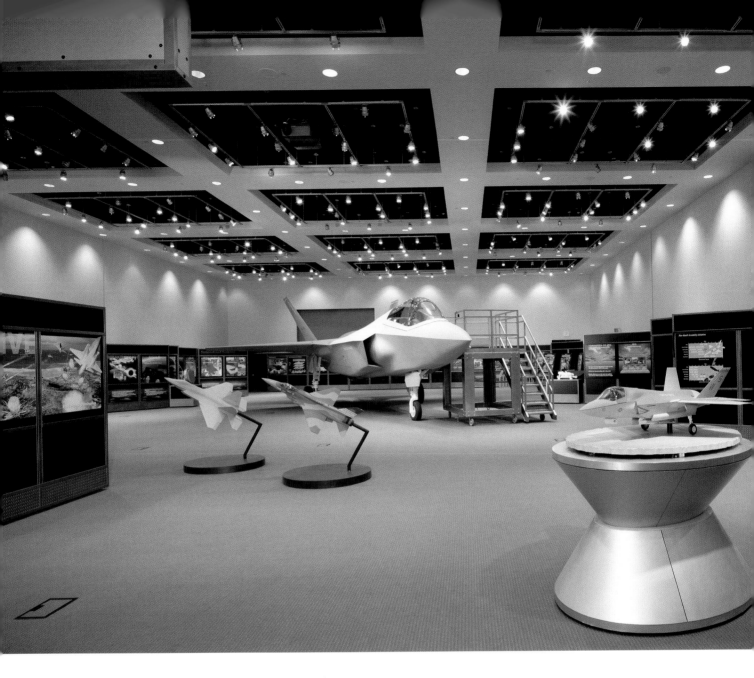

ance and management of battlefield operations." In the showroom beyond there are spinning models of aircraft on top of kiosks fabricated of mill finished aluminum and MDF with a clear finish. The computer interaction on the kiosk presents and illustrates the aircraft available from Lockheed Martin.

The VPDI Theater "is a state-of-the-art enhanced briefing environment specifically designed to present vertical reality briefing" to groups as large as 32. A 9 ft. x 16 ft. rear projection screen and virtual reality emitters are fitted into the space. By wearing special glasses visitors can see computer simulations in 3D. The highlight and central focus of the facility is the JSF Center where a full scale model of the JSF aircraft is displayed. The model cost over one million dollars to produce and it has working missile bays, an operating canopy and a cockpit into which visitors may enter. The model is surrounded by movable wall displays that represent in both static and interactive displays the development and testing data of the program. The displays are updated constantly "to make the center fresh and accurate, an important part of the program." The main display space can be reconfigured to accommodate a sit-down meeting of up to 300 persons. The Center has become "a three dimensional manifestation of the company's corporate culture."

GEORGIA PACIFIC

DENVER HEADQUARTERS—*Denver CO*

EXHIBIT DESIGN—*Lorenc + Yoo Design, Roswell, GA*

PHOTOGRAPHY—*Edward LaCasse Photography*

Georgia Pacific has two major headquarters—one in Atlanta and the other is in Denver. Lorenc + Yoo Design was presented with the following objective by the client—"Explain the sales and distribution process and show as many products as possible and demonstrate the connection between products and people." Perhaps the major problem for the designers was "to develop a design that would not be swallowed by the vast Denver Center—and to do it on a budget."

The allotted 15,000 sq. ft. space, located on a mezzanine in the Denver Corporate Center has 24 ft. ceilings and overlooks 90,000 sq. ft. of desk kiosks. The designers took advantage of that large space "to create a visual metaphor for the West—wide green spaces and wind swept plains." The design team created "towering forms that loom over the vast space below, forming sails, funnel clouds and westernized totem poles."

Visitors move freely through the space where the

bright yellow coated, high tech sculptures stand free so that they can be viewed from all sides. Incorporated into these dramatic technological constructions—many angled and askew and reaching up to the open ceiling—are graphic images and messages and actual products for hands-on inspection and demonstration purposes. The towers represent an aspect of the three part story—process, products and customers. The "tape measure" that is spirally wrapped around the cluster of beams unravels into a "time line"—at eye level—and connects the narrative shown on the construction adjacent to the angled tower.

In keeping with the theme—"lighting draws visitors to the site like night stars; wheels spin when pushed, wind fills sails, the entire exhibit appears as though it will take flight moving, spinning, flowing and finally—filling the vast space."

HAWORTH

HAWORTH OFFICES—*Chicago, IL.*

EXHIBIT DESIGN—*Lorenc + Yoo Design, Roswell. IL*
 Jan Lorenc / Chung Yoo, David Park/ Steve McCall/
 Mark Malaer / Susie Caldwell / Sakchai Rangsiyakorn /
 Ken Boyd

FABRICATION OF EXHIBIT—*Xhibitz*

LIGHTING—*Stefan Graf*

PHOTOGRAPHY—*Darris Lee*

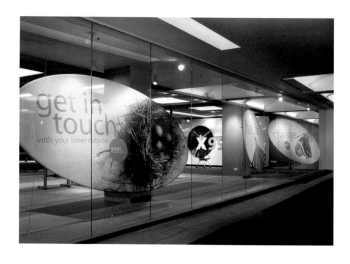

The 20,000 sq. ft. showroom of Haworth, one of the largest and most respected system furniture manufacturers in the U.S., was recently redesigned by Lorenc + Yoo Design "to complement product displays and establish a bold identity expressing the company's vision, core values and key 'stories.'" It was to be a "visually dynamic environment" that in addition to communicating the company's

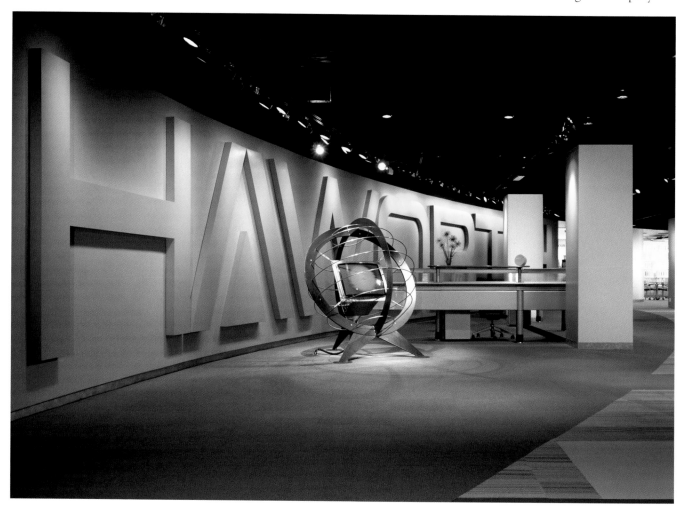

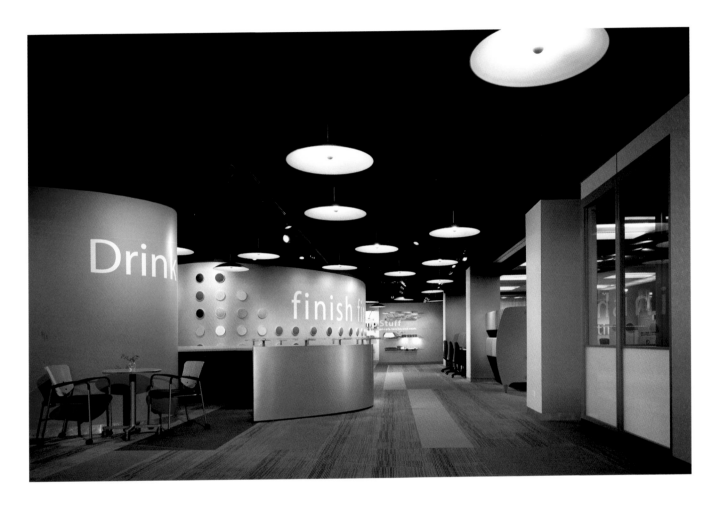

goal had to work within pragmatic restraints of time, space and cost effectiveness." The display/exhibit was to be ready for the 2002 NeoCon Show and it would eventually become the catalyst for a brand roll-out into 20 additional markets.

To communicate the client's multi-faceted nature of being both an innovator and creator as well as an established and client-focused company, the designers used a bold color palette of apple green and sky blue teamed up with black and white graphics, metaphoric images and "witty copy." "Color was applied in an architectonic manner, creating focal elements in the space and also de-materializing a forest of internal columns into an artistic graphic composition." The showroom features a large

apple green wall with a super-graphic Haworth logo on it. The columns were painted blue on one face, green on the opposite face and the separating surfaces were finished in white. Along the public access corridor large oval shaped black and white graphic disks with metaphorical images and sayings—"communicated key corporate messages." "These floating message ovals are pitched at different angles in respect to one another and appear to dance along the facade."

An angled black and white graphic signature chair wall serves as a background for the chair exhibit. Set within large punctuated circular and rectilinear shapes, black and white images of people mimic the first letter of the respective chairs being exhibited. "Who's been sitting in my chair?"—appears on the wall above and guests are invited to "test drive" the chairs then sign in on the wall behind as part of the experience. Throughout feature elements have been designed to lead people further into the space while emphasizing other aspects of the company. Haworth's "Global Presence" is suggested by the large steel plate and circular ring globe that contains a "decon-

structed video monitor" which is located at the reception desk while a "product constellation" overview of furniture images on circular disks are positioned to simplify and illustrate the company's vast line.

The existing showroom carpet was "revitalized" by cutting in complementary color accents to create a "welcome mat" and a sweeping entrance area that anchors the reception space. These color insets also bring the viewer's eye to specific product wall displays and define the floor areas of the chair exhibit. Colored gels modify and add a theatrical quality to the ceiling lights and transparent scrim screens help to organize the space while offering secondary messages. The product displays are kept neutral in color "thereby allowing the system components to read as a composition and create showroom visual harmony."

The Haworth NeoCon 2002 showroom exhibit was "designed to complement the product, create a new environmental brand image with an edge, and is an easily transferable system to adapt to other company showrooms in the future."

Atlanta Showroom Concept Sketch

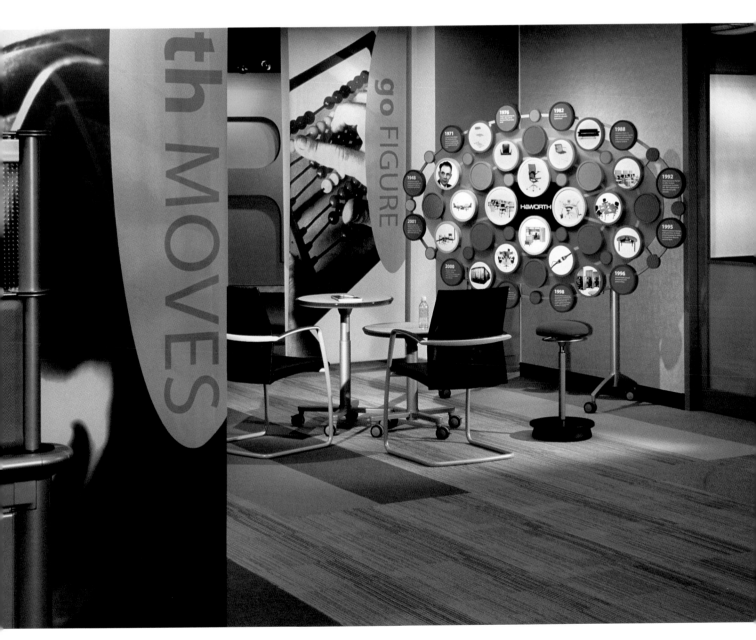

SAMSUNG'S OLYMPIC RENDEZVOUS

SUMMER OLYMPIC GAMES—*Sydney, Australia*

EXHIBIT DESIGN—*Exhibitgroup/Giltspur, New York, NY*

PRINCIPAL IN CHARGE—*Mihri Kim*

LEAD ARCHITECT/DESIGNER—*John Kim*

DESIGN TEAM—*Mickey McManus / Joasnne Sivess / Rebecca Shields / Stephen Streibig*

LOCAL EXHIBIT PARTNER—*National Exhibitors, Australia*

PHOTOGRAPHY—*Martin van den Wal, Australia*

Working in conjunction with Samsung's in-house planning team, Cheil Communications, Exhibitgroup/Giltspur transformed an existing outdoor parking structure of about 45,000 sq. ft. into an elaborate visitor's center and athlete hospitality facility.

"Powerful metaphors and breathtaking architecture" drove the design which had at its foundation the flame and the flower. "The flame transforms into a series of tension fabric structures symbolizing the spirit of the Olympic movement—creating a composite image of the Olympic torch constantly moving and eternally on fire." "The native Australian flower symbolizes two aspects of Samsung's sponsorship: the millennium/green games at one with the indigenous environment, as well as the effortless flowering and growth from the earth, a festive, joyful and natural solution to represent the wireless telecommunications revolution."

The outdoor pavilion featured a 60 ft., one-piece steel beam covered with tension fabric. Passing through the pavilion, guests entered the Spectator Center where the evolution of Samsung Technology was presented. It was also where all the fun began. Guests could follow the choreographed walk starting at the Timeline. The CCD

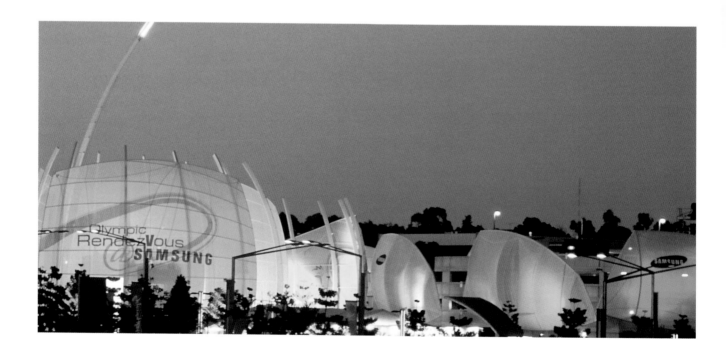

Monitor tunnel was the portal that transported visitors into the future world of Samsung Wireless telecommunications. Visitors walked across a bridge surrounded by a pond and a field of phones. "The bridge and the pond were symbolic of the transition that takes place from the old technology to the new—the need to traverse traditional boundaries and invent a brighter future."

The program finale was the Digital Interlude: an original live action, acrobatic performance complemented by a special musical score and exciting lighting sequences. Throughout the Olympic Rendezvous computer controlled projectors and theatrical lights were used to provide dynamic Samsung and Olympic messages as well as lighting arrangements that rivaled the city's.

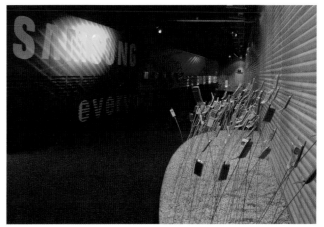

Index by Design Firm